bosch

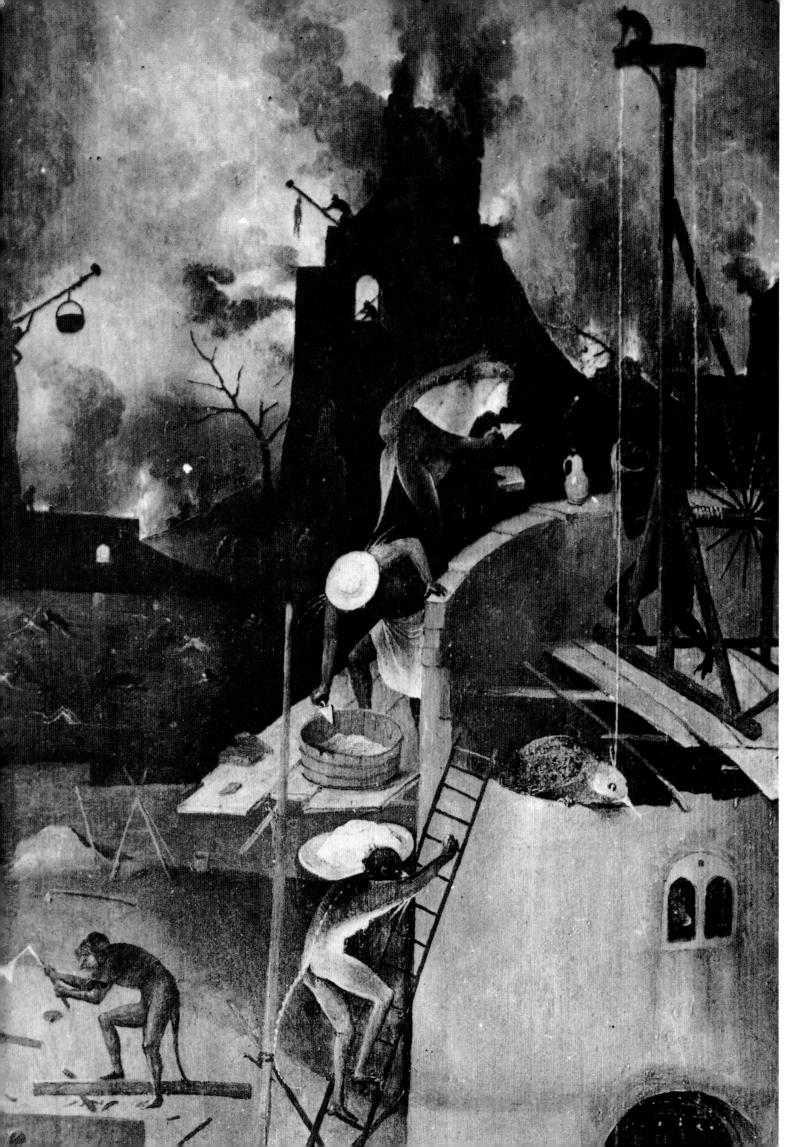

hieronymus bosch

carl linfert

HARRY N. ABRAMS, INC., PUBLISHERS

Contents

9 Hieronymus Bosch by Carl Linfert

Plates

```
The Hay Wain (detail)
Frontispiece
          The Seven Deadly Sins (details)
          The Seven Deadly Sins (details)
          The Operation for the Stone (The Cure of Folly)
          The Conjurer
          Ecce Homo
          The Adoration of the Magi
          The Ascent to Calvary
          The Hay Wain (detail)
          The Hay Wain (detail)
          The Hay Wain (detail)
          The Hay Wain (detail)
          Death and the Miser (detail)
          The Ship of Fools
          Ecce Homo
          The Temptations of Saint Anthony (detail)
          The Temptations of Saint Anthony (detail)
```

The Temptations of Saint Anthony (detail)

- 85 The Last Judgment (detail)
- 87 The Last Judgment (detail)
- 89 The Last Judgment (detail)
- 91 The Last Judgment (detail)
- 93 Saint Jerome in Penitence
- 95 Saint Christopher with the Christ Child
- 97 The Garden of Delights (detail)
- 79 The Garden of Delights (detail)
- 101 The Garden of Delights (detail)
- 103 The Garden of Delights (detail)
- 105 The Garden of Delights (detail)
- 107 The Garden of Delights (detail)
- 109 The Garden of Delights (detail)
- 111 The Last Judgment (detail of fragment)
- 113 The Last Judgment (detail of fragment)
- 115 Christ Carrying the Cross (detail)
- 117 The Adoration of the Magi (detail)
- 119 The Adoration of the Magi (detail)
- 121 The Adoration of the Magi (detail)
- 123 The Adoration of the Magi (detail)
- 125 The Temptation of Saint Anthony
- 127 The Temptation of Saint Anthony (detail)

hieronymus bosch

BOSCH'S WAY-THE LONELY PATH

Considering how much the painting of Bosch has been probed and pried into, and from every conceivable angle, the sum total learned is not very much. The body of his works has been sifted through, and anything deemed not up to standard winnowed out, but the author of those unique pictures remains scarcely less of an enigma. We do not even know when the Jeroen van Aken who took the name of Hieronymus Bosch was born. The recently proposed date of 1453 has been accepted without definitive proof only as the most serviceable of possibilities. We are sure, at any rate, that he died in 1516 in 's Hertogenbosch, the small town in North Brabant where he seems to have spent most of his life. From 1480 on he was registered there as a painter, in 1481 he married a wealthy woman of the town and thereafter lived with her on an estate in the vicinity which was part of her dowry, and a few years later his name began to appear in the rolls of the Brotherhood of Our Lady. There is no lack of such documented facts concerning his social and financial affairs, but not a word about any travels roundabout or abroad, neither in his youth nor later.

We know that he belonged to a family recorded as living in 's Hertogenbosch for something like two centuries under the name of Van Aken—which tells us that they came from Aachen in Germany—and whose chief members for several generations had been registered as painters by profession. So at least from the standpoint of the craft of painting, the art of Hieronymus was part of a family tradition, though nothing in his ancestors' work gives a clue to the origins of their more famous descendant's unique imagination. When he renounced his family name and took to signing himself in carefully painted large letters JHERONIMUS BOSCH on most of his pictures, it must have been with the aim of calling attention to his native place (the boschwoods—of the hertog, the duke), whose chief monument was a Gothic cathedral built after the model of those in France. Otherwise 's Hertogenbosch had no claim to fame, and, as concerns painting, it lay at a considerable distance from the centers of art, Bruges, Louvain, and Tournai. On the other hand, there are no grounds for surmising that its very remoteness from the main centers explains the rise of such a novel art so unlike anything anywhere at the time, because there is nothing in the art of Bosch to suggest provincial awkwardness or naïveté. The new vision he introduced was serious, vast in scope and sure of itself, and never without its tinge of mocking and irony. However fantastic and unheard-of the things he imagined, he was never anything but heart and soul a

man of his time. His ghastly fancies were products of his age, visible evidence of the fear of witchcraft and devilry that obsessed the decades immediately preceding the Reformation. What Bosch invented was not very different from what the folk in general took to be real. Nevertheless his was no mere fairy-tale world, though much in it took on the guise of fable and bugbear. The picture he held before men's eyes could easily be accused of exaggeration and falsity to fact, but it was part and parcel of his single theme, the fortune and misfortune of human existence, a theme cloaked in cryptic language piling riddle upon riddle but whose basic meaning, once decoded, proves clear as glass and anything but ambiguous. For all that he spoke in riddles and fables, Bosch was, at heart and always, a realist.

But what, we may ask, was the reason for these weird puzzles set down with such utter realism? It was certainly not that Bosch was heralding an apocalyptic end of the world, however much it might look like that, nor did he portray a desolate wilderness of stinking swamp and barren scrubland as the inevitable final destination of the traditions of his age—which, in any case, in his time were still honored and obeyed. He was neither heretic nor unquestioning adherent of the age-old form of worship. All the lay brotherhoods of the Netherlands and Lower Rhine challenged old values and preluded the Reformation, but their goal was never the destruction of the established church, but only its salvation. So, this apart, the first and crucial question confronting anyone writing about Bosch is to decide how it was that he differed from the few painters with whom he had anything in common: Geertgen tot Sint Jans, the Master of the Virgo inter Virgines, and Gerard David. For their iconography these masters were all content to make do with the usual themes from the New Testament. Only in the often troubling secondary actions largely confined to the backgrounds are there figures differing from the statuesque or elegant personages of the Van Eycks, Rogier van der Weyden, and Memling which had become characteristic of Flemish painting. Bosch did more. He transformed the entire subject matter. With him, sins began to be depicted in a manner no longer entirely dependent on the descriptions in the Bible and the apocalyptic literature. The Apocalypse and the Last Judgment in particular took on a quite different appearance than at any time in the Middle Ages. The meting out of rewards and punishments had, before Bosch, been an edifying image to be contemplated with thoughtful resignation. Now it became a moralizing representation open to personal interpretation by the individual viewer. Nor did it provide simply an illustration of the punishment awaiting those who transgress God's commands and the principles of righteous living. Rather, the evil that men do in their daily

The Seven Deadly Sins

Oil on panel, $47^{1/4} \times 59$ in. The Prado, Madrid (see also figures 2, 3; pages 43, 45)

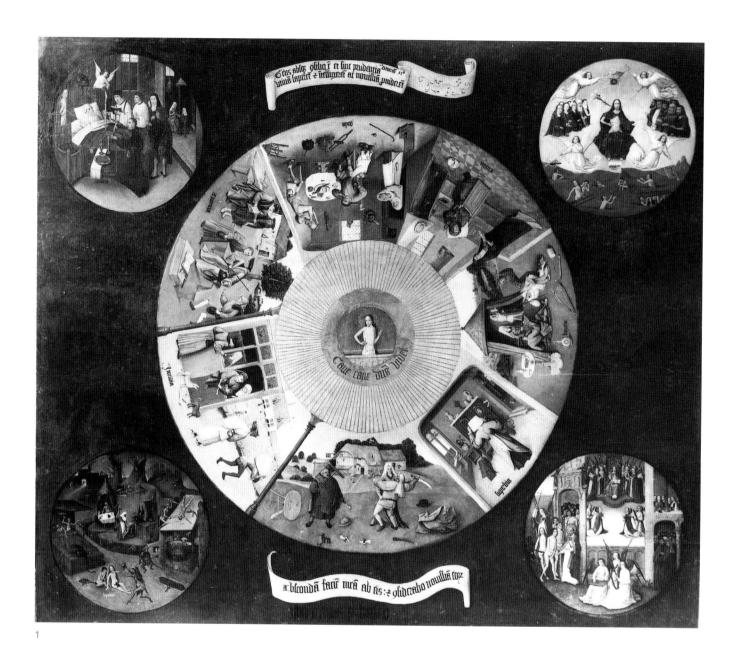

lives was shown more nakedly than ever before in relation to the sufferings of Christ. But then this realism in turn was shifted to a less direct plane, and in its place Bosch began to populate his world of images with demonic creatures whose like was never seen before in life or paint. However such beings may have been depicted before then, Bosch went far beyond the tradition to a total metamorphosis of the representations of evil spirits he would have seen in contemporary woodcuts. No longer merely some sort of grotesquely caricatured animal, the devil soon came to be exhibited as a monstrous hybrid of insects, reptiles, chunks of human anatomy, and bits and pieces of machinery. In itself this fantastic imagery was enough to drive the traditional Christian content from center stage. The devilish

brood contaminated everything human and real in Bosch's pictures. Certainly his entire attitude remained Christian, but there came into it a pungent vein of skepticism. The theme of transgression and punishment, still linked only tenuously with the afterlife, was brought down to earth. Which is why, in Bosch's paintings, everything having to do with earth itself seems as if it has undergone some dreadful cataclysm. Storms slash across them, leaving destruction in their wake, and though all roundabout the land lies peaceful and untouched, the horror is scarcely less.

Bosch's realism led him to invent a whole new world of meaningful signs so much the more effective because of their inherent tendency to deform reality. He no longer spoke the fixed and static language of symbols on which

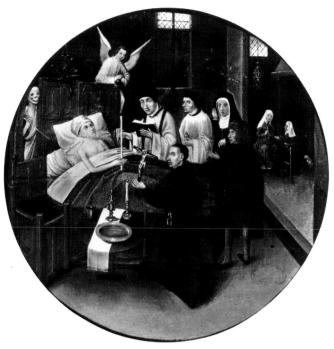

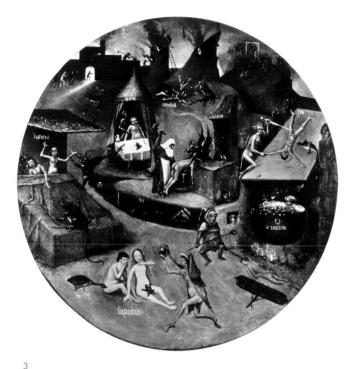

2

the Middle Ages had relied. Indeed, wherever he actually invented something, it was always as unlike as possible what the eye is used to seeing. But let there be no mistake, these are not symbols in the accepted sense but explosions of meaning, phantasmagorias designed to lay bare the essence of reality. The result is a vocabulary of images that seldom draws its symbols out of any existing stock, but instead, experiments with possibilities, with symbols that have as yet no determinable significance but are rich in suggestion.

What Bosch devised, then, were new prototypes of an unfamiliar sort. A lone wolf and curious personality, it was inevitable that he should be an innovator. As so often with innovators, he also strikes us as old-fashioned, reaching back as he did to the International Gothic style of the Flemish-Burgundian miniaturists of the beginning of the fifteenth century and introducing it, almost like a quotation, into a satirical moralizing context for which it was never intended. Working quietly in his native town, without any disciples or followers we can name, he nevertheless became a shaping force of his time. Those who, like Tolnay, insist on the importance of the local tradition must be so much the more hard put to explain the extraordinary imaginative faculty that Bosch was able to develop out of it. He made use of the subjects standard in his day—the Mocking of Christ, Christ Carrying the Cross, the Last Judgment, and the others—only after having hacked away everything in them that smacked of the conventional. In his hands they became something quite different, and the course he pursued to arrive at this was the same as that which led him to his own uniquely personal subject matter.

How much he was a stranger in his own time and place is clear to read in his works. Yet not so much as to prevent his being the first to realize and clarify a way of seeing already initiated before him and native to Holland. And similarly, in terms of geography, it was he who made a new artistic center out of a previously fallow region. Yet whatever stamped him as an outsider, it was only the reverse of the coin of his singularity. A pivotal figure, an epoch-maker who, however, founded no style, having no pupils but only imitators who at the most may have had some personal contact with him, he neither wrote finis to the Middle Ages nor launched a new era. Yet there he stands at the frontier, pointing back to the old though in transfigured guise, ahead to something as yet unknown. From the first he possessed two gifts: clear-eyed insight into all blind folly, a coldly critical view of all excess and exaggeration. However much or little religious as may be his paintings that comment on these failings, he never ceased to show how all God's beneficent influence on the world is constantly thwarted by man himself. As early as his time the question may have been raised whether it was self-will or insubordination that drove rebellious mankind to such extremes. And though there was no sign as yet of a Reformation, in such pictures there was a first hint, a seed of doubt, perhaps even a warning to the artist's contemporaries, an unmistakable, though enigmatic, glimpse of things to come.

4, 5 The Mob and The Market Place Details from Ecce Homo (see page 51)

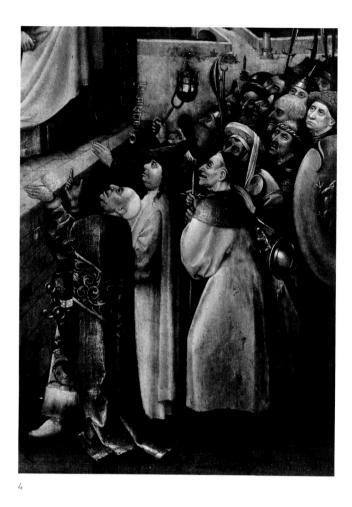

FOLLY, CHOICE, AND VISION

Not a single picture by Bosch is dated, not even one of those to which he set his name. This has had some odd consequences. More than a half-century ago, Baldass worked out Bosch's artistic development on the basis of a progressive increase in realism. This meant that such realistic depictions of folly and excess as one finds on the tabletop with The Seven Deadly Sins (figures 1–3; pages 43, 45) would have to be assigned to the artist's late period. Faced with the facts, even the proponent of this theory had to give it up, and no one now believes this to be a precocious example of the genre painting that became common only a hundred years later, and therefore of necessity a late work. Nonetheless it was a bold beginning to an art that defies analysis by the criterion of realism and can only be explained in terms of a unique personal idiom which, as Cinotti shows, was a compound of the progressive and the reactionary, of prophetic anticipations and reliance on the old-fashioned tried and true, an idiom with which Bosch began and ended. Without opting for one or the other, in his pictures he showed what, in the very different ages at whose watershed he lived,

remained valid from the past, and what new and changed values were for the first time imposing themselves.

The tabletop has a small medallion in each corner and, in the center, a sequence of scenes combined into a large circle. The arrangement is old-fashioned, with the kind of distribution of episodes into separate roundels that had been frequent in sculptured tracery since the late Romanesque era. What, however, is more than ornamental is the disk in the center with its scenes illustrating the Seven Deadly Sins. Those scenes are the real core and purpose of the picture, more than the roundels with the traditional subjects of the Four Last Things (Death, Judgment, Hell, and Heaven) for all that the latter, and especially the **Death** and **Hell** (figures 2, 3), are a promise of things to come in Bosch's painting. The seven sins make up the iris of an eye in whose pupil we recognize, as we come closer to the tabletop, the Risen Christ. The sin we notice first, and to which the gaze of Christ directs us, is **Anger** (page 45). Certainly Bosch hits out here mostly at headstrong obstinacy and pigheadedness, but already he gives us a glimpse of something less obvious, some obscure threat which, for him, is latent in every action and even in inaction. Although this is a didactic picture designed to teach a moral lesson, implicit in the icy stares of his personages are the first intimations of the menace that later, in the guise of temptation, doubt, and the ever-waiting trap, would constitute an essential trait of all of Bosch's work.

The worst threat, though, is always folly. Ready tool for the Arch-Deceiver that it is, more often it begins as mere self-deception. **The Operation for the Stone** (page 47), also called **The Cure of Folly**, is another didactic picture making its point through mockery. Here folly is in full sway. The credulous dupe is his own victim, but there is also a first sign of

what was to become a major theme for Bosch, the tormenting of the helpless. The moral of this cautionary tale is clear: the wages of folly are death. The peaceful lowlands where the scene takes place serve to emphasize the point that one man's misfortune is of no moment to the world at large.

The gullible blockheads dumbly or glumly watching **The Conjurer** (page 49) are let off more easily, but this too is a folly that can spread and turn nasty. Here we have only a confidence game, but the trickster who runs the show is one of those who know how to palm off lies as gospel truth, who go on from small prey to bigger game, the game that ends up in backbiting and ill-will and aggression, that lets all Hell loose.

With no sure chronology for his pictures, we have no choice but to scour every work of Bosch to see if perhaps, despite the rigorous but unfettered perspicacity that never left him, there are not some paintings that betray the more tentative hand of a beginner. When we find it, it always has to do with form as such, and its sign is a certain monotonous flatness which only gradually becomes enlivened. The three pictures mentioned so far all have this to some degree or another. As we begin to grasp just how that style developed into a virtuoso juggling with colors and finally into a sublime serenity in workmanship where all effort is concealed, we find that almost without knowing it we have arrived at a series of criteria that make sense, far more sense than the attempt to attribute everything to a hypothetical growth in realism.

That Bosch painted profane subjects was no innovation, since they could be found even before his time throughout the Franco-Flemish regions. But in so far as he infused them with both liveliness and a feeling of significance, giving each its own physiognomy, sometimes sharply etched, sometimes appropriately stolid, he created an art uniquely his own, one he was able to carry over into the Christian subjects which, for him as for his contemporaries, were his chief concern. There is a new trenchancy in his approach to old themes like the **Ecce Homo** (page 51; figures 4, 5). Stripped and exposed, the condemned Christ is led out high above the throng like the vanguished ruler on some old Roman triumphal arch. Below him, but by far outnumbering his feeble force, a mob presses forward bursting with the hostility of those who, wretched in themselves, mistake their whippedup and inflamed passions for righteous sentiments. One innovation here, to be carried much further in Bosch's work, is the portrayal of the crowd as a mob incapable of judgment and inclined to every bestiality as long as there is the safety of numbers. Even when its members are masked as monsters it signifies the living proof of man's guilt, and therefore something realistic. The other innovation is seen here in the marketplace in the background (figure 5), a peaceful

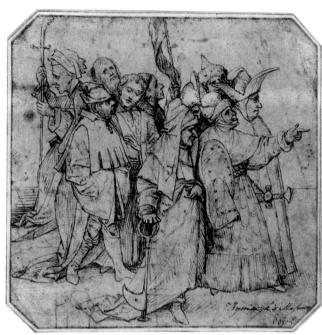

6

hinterland which is no longer a mere accessory to the scene, as was still the case with Memling, but instead has the significance of an untroubled place where men no longer recall the dire events pictured in the foreground, and where the supreme injustice of the exposure of Jesus to the taunts of the people ceases to have meaning for men who are unaware or indifferent. Related in approach to this painting is a drawing of a compact mob of self-righteous accusers marching on their prey (figure 6) where, for all the puffed-up bulk of the costumes, there is no clearly defined plastic volume.

Even where one would least expect it Bosch infuses the conventional themes of the life of Christ with an unrest entirely without precedent. Thus, in an Adoration of the Magi (page 53) some of the gestures strike one as overwrought, others as puzzlingly standoffish, and all of them as very remote indeed from the richly ceremonial character of this scene as treated by Bosch's predecessors. The Wedding Feast at Cana (figures 7, 8) tends by nature to be treated as a pleasant genre painting. In Bosch's hands it is converted into a solemn and almost frozen tableau vivant. Ostensibly the theme is Christ's miraculous transformation of water into wine, but what is really happening is anything but certain. Look closer: in the background there is a sorcerer's altar, and among the dishes being brought in is a swan spewing smoke (figure 8). A crone plays the bagpipes, an instrument often painted by Bosch later. That the assembly seems bowed down or even depressed, as scarcely befits the circumstances, must surely be due to these mysterious goings-on of a sort that was to become a frequent feature

The Wedding Feast at Cana

Oil on panel, $36^{5/8}$ x $28^{3/8}$ in. Museum Boymans-van Beuningen, Rotterdam

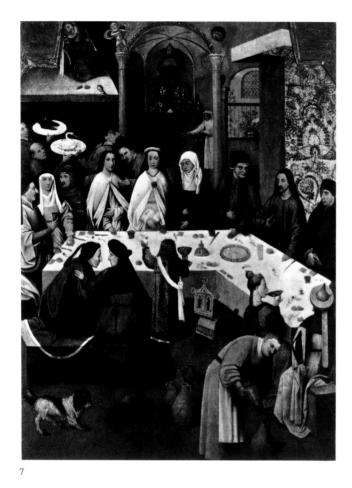

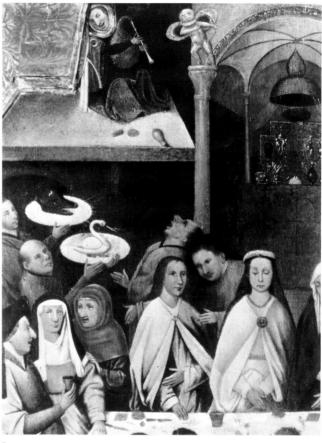

of Bosch's subsequent works, and which rightly enough compels us to the frustrating and eventually hopeless task of trying to explain just what the artist had in mind. Whatever it was, we can be sure that it was part and parcel of his time, whether superstition or some other foolishness, and even if it only showed itself in the guise of the wildest apparitions. The Wedding Feast at Cana plunges us directly into Bosch's personal hermetic language, a language already present earlier, though not overtly, in a perfectly conventional Crucifixion (figure 10) in which, here and there, one senses something not quite right, something uncanny reaching out beyond the conventions. In contrast with the characteristic rendering of Saint John, Christ is painted not as a real man enduring crucifixion but rather as just such a devotional image carved in wood as the artist would have seen often enough, perhaps even in his local cathedral. It strikes one as a crucifix painted from memory, a notion borne out by the fact that Christ is smaller and more stylized than the other figures. There is uncanniness of another sort in the background landscape (figure 11) which one suspects is more a literal rendering of the local reality than most such landscapes, and yet has right in its

middle a tower of such preposterous height and breadth that it can only be an invention of the artist's. There is more of this kind of thing in an **Ascent to Calvary** (figure 9), where the figures move through an alien world, if not outright a world of the future. Furthermore, here Bosch took over from the accessory figures in the long-traditional scenes of martyrdom those heads possessed by madness and fanatical obstinacy which thenceforth were never to be absent from his work.

How faithful Bosch was to tradition, for all the changes he introduced, is shown also by two drawings. One, with Saint John and the grief-stricken Virgin (figure 13), imitates and emphasizes even more the painstaking naturalism of gesture in vogue around 1400. On the other hand, the studied nervousness of the other, **Burial of Christ** (figure 12), goes beyond the old-fashioned manner to take on a smoothly undisturbed polish. A third drawing, **Christ Carrying the Cross** (figure 14) with lean and long-limbed figures, exchanges the turbulence traditional to that subject for an elegant and worldly nonchalance. Everyday persons and gestures intrude openly into such religious scenes as the Vienna painting on the same subject (page 55) where they

9 Ascent to Calvary Oil on panel, 59 x 37 in. Royal Palace, Madrid

10 The Crucifixion

Oil on panel, 28^{7/8} x 24^{1/8} in. Musées Royaux des Beaux-Arts, Brussels

11 Detail of figure 10

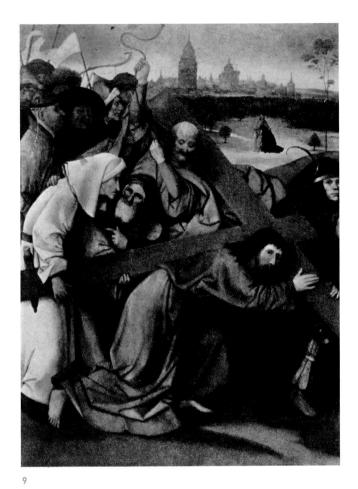

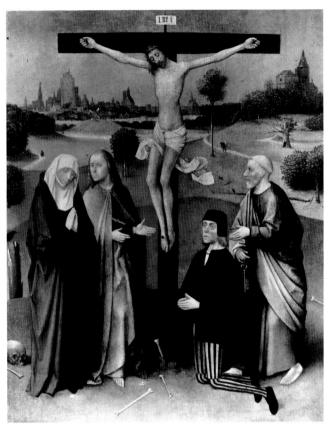

10

too become caught up in the violence and terror of the grim event. The fury of the executioners is no more than their trade demands (figure 15), while their victim trembles only before the ugly deed and not what lies beyond. The presence of so many profane elements vitiates the quality of religious consolation which, despite everything, is the message of the Passion story. Cruelty becomes an end in itself no longer to be conjured away. By smashing the conventional representation of the road to Golgotha, Bosch intensified the emotion inherent in the subject, and a consolatory image became a picture of the menace men already knew too well in their daily lives. The madness of those who take upon themselves the right to punish others opens the way to their own unbridled aggression and, for their victims, to the shock of a frightful death. In no picture more than this did Bosch demonstrate more stringently how forcefully tradition can be invaded by a new idea or, better, by the old concept of Redemption retested and revitalized. Even the playing child on the back of this panel (figure 16) is neither an infant Jesus nor a symbol, but only a friendly and playful representation of precisely that innocent awareness that the picture on the front has forever driven from men's minds. Here

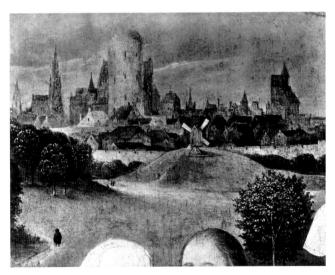

11

Bosch has found his way. But before he set about translating doom into images of stark fantasy, he did a number of drawings of human beings deformed, plagued, and crippled by misery and violence (figure 17). Indeed, in Bosch's world of images the self-mutilation of those who actively seek their fortune appears no less often than the illustration of the misfortunes that lie in wait for the unsuspecting.

12 **The Burial of Christ**Brush drawing, 9^{7/8} x 13^{3/4} in.
The British Museum, London

13 **The Virgin and Saint John at the Cross**Brush drawing, 11^{7/8} x 6^{3/4} in.
Kupferstichkabinett, Dresden

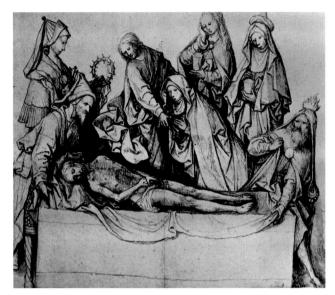

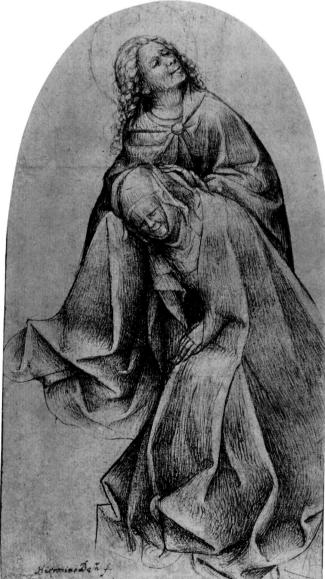

14 **Christ Carrying the Cross**Drawing, 91/4 x 73/4 in.
Museum Boymans-van Beuningen, Rotterdam

15 The Mob

Detail from **The Ascent to Calvary** (see page 55)

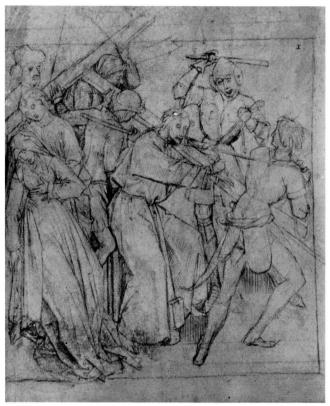

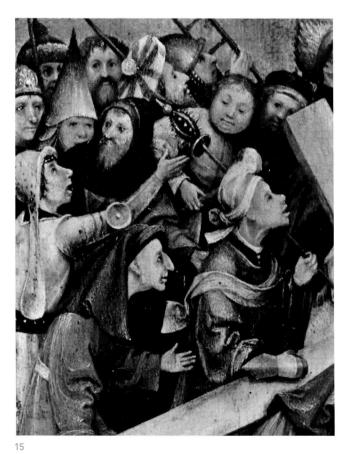

17 Beggars and Cripples

Pen and bister drawing, 10^{3/8} x 7^{3/4} in. Print Room, Bibliothèque Royale, Brussels

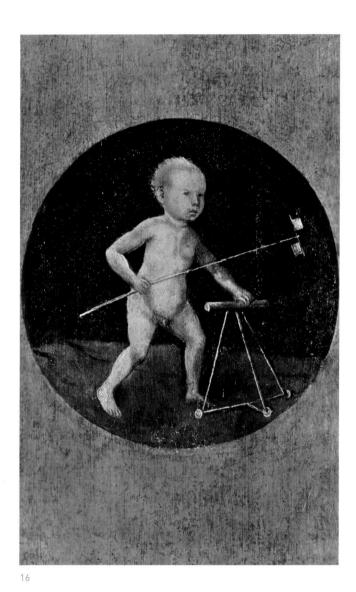

17

Even at a glance it would appear that The Hay Wain (figures 18-22; frontispiece and pages 57-63) has to do with the pursuit of happiness. Surely there is no real reason why human striving, even if it is only for what all men need money (or, in Bosch's metaphor, hay)—should not always be crowned with luck and happiness. But we live in a topsyturvy world. What Bosch paints here is greed, not felicity. Hot in the quest of happiness, men crowd each other out, wage a free-for-all war where every man fights alone. Right from the start, with the exteriors of the closed shutters, the message is pessimistic. There a sad-faced man staggers through a landscape littered with useless debris. Indeed, he flies from it because in the background a man is being attacked by robbers, while not far off others make merry with never a thought for their fellow man. The countryside seems strangely empty and barren, strewn everywhere with

things that speak of fear, and the man himself seems to

flee in panic. When the wings of the triptych are opened and we see the central panel, we sense that here too the same harsh wasteland will take over once the passing hay wain has moved on out of the picture. In terms of composition, what was once a perfectly respectable pictorial form with an easily recognized center has been set into movement here and turned upside down: what was secure and trustworthy has been replaced by delusion. Not that this is a denial of the way things truly are. Before ever picking up brushes, the genius who conceived this picture had looked about him and seen everywhere a destruction and decay without rhyme or reason. And so, for truth's sake, he painted lies and folly and frenzy and malevolence and brute violence. All of this, plus the transitoriness of the trash that drives men to such cupidity, he then locked into a form, the triptych, which once served the purposes of devotion but which, in his hands, became a vehicle for teaching and preaching.

18 The Hay Wain

Triptych. Oil on panel, wings $53^{1/8}$ x $17^{3/4}$ in.; central panel $53^{1/8}$ x $39^{3/8}$ in. The Prado, Madrid (see also figures 19–22, pages 57–63, and frontispiece)

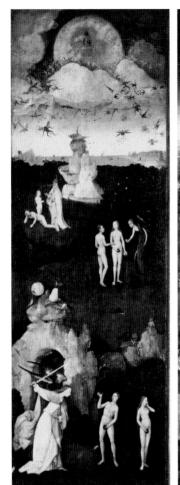

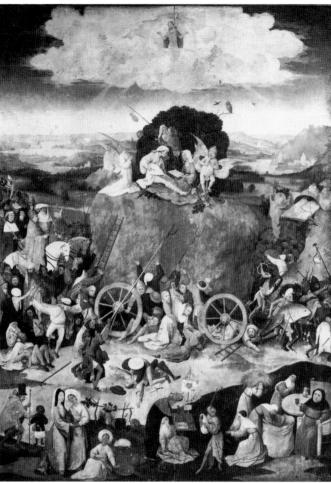

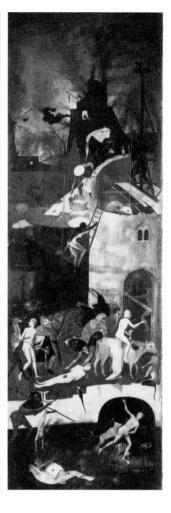

18

19

Having set to nought the traditional form of altarpiece, he did not, however, disrupt its essential character. Even before we come to Bosch's entirely new version of the Last Judgment, here already we find him bringing man to judgment, though it be only in earthly terms and, so to speak, provisionally. The wings of the triptych show the reason for it all and the consequences. The original sin in the Garden still leaves the way open to hope (page 57), and Hell is not a bottomless pit but a tower still under construction and more like some building set afire on earth itself (figure 18; frontispiece and page 63). When our eye is drawn back to the jumble of human illusions in the central panel we find that the greatest self-deceivers are the lovers, foolish souls who fancy themselves safe at the very top of the haystack. True, Christ directly overhead looks down on all this anarchy like an uninvolved observer (figure 20). And, in any case, a moment's sober reflection would suffice to dispel the whole mad scene. So, to that extent at least, the painting is a sermon pronounced by a skeptic, a finger pointed against Christians rather than against Christianity.

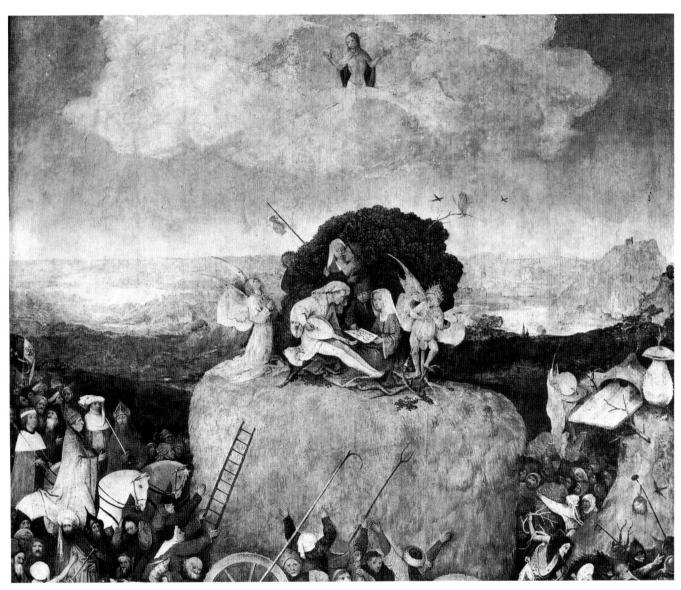

20

Once he had ventured into this topsy-turvydom, Bosch was to remain there for many years to come. Although dated later by Tolnay, a drawing of **Madwomen** (figure 13) is full of the never-quiet hurly-burly of **The Hay Wain**. And another sketch (figure 24), where a gnome strolls blithely along with a burning ship around his neck, has less to do with **The Ship of Fools** (page 67) than with Bosch's newfound delight in bizarre alterations of the usual dimensions of things. Along with this he was becoming ever more daring in inventing monstrous creatures. Pointed, gaunt, harassed faces gave the first hint of this, as in **Death and the Miser** (figure 25, page 65), where the dying man and the one rummaging in his strongbox are one and the same person who, in either guise, oscillates between sanctimoniousness and avarice without ever noticing the bloated

22 **The Itinerent Peddler**. Closed shutters of **The Hay Wain** triptych Oil on panel, $53^{1/8}$ x $35^{3/8}$ in. The Prado, Madrid

monsters lurking in every corner. As in the picture on the exterior of The Hay Wain, here too all sorts of useless objects are strewn about, things no one would try to take with him when fleeing, let alone into the jaws of death. Here again Bosch was the pioneer, depicting as transitory stuff the same sort of objects that, a century later, would figure in the Vanitas still lifes. The substratum for everything is already the monstrous, an element which would take an ever larger place in Bosch's work right up to the end but which should not be dismissed as farcical and fantastic since, if that were all, it would be no more than the incidental stage trappings found in the work of his imitators. Instead, with Bosch, it burrows its way into everything, becomes even a kind of invisible presence, and in the late works often takes over entire pictures. In his middle years this element of the monstrous or terrifying assumed two formal characters which must be viewed in association with each other. The one produces a skin-thin integument or sheath, soft, bloated, almost bursting as in the Philadelphia Ecce Homo (page 69; figures 26, 27), where it is more evident among the evil mob than in the perplexed Pilate and the bound Christ. This does not constitute an alienation from

23 **Madwomen**Bister and pen drawing, 8 x 10^{3/8} in.
The Louvre. Paris

24 **Gnome with Ship around His Neck**Bister and pen drawing, 67/8 x 6 in.
Akademie der Bildenden Künste, Vienna

23

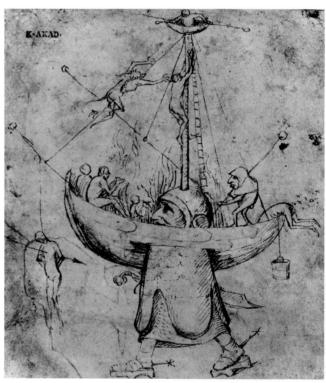

24

reality. Instead, as here, deformation is the sign of reality itself. The other formal character makes a basic principle of containment within some kind of receptacle or hollow—vessel, shell, husk, pod, cave, or the like—as we see in the altarpiece of **Saint Julia of Corsica on the Cross** (figure 28), where a cleft in a rock (or tree?) serves as outlet for a tumult of terror and helplessness that irrupts into the picture. Both constitute a kind of envelope or, in more general terms, a masking or blocking of the open form. Often this is

25 Death and the Miser

Oil on panel, $36^{5/8}$ x $12^{1/8}$ in. National Gallery of Art, Washington, D.C. Samuel H. Kress Collection (see also page 65)

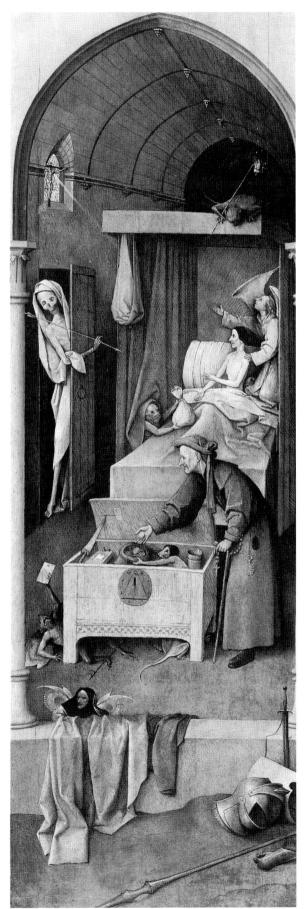

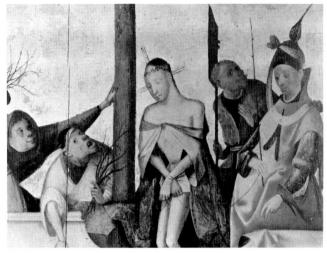

26

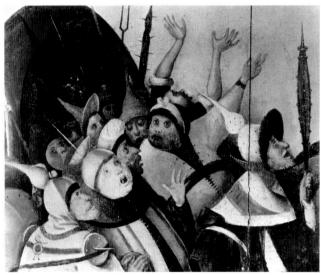

27

a thin mask slipped on like a second skin, elsewhere it may be like a dried shell or pod that has burst open and makes us think that everything around it will likewise collapse and crumble to dust, a suggestion never absent from all of Bosch's subsequent work.

There is scarcely a picture by Bosch in which his bright, flowing forms do not at one and the same time conceal and proclaim whatever it is that threatens to break through. For just that reason it is much too narrow to think of these husklike images as no more than cast-off incrustations such as are found in nature. Rather they involve decisive, even crudely elementary processes that either openly take their beginnings from disguise and concealment or are brought thereby to some radical conclusion. The most powerful examples of this, and the most inexorably imaginative, are

28 Saint Julia of Corsica on the Cross

Triptych. Oil on panel, wings 41 x 11 in., central panel 41 x $24^{3/4}$ in. Palazzo Ducale, Venice

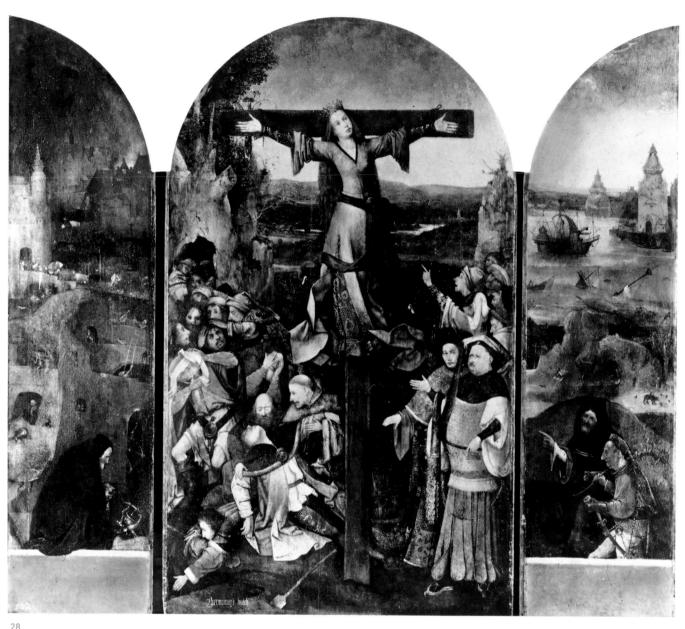

20

the two panels of **The World Before the Flood** and **The World After the Flood** (figures 29, 30). In the first of them, whose figures are explained as the ghastly offspring of the fallen angels and their human couplings, Fraenger found the decisive factor to be the form itself, with its steeply raked topography, its hollows and caves, and its pit in the foreground. In the other panel the predicted cataclysm has taken place. In mud-slimy troughs and gullies, in caves that proved to be death-traps and not refuges, in the cracking sheet of ice, the men and animals now able to leave the Ark look upon the death that they alone survived. And so, despite these gloomy wastes, this is an image of hope. The monotonous barrenness holds promise of one certainty: that the wreckage left by the merciless flood will be over-

come by the perseverance of the survivors. Wherever we look, the mountains of slime as well as the steep declivities are covered with the sort of sheathing we have been describing, one that simultaneously disguises and reveals. Further, the four roundels on the backs of these two panels (figures 31, 32) may be sketchy, but they already bear the stamp of the incipient Renaissance, and they contain the same sort of half-revealed riddles. The cataclysm evoked in the two panels swept down swiftly and devastatingly, though the pictures show only the traces it left and the slow revival of what little has survived. The air seems not to move, everything continues oppressive. In drawings from Bosch's middle age such as **Head with Claws** and **Stinging Beasts** (figures 34, 35) the same oppressive slowness of time that barely crawls is

29, 30 The World Before the Flood and The World After the Flood

Wings of an incomplete triptych Oil on panel, respectively $27^{1/8}$ x $14^{1/8}$ in. and $27^{3/8}$ x 15 in. Museum Boymans–van Beuningen, Rotterdam

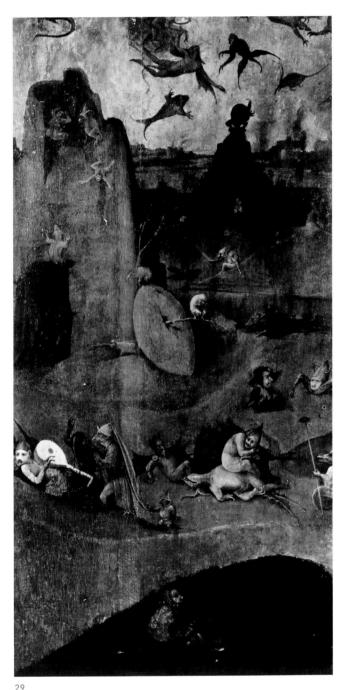

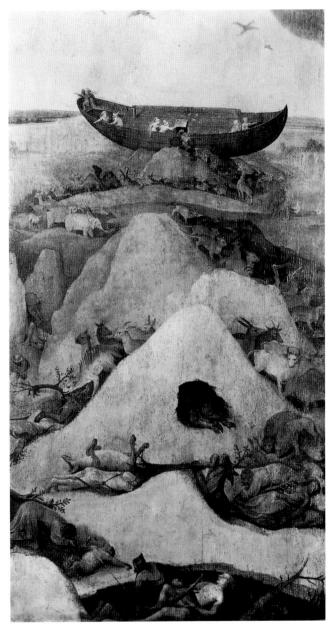

30

_ /

suggested. This too distinguishes the monochrome gray of these two pictures (as likewise **Death and the Miser**) from all other grisailles whether by Van Eyck, Grünewald, or one of the Mannerists. With them gray is always harsh, cold, petrified. With Bosch, even in representing dust and desert, some trace of color still comes through. This is why upon occasion he had recourse to grisaille to represent life reduced to its minimum qualities, to ultimate vestiges. Tones of gray and yellow containing the sparks of life: this is the grisaille that Bosch, and Bosch alone, invented.

There is a single exception, the exteriors of the wings of the Lisbon **Temptations of Saint Anthony**. In them grisaille gives a vivid, gleaming rendering from which color as such is absent, though pure light, the essence of all color, remains. With light alone Bosch produces radiant and incisive brushwork which, here more than in any other of his paintings, gives impulse to the dynamic action, an action that begins in violence with derision heaped on Christ from the moment of his arrest. True, the mockery of the mob that follows him to Golgotha strikes one as almost routine (figure 33). But here,

31, 32 Expulsion of Demons and Peasant and Devil, Soul Tormented by Demons and Homecoming of the Soul Reverse sides of The Flood panels

33 The Ascent to Calvary. Detail of the exterior of the right wing of The Temptations of Saint Anthony [see figure 36]

3

34, 35 Head with Claws and Stinging Beasts

Pen drawings with black ink on pink ground, $3^{3/8}$ x $7^{1/4}$ in. each Kupferstichkabinett, Berlin

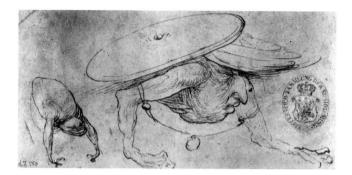

See bes

35

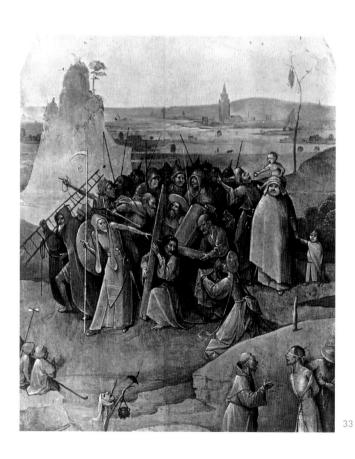

however, there is something new: the furious, impetuous throng of Bosch's earlier depictions becomes a dense rabble which—as is most unusual—has turned and moves directly on the viewer, less with hatred than with gross crudeness and hardheartedness. One scarcely realizes that this is the same episode of the Passion that for so long had been poured into a standard mold for devotional pictures. Not that the theme is lost or hidden, but Bosch stresses the act of violence itself, surrounds it with the brutalities of daily life, lets children look on in dumb puzzlement. This, and not anything else, sets the basic tone for his fantasy. Only secondarily does he resort to images of horror, and even then uses them more as signs that stand for human violence than as likenesses of the devil's brood from Gehenna. Torture takes its place as a theme, torture in the here-and-now and no longer thought of as plain and simple and well-deserved punishment for wickedness. There are hints of it in the foreground here: the ordeal by fear of the condemned man and, as tokens of the end that lies ahead, the almost fleshless body of a starving man and a horrible chopped-off head impaled on a stake. The setting nevertheless tilts steeply down before us, for all that it represents a flat plateau reached by gently rising steps. Here again, as in the Vienna Ascent to Calvary (page 55), the final phase of the action is brought into the immediate foreground.

On the other hand, the three interior panels with ${\bf The}$

36 The Temptations of Saint Anthony

Triptych. Oil on panel, wings $51^{5/8} \times 20^{7/8}$ in. each, central panel $51^{5/8} \times 46^{7/8}$ in. Museu Nacional de Arte Antiga, Lisbon (see also pages 71-83)

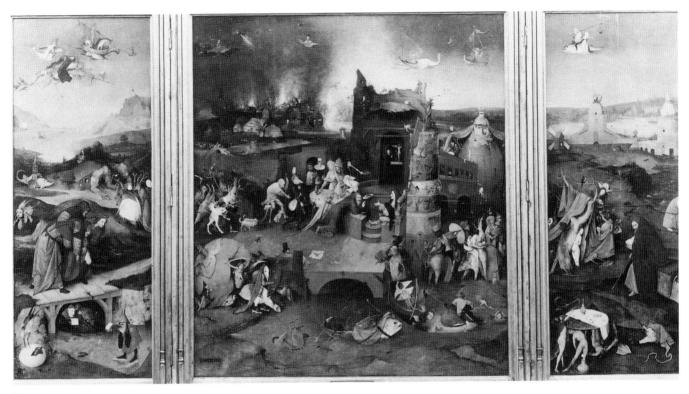

36

Temptations of Saint Anthony (figure 36; pages 71–83) have landscapes filled with all sorts of covered, hollowed-out, and veiled-over forms, with equally extraordinary composite creatures, and with a strange collection of buildings and constructions stretching to all sides, all of which we have seen in embryo in previous works. Earth, water, fire, and phantasm-infected air become an all-permeating, pulsing, interpenetrating unity as in no picture before this. The terrain, close and distant, is so intricate, so vast, so veiled and hazy, that when curious, strangely seductive, and willfully enigmatic creatures pop up in it they seem perfectly understandable denizens of such a setting. The fact that everything here is interrelated, that anything can suddenly transform itself into everything, is so immediately self-evident that, to Combe's mind, behind it all must lie the speculations and experiments of the alchemists. Thus the world of the Late Antique Egyptian secret hermetical lore of alchemistic affinities and metamorphoses becomes, in art, the fountainhead of the temptations that will endlessly plague the saintly Anthony and be repulsed by him. And only Bosch's pictorial language truly sensed the track of these dark arts and seductions. One finds oneself wondering if the vessel and husk forms so frequent here, whether concealing or broken open, may not have been the universal basic form as conceived by an adept of those ancient doctrines. The fact is, in Bosch's time those teachings had again become widespread, so much so

as to become virtually the hallmark of anyone exceptionally gifted. So we shall continue to take what we can call the containment form as symptom, as the natural vehicle for Bosch's essential concept of form at the same time as it is closely related in details to extra-artistic symbols. The earth itself is a "vessel." A giant burrows through it (page 71), but the vessel shatters and there he is, back in the world where he must do penance. Others simply pull over themselves whatever can serve as protective covering, like the women who sheathe themselves in a hollow tree (page 81).

I think one should not flatly label the subject of this painting as the world under the sway of evil. This would imply that at most Bosch was illustrating sorcery and the fear of the demonic. On the contrary, he travestied them with utmost art, and in the more specific sense of mocking ceremonial that results from this he exposed all such unholy practices as contemptible. In so doing he clung to the idea that the much-beplaqued Anthony proved his strength through self-control. In any case, the theme of temptation itself has a double meaning not to be overlooked in this picture: temptation, by its nature, always leaves in suspense what is yet to come and who is to be the ultimate victor. Significantly, the composition is itself most ingenious precisely where it involves wrecked, decayed, half-defined forms swept away like detritus. Thus the real meaning of the picture is this: nothing works out rightly and as it should,

39 The Forest That Hears and the Field That Sees

Bister and pen drawing, 8 x 5 in. Kupferstichkabinett, Berlin

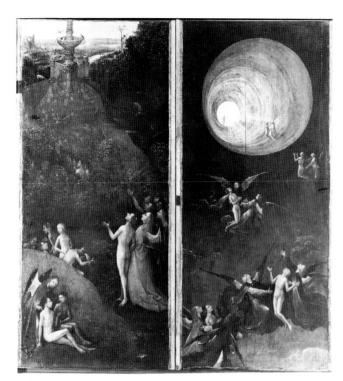

37 | 38

human misery and vain ambition raise their ugly heads, and out of both of them too easily comes evil, though evil itself is not yet present. There is more of misery here than of wicked, overweening sorcery, shown by the frightening apparitions (if that is what they are), victims of misery and yet entirely self-possessed, who surround the hermit, harass him, and even—in a manner difficult to define tempt him. As for their prey, does he really hold his own? He may stand steady and resist their coils, but he cannot be said to be master of the situation. The world he finds himself in is under a rule whose laws, and even more whose powers, are not easy to recognize. At the table a madly fanatical priest holds out a chalice in a manner commanding and rhetorical but, at the same time, questioning (page 75). From the tent formed by fruit burst open emerges a harpist with a horse's skull for a head (page 73). Everywhere wanton mischief is intermingled with helplessness. From the far distance an army seems to invade the picture. The pole of attraction for everything is Anthony himself, and he is at the same time perhaps the guarantee that the demonic power will come so far and no farther. But even that is not much. Even the sight of temptation saps a man's resolution. Here one man has made an end to his own misery. But what of that of others? It seems almost as if he has washed his hands of them. The whole panorama of such a temptation is set forth, from impotent surrender to bold resistance, but how it will end and who really rules the world remains a

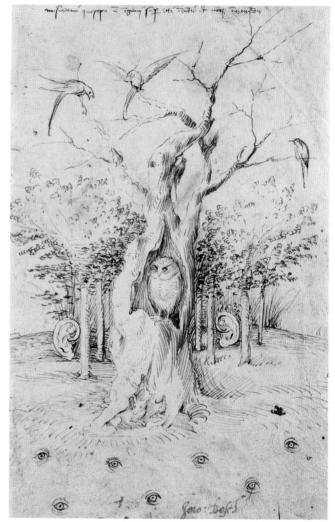

39

mystery. It may well be that the hermit saint is not alone in being tempted, that those who surround him in this world of images are themselves subject to temptations, seductions, extortions, and even, more or less clearly, to violent attack. And Anthony would behold those vulnerable creatures also and not only the demons, but it is precisely here that he has less certainty of the outcome of this struggle, because he can exert no influence and whatever power he possesses is over himself alone.

Generally speaking, Bosch always envisaged the outcome and its consequences only obscurely and enigmatically. This is so already in the four panels in Venice known collectively as **Visions of the Hereafter**, which would appear to have been originally superimposed to make up the wings of a polytych. Outwardly they cling to the old themes of Hell and Heaven. But the principal figure in **The Damned in Hell** could equally well be titled **The Forsaken One** as he sits there fruitlessly brooding over the past. And the blessed in

40 Page of sketches for **The Temptations of Saint Anthony** Bister and pen drawing, $8^{1/8} \times 10^{3/8}$ in. The Louvre, Paris

41 Scenes in Hell Bister and pen drawing, 61/8 x 67/8 in. Kupferstichkabinett, Berlin

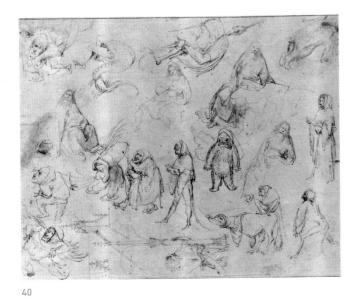

41

Paradise (figure 37) look forward less to the joyful afterlife than to an illumination (or enlightenment) that streams from the weird cylindrical apparatus crowning the heights. Or we find Bosch designing forms that are themselves questions and embody an expectation of something unknown, as in a sketch of Anthony together with crippled and disquised figures (figure 40) or another of a hollow tree in which sits an owl (figure 39), symmetrically flanked by a scrub forest with ears to either side and set in a field studded with eyes, much like the allegorical emblems that would not become current for decades yet. However, what seems so puzzling and full of hidden meaning I prefer to consider as the realism of a skeptic. The unreal, wild, and exaggerated is then merely the outer vestment assumed by what is real to the point of sheer horror. The forms to which Bosch has recourse are monstrous, what we call "unreal." But is what goes on in the Vienna Last Judgment (figures 42, 43; pages 85-91) truly so far from reality? The central panel (page 85) shows the Judge of Judges enthroned in the skies as usual, but the risen dead are still below. As if sentence had been passed some time before, torture apparatuses are already at work everywhere. And all this ordeal takes place on earth. Only on the right wing does one see the predestined place of final punishment, Hell with its grim gate. That the tormentors are not men but grotesque monsters is to be understood as the artist's expression of his shame at being a man among such men. The violence here is native to the world of men, effected by machines that men invent, and conceived in what we are forced to call human terms. Nor do the victims cry out, not even at the first pain. They are

apathetic, scarcely aware of suffering. The two varieties of punishment, divine and human, are depicted as interchangeable. Though one's confidence in God may be less shaken thereby than one's trust in man, over and beyond all ambivalence art alone has created here scenes of action and incidents never glimpsed before, in which earthly catastrophe and heavenly justice become mirror images alike distorted by man's self-will. A drawing for this (figure 41) shows both aspects, gluttonously omnivorous monsters and unresisting humans whose bodies are broken by hammers.

Contemporary with or following pictures with such a penetrating and harsh view of earthly traps and troubles, there are others where men who shun the world are visited with the after-pains of that existence and yet hold fast. On The Altarpiece of the Hermits in Venice (figure 44) only the left wing with Saint Anthony still has the usual monsters horribly put together from ill-matched bits and pieces. The man crawling into a beehive on a drawing (figure 45) is anything but monstrous, and he reappears in this triptych in a relief on the round structure before which Saint Jerome kneels (figure 44). Monsters are also absent from the Ghent Saint Jerome in Penitence (page 93) where rank weeds, tree roots, and the Burgundy-red, half-burst-open peeling of a fruit lying in the water are enough to tell us that this is wasteland. In Saint John the Baptist in the Wilderness (figure 47) the note of evil is struck even more simply, by a single plant in the greensward: a thistle bearing a pomegranate grows out of a narrow cleft, as much the signal of a moment of terror as the pile of flapped and lidded caves and stone slabs in the background. It is noteworthy

42, 43 Paradise and Hell
Wings of the Last Judgment triptych
Oil on panel, 65^{3/4} x 23^{5/8} in. each
Akademie der Bildenden Künste, Vienna
(see also pages 85–91)

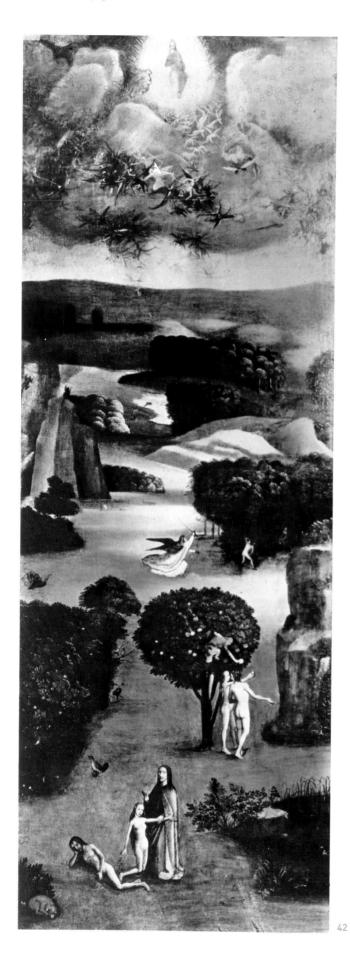

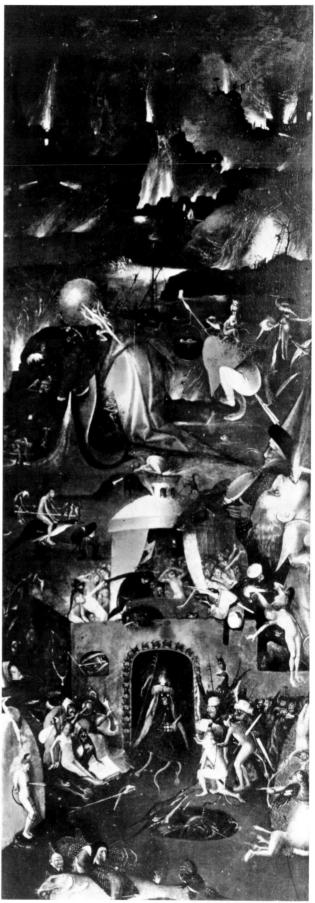

44 The Altarpiece of the Hermits

Triptych. Oil on panel, wings 34 x $11^{3/8}$ in. each, central panel $34 \times 23^{5/8}$ in. Palazzo Ducal, Venice

45 Beehive and Witches

Bister and pen drawing, $7^{1/2} \times 10^{5/8}$ in. Albertina, Vienna

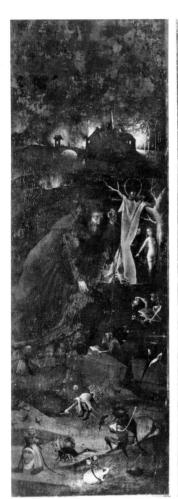

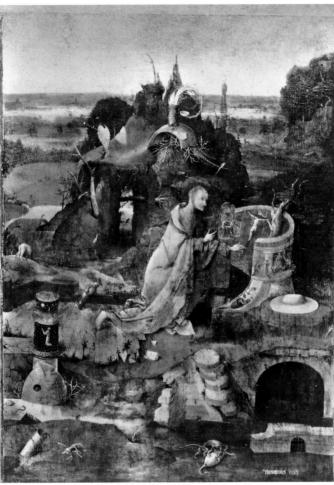

44

that, despite the myriad details in his pictures, Bosch never chooses to show us mere outward symptoms of whatever takes place on earth. Upon occasion he used the roundel format to depict what is more or less earthly in the form of a globe of the world. Or, as on the back of Saint John on Patmos, as a reflection in a huge eye where the iris is a circular band on which are painted, in brownish gray and in a continuous landscape, The Stations of the Cross (figure 46), first descending from the agony in the garden, then rising to Calvary, finally closing the circle with the entombment. The swift-moving, lean personages hurry through a landscape of troughs and hollows like a wind-scattered calligraphy of figures. It is an astonishing picture, portraying great actions in miniature, and its purely fanciful Eastern buildings meant to designate Jerusalem are further evidence that Bosch repeatedly rethought and reconstructed the world of his paintings and was not content merely to sketch in glimpses of his native landscape as background.

What is that world like? That Bosch aspired to represent the world entire is proven in his large-scale works, diversi-

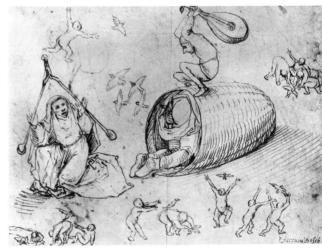

45

fied as their views of it are and prone as he was to focus on isolated aspects that aroused his enthusiasm. One of these entire world-pictures is **The Garden of Delights** (figure 48; pages 97–109). When its wings are closed they show the earth as a disk floating obliquely within a larger circle which

46 The Stations of the Cross. Reverse of Saint John on Patmos Oil on panel in grisaille, 243/4 x 167/8 in. State Museums, Berlin-Dahlem

47 Saint John the Baptist in the Wilderness Oil on panel, 191/8 x 15 3/4 in. Lázaro Galdiano Museum, Madrid

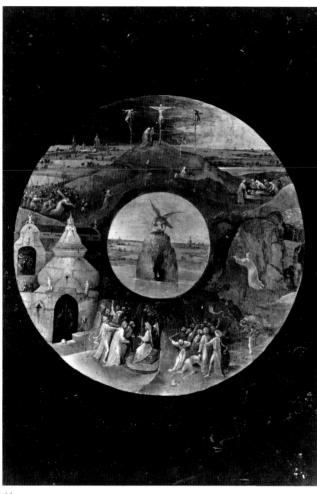

46

scholars once agreed must be a globe. Subsequently everyone agreed that the floating disk represents the dry land of the earth on the third day of Creation, as yet without living creatures but with strange monument-like outcroppings that might possibly be prickly, bulbous plants, though because they are painted in grisaille—one cannot be sure. Likewise because of the grisaille, Gombrich found rather absurd and not worth discussing the claim that one can make out a rainbow in the bright streaks below the storm clouds. But things with color have never been excluded from depiction in grisaille, quite apart from the fact that Bosch himself regularly introduced traces of color into the medium. And since there are certainly some edifices scattered across the landscape, this cannot be the world of Creation but, instead, that from after the Flood when the earth emerged from the waters and a rainbow was stretched over it as a sign of God's covenant with Noah. While the words inscribed at the top do refer to the Creation, they have to do here with the world's rebirth. This led Gombrich to an interpretation as attractive as it is legitimate, that

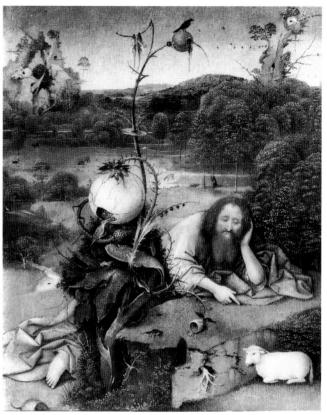

47

the central picture of the polyptych represents a fantastic formula for life before the Flood. This is less far-fetched than it may seem. In Bosch's personal iconography the age of Noah is depicted twice, in the Rotterdam panels already mentioned (figures 29, 30) and in a picture now lost that Carel van Mander identified in a 1595 Brussels court inventory as *Sicut erat in diebus Noë*. The latter, however, cannot be either the surviving wings in Rotterdam or **The Garden of Delights** because a picture of the times of Noah would, by tradition, be more likely to appear in conjunction with a central panel showing the Last Judgment, though even then it would exhibit not the gruesome consequence of the judgment already handed down, as in the Vienna picture (page 85), but a startled emergence of the dead just risen in expectation of their final doom.

That is not the case here. The garden of delights on the middle panel represents a world still far from last judgment, even from the threat of it (figure 48; pages 99–105). These naked humans seem to bask instead in the utmost joy and are all one in their nakedness. They are scarcely touched by passion, or at most in passing only and without immoderate appetite, and no premonition of a less happy fate disturbs them. Neither compunction nor envy intrudes on the universal amity. Those who live so inhabit a world where neither

48 The Garden of Delights

Triptych. Oil on panel, wings $86^{3/8}$ x $38^{1/8}$ in. each, central panel $86^{5/8}$ x $76^{3/4}$ in. The Prado, Madrid (see also pages 97-109)

49 Exterior of **The Garden of Delights** with the shutters closed Oil on panel, $86^{5/8}$ x $76^{3/4}$ in. The Prado, Madrid

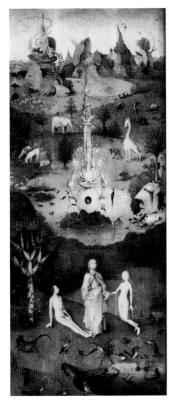

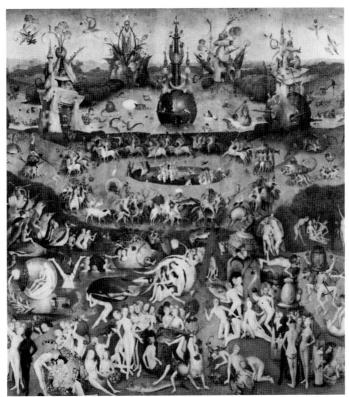

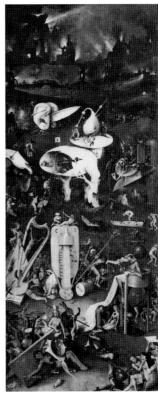

48

exaggerated respect nor dramatic gestures of aggression carry any weight. The composition itself bears witness to this. It circles elegantly and with delicate articulation from the remote distances forward to the lake or pond in the middle left and the meadow overgrown with bushes on the right. For all the many figures, there is no congestion but only the happiness of "togetherness." One is struck by the fact that most of them are heading somewhere, perhaps even hurrying, but seem really to prefer merely standing about together or, far less often, snuggling close or dancing. The central theme is quest, the seeking of one human being for another. Actual physical union—except for what goes on in the shell being carried across the scene (page 103)—is most often implied by the spherical blossoms, pavilions of coral, and glass turrets where they gather. Another kind of sweetness is expressed through the colors themselves, which are made light and clear, so that often a yellowish hue shimmers softly through the greens and the local colors stand out flickeringly. This is the gentle old-style use of light found in the Burgundian miniatures of Van Eyck's time and from which, in his late works in particular, Bosch drew what Tolnay has described as a sublime immateriality in the use of paint. Whence this cool and temperate, springlike atmosphere in an ecstatic scenery more the product of

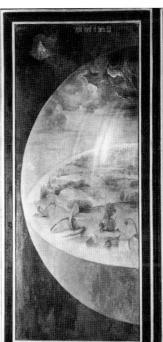

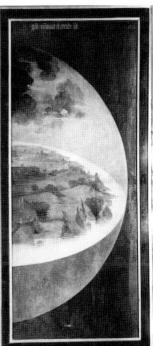

49

Bister and pen drawing, $5^{1/2} \times 7^{3/4}$ in. Museum Boymans-van Beuningen, Rotterdam 51 The Tree-Man

Bister and pen drawing, $10^{7/8} \times 8^{1/4}$ in. Albertina, Vienna

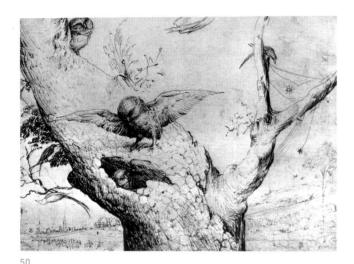

The only completely impenetrable riddle is the figure on the right wing, whose body has burst open to reveal an interior with people and whose legs (presumably) are hollow tree trunks resting in boats (page 107). Some see the face as malignant and depraved, others as melancholy. His abdomen is like an eggshell and inside it there is a dusky cave where people sit at table. Not particularly molested by the animal specters, a pair of humans clamber up a ladder to the cave, one of them very stocky and, despite the arrow in his posterior, apparently quite undisturbed. But all around are figures undergoing some sort of suffering.

It is this which provides the connecting link between the

actions in all parts of this triptych.

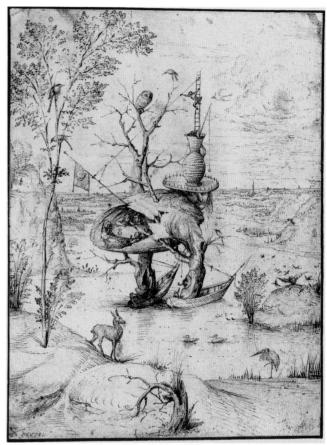

51

Would this be, then, the ultimate end with a brief respite of seductive delight beforehand? What is he meant to be, this innkeeper whose inn is his own body? The void of existence? Yet he seems so dominant, so prepossessing. The experts on symbols have no explanation. Bosch himself would seem to have valued this "conceit" which he repeated in a drawing (figure 51) perhaps as a cipher of himself, a riddle not to be unraveled like any ordinary allegory whose components all have their meaning by general agreement. The drawing cannot be a study for the triptych because the tree-man is planted most inappropriately in a tranquil landscape. His millstone-hat has become a thin plate on which stands a pitcher instead of the bagpipe to which a motley crew pays homage in the painting. The mark of that strangeness which stamps everything Bosch does is found again in the hollow, scraggly tree stump at the lower margin of the drawing. To what extent the artist's eye for real things fixes all forms of life with utter objectivity and penetration in The Garden of Delights, and how at the same time his feeling for broad-surfaced forms that conceal as much as they reveal remains undiminished, is seen

Obverse and reverse of a bister and pen drawing, $6^{1/2}$ x $4^{1/2}$ in. Kupferstichkabinett, Berlin

in a comparison with two drawings from this period. **Owl's Nest on a Branch** (figure 50), is viewed sharply and almost as a snapshot while remaining patently calligraphic in technique, whereas in the other (figure 52) a duck-headed monster gives the impression of parts exploding into view though, in fact, they are inserted into each other, much like the turtle on the back of the same drawing whose shell is covered by the skull of some mammal (figure 53).

With these we arrive at a kind of painting both mordantly striking and gently fascinating, and which Bosch nowhere deployed with more mastery than in the only surviving fragment of another Last Judgment (figure 56; pages 111, 113). There the devils are less than ever clearly defined creatures, more like some by-product of an explosion, though one that has jammed their components firmly together. In no other picture are there such many-limbed insectlike creatures, so radiant (though their radiance is evil), and where one cannot tell what is front and what back nor if their constituent parts come from machinery or amputated human limbs. They are the reflection of the just-awakened terror of the risen dead, the product of consciences suddenly aware that there is no

way out, no hiding place, and yet they seem so at home in their glittering shapes that one would think it quite natural to encounter them by daylight. Before then Bosch had painted the tangled maze of error and persecution. Here, instead, the two worlds meet, that of the ultimate destroyers and that of those who finally lose hope. Fragmentary as this picture is, we can still make out broad areas within the landscape against which the final tragedy is enacted. Here the last judgment is a war of signs and signals: emblems seem weapons, weapons emblems, and they are the true mark of every catastrophe, whenever it may occur and wherever it exceeds what men have previously known.

With this work can be associated two of the most significant drawings by Bosch to have come down to us (figures 54, 55). They should be read as the figural alphabet of a kind of pictural writing. At least three of the stocky, draped monsters from the painting—among them the one seen from the rear hung over with metallic insect forms as with a mantle—are found here in embryo, drawn with the spiky-leafed Late Gothic curve though the line itself is tied to no ornamental convention. To the contrary, something like

54, 55 Studies for Monsters Reverse and obverse of a bister and pen drawing, $12^{1/2}$ x $8^{1/4}$ in. Ashmolean Museum, Oxford

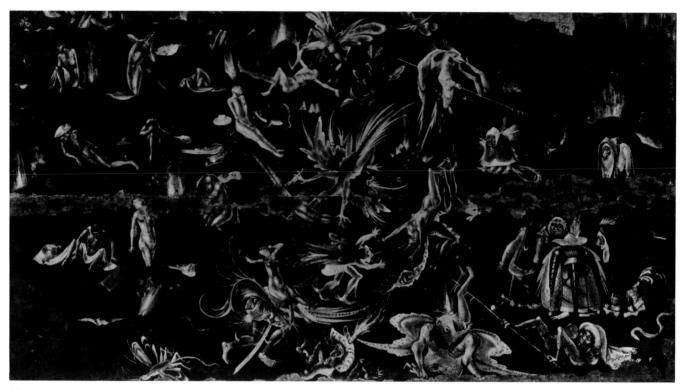

56

the female bust with headkerchief of one fish swallowing another and with broad-splayed sphinx claws is so distinctive an invention as to set the course for all subsequent Mannerist grotesques and on to Stefano della Bella and the early-eighteenth-century Jean Berain. Even at first sight, and even in their most inexplicable details, these phantasms appear solid flesh and real. Surprisingly enough, such preciseness led to a new restraint in the late works, where less and less use is made of bizarre inventions and the demonic in particular. This is effected in two ways. In one, everything diabolic retreats and only its essence continues to impregnate the taciturn faces in a few pictures with half-length figures in which, as in the Escorial Crowning with Thorns (figure 58), brutality becomes perfection and torture a solemn ceremony. The dry, light palette becomes increasingly cold. The leering face of the man holding a staff and with leg raised to serve as lever is literally gray as rock. This is carried further in a very late painting (figure 59; page 115) in the ugly swarm of heads around Veronica, the two thieves, and Christ bowed under the Cross. All of them sink into a night-dark background, but the stains of evil have corroded the light colors of the faces through and through. In these faces hostility is rendered so perfectly that any further exaggeration would be fatuous, as it is in Bosch's imitators. The smug fury we see in a drawing (figure 57) shows us the basic minimum from which Bosch always proceeded.

In the other approach, whatever is overtly unsettling, menacing, or dubious becomes incorporated into the landscape. Thus, in the late Adoration of the Magi (figures 60, 62; pages 117-23) the stillness itself unfailingly arouses our amazement. Broad slopes stretch gently across the scene in almost steplike gradations of brownish-yellow tones. The few odd characters lowering from the doorway can be explained as part of the kings' escort. Nowhere are there the usual devices for arousing apprehension. Yet far off one notes menacing bands of horsemen (figure 62) and even violent assaults (page 123). In **The Prodigal Son** (figure 61) this art of impenetrable stillness makes it seem as if the human face and the face of the landscape have become as one. The care-ridden countenance does not reveal if the man is returning home or will continue his rake's progress, and the landscape too cloaks him in an equally indeterminate gray, so that what remains visible no longer seems relevant. The landscape where Saint Anthony meditates in the last of the **Temptations** (pages 125, 127) is less fluid and is laid out. in carefully proportioned zones of green that pale away steplike in the slopes, fields, and greenery. There is a drawing on this subject from the same time (figure 63) where, in addition to the church seen in the Ghent Saint Jerome in Penitence (page 93), one finds the basic ground plan of the late landscapes: through rolling or terraced strata a road leads to the horizon depicted now in a new manner.

57 **Two Heads**Drawing
Whereabouts unknown

58 **The Crowning with Thorns**Oil on panel, 65 x 76^{3/4} in. El Escorial, Madrid

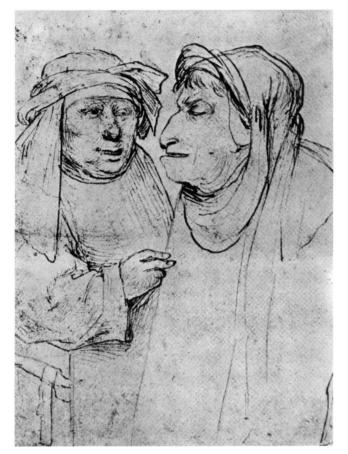

57

As late as The Garden of Delights Bosch continued to paint his familiar local landscape in the distance, separated from the main action of his pictures. But only a most superficial observer could mistake this for the same sort of merely accessory landscape customary in painting from the Van Eyck brothers up to and beyond Geertgen tot Sint Jans. Unlike those, Bosch's landscapes stretch from the background into the main area of his compositions, though still in a passive manner. With earlier artists the Biblical episode depicted held the center of the stage, while the landscape remained a distant background or at most extended a few stereotyped forms toward the central figures. Bosch, however, shifted his protagonists about in the actual physical setting, often in strange guises and in the midst of natural phenomena whipped up by diabolical or other outlandish forces. And this may have been meant as a hint that the oddly distorted, impassioned or pathetic vision of salvation or punishment which then became his central focus might all too readily invade the still peaceful country in the background. In none of the major triptychs is the distant land really secure from such a threat. Yet the invisible barrier remained intact. Instead, disquieting signs and tokens in vegetable, animal,

59 Christ Carrying the Cross

Oil on panel, 29 1/8 x 317/8 in. Museum voor Schone Kunsten, Ghent (see also page 115)

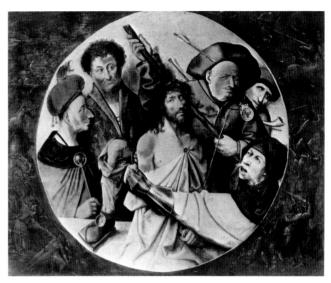

58

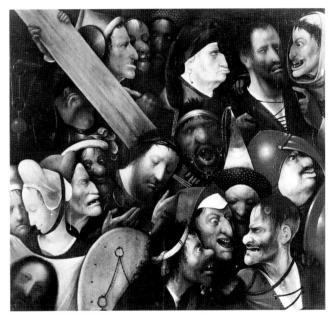

59

or diabolical guise crop up in the foreground, and, for the first time in **The Adoration of the Magi**, a type of landscape comes into being which would thenceforth become a problem of its own for the painter, whether as an image in and for itself or as the field of dramatic actions.

THE ULTIMATE DESTINATION

Seen in these terms, it is clear that Bosch in no way anticipated the kind of autonomous landscape prevalent after 1600. In his pictures there is a clash between the undisturbed, though also uncommunicative, earthly terrain

60 The Adoration of the Magi

Triptych. Oil on panel, wings $54^{3/8}$ x 13 in. each, central panel $54^{3/8}$ x $28^{3/8}$ in. The Prado, Madrid [see also pages 117-23]

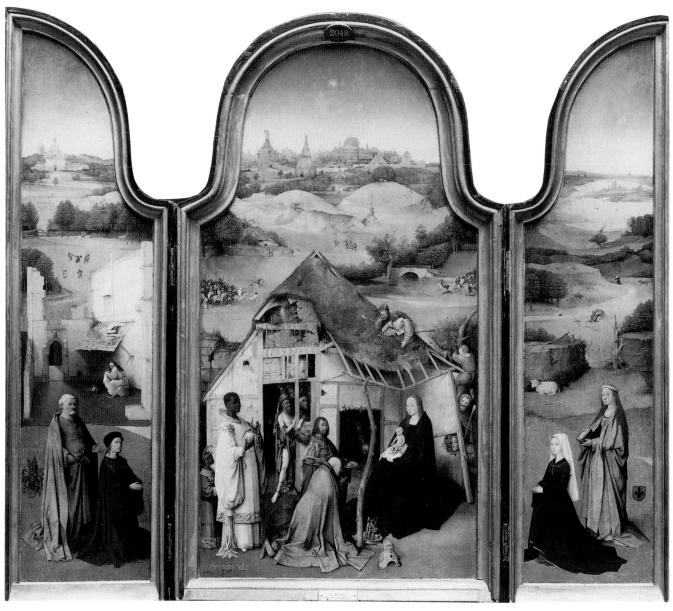

60

and that counter-world which already bore the mark of disquiet even before the devils invaded the scene. Both of these are juxtaposed and interlocked in Bosch's pictures, and often with no transition between them. What does this imply? Bosch's fantasies were not simply a playful imitation of the medieval repertory with somewhat more indulgence in a subjective taste for the indecent and the ludicrous. Their aim was new: to make visible the hidden significances no one had dared even look at for ages and to which, in part because of the seductions of the here-and-now, in part because of mistrust of a church obviously in need of reform, men willfully turned a blind eye. Not that many did not experience a sense of oppression elicited either by the

hostility and outrageous violence of daily life or by an uneasy premonition of the punishments the afterlife might hold in store. Yet however much and long the age may have been abashed or alarmed by this, Bosch was the first to set it down in pictorial form and, in so doing, to transform its ancient secret burden. In all of his work he grasped the interpenetration of the demonic and the everyday, understanding even that they may often enough be identical. When we think of the inspirations and origins of his art in this way, there is no reason to marvel at his extraordinary inventiveness, unique as it is. Because, once made into the focus of attention, the only thing that would count in such a gift of invention or fantasy would be if it created something

61 The Prodigal Son

Oil on panel, diameter 27^{3/4} in. Museum Boymans-van Beuningen, Rotterdam

62 Detail from the central panel of The Adoration of the Magi

63 **The Temptation of Saint Anthony in a Landscape**Bister and pen drawing, 10^{1/8} x 6^{7/8} in.
Kupferstichkabinett, Berlin

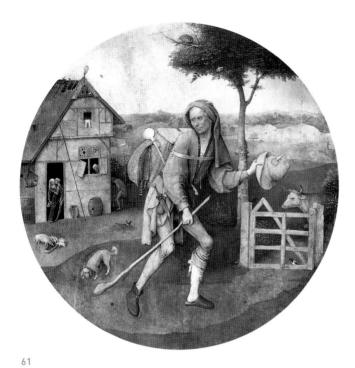

62

that does not exist. But invention for the sake of invention is not Bosch's way: what he invents also exists. Even his most unhuman or inhuman monsters are allegories of violence inflicted on or by human beings themselves. The processes they go through or the fates they endure are indeed innumerable. If for nothing else than their scarcely calculable number, Bosch's images are subject to infinite diversity and change, and this not alone thanks to his stupendous powers of imagination. Thus his entire production was a development, with concealments and disguises, of the subject of the Seven Deadly Sins with which it began. The riddles he propounded never lost contact with the reality of his time. They were read and solved by his contemporaries, even when the painter devised them himself and the current keys to symbolism did not fit. The monsters and bugbears he painted were not phantasms simply taken from anywhere or dreamed up on his own: however cryptic they might be, their origin was here on earth. If they were such that the "normal" eye could not behold them, it was because they required another eye: that of the artist.

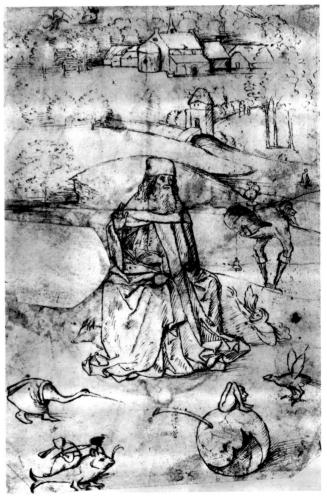

Bosch always viewed with utmost rigor whatever was extreme, whether suffering and passive acceptance or unbridled destruction. In painting such extremes he was able to show how both sides end up in a resigned indifference which acts almost as a safety valve, and which accounts for a certain gloomy accent of brutality in all his pictures. He was the first to demonstrate in painting what hap-pens when hidden things alien to our experience or even inconceivable

6

do indeed crop up in the midst of reality. To become aware of this aspect of Bosch means also to admit that it is only in the arts of today, when all barriers between the forms and species have been broken down, that the terror of destruction reappears, and this time as a more genuine reflection of what is happening around us. Long before our time Bosch too—a man only half faithful to the age he lived in likewise made a great leap forward. He altered the customary limits of the picture and opened the way to the unknown. He saw and portraved menace, violence, the horrors of the machine. Elementary or even primitive as yet, the technology in his pictures is none the less prophetic of how the machine can subjugate and enslave mankind. Yet, attractive as the comparison with Surrealism may be, it remains external. Bosch's shock tactics go far beyond forcing marriages between things that are irreconcilable as a way of upsetting people who think themselves normal. Something far more serious is involved here: first Bosch observed what life itself had smashed (cripples, madmen. horribly ugly and deformed people), then he himself smashed the pictorial forms he had inherited or put them together differently, the latter an innovation which has its significance in both the form and the content of his triptychs. While restricting himself to the most artistic means, his aim was to batter down and go beyond the frontiers of art, much as happens today though in a cruder manner. He had a subtle understanding of how to shatter the pictorial vocabulary of his age and then to infuse his pictures with revolutionary content and form. It is precisely this that explains why his style was without influence in his time. Representational motivation was too indissolubly welded to form in his pictures to yield a style from which others could profit. Regardless of the Late Gothic style of his time, he was a discoverer of characterological images of eschatological significance which understandably enough expressed his own age's dread of an impending final cataclysm, but also the "end-game" we envisage today. We are led to this conviction by the unremitting awareness with which, in all of his pictures, he worked out his critical motifs, sharpened them, and then repeatedly cloaked them in new mystery. Hence the singular oscillation in his career between memory and premonition.

If we are to compare points in time almost half a millennium removed, we must keep in mind that Bosch lived at the beginning of an age that is not yet over. In his art, however, unlike that of today, destruction was at one and the same time a radiance, even if it was the flickering radiance of a world in flames. In it, jumbled together, are chaos, the vestiges of a civilization, and a paradise overrun with a wild growth nurtured by art if not by madness. At the same time, however, strange laws govern all. The demonic need not be permanent, it can all too readily be reconstituted anew. Inversely, monsters achieve a life of their own and perpetuate destruction in unsuspected places. The essential element in Bosch's picture of destruction is, however, the theme of temptation. Here the demonic is provoked, enticed into the open, made to show itself, betray itself. The outcome is always uncertain. And yet the affliction will reveal its hand clearly enough if the victim can but hold out, and it is not without hope, and not even to be viewed as ineluctably hellish. For the individual tempted is himself the evidence that the entire world is not under the exclusive sway of the infernal powers. In the worst, infectious cases, to surrender to temptation means exciting the lust for aggression of others so that they, justly or not, attack some great power that stands in their way, thwart it, and if possible destroy it. Anthony himself often witnessed, and perhaps even experienced, such seduction, the attempt to establish a folly as a new reality.

The ordeal by destruction is here at its keenest. Anyone who thinks that temptation entails only the sight of all sorts of wickedness forgets that the men enduring it in Bosch's paintings are more than stoical onlookers. Such onlookers, as the painter saw it, must come to understand that everything threatening them is of their own making and doing. Further, that a temptation is more than merely a roundabout expression of spiritual stresses, that it represents opposition and resistance to reality. This holds for both sides: tempter and tempted alike set their face against reality. Hopefully only the latter truly achieves a new view of reality. It cannot be mere chance that, among all of Bosch's works, it is the **Temptations** that impress us most, and in terms of painting likewise. This above all, and not so much the influences of mysticism, of moralizing zeal. and of skeptical fidelity to an inheritance he knew all too well, is what characterizes the greatness of the painter Hieronymus Bosch.

plates

The Seven Deadly Sins

This was no doubt the first time in medieval painting that human qualities, vices, and sins were no longer presented as allegorical personages equipped with attributes alluding to the acts they personify. Here the acts themselves take the stage. In that respect Bosch was no longer a prisoner of the medieval system of symbolism, though it survived beyond his time. He broke down symbols into their components, made tools of them, used them as he wished, so that, if nothing else, they at least stand for the principle behind the action performed. The result here was a succession of theatrical scenes where human beings act out the circumstances of a sin, either in dramatic and crude manner or else subtly and suggestively, but never outright realistically with all the paraphernalia and minutiae of something observed in life. The latter was not Bosch's way, mindful as he was of all the diverse possibilities within any particular action. Only very much later were real occurrences portrayed with fidelity to life. What interested Bosch, despite all his otherwise entirely unmedieval modernity, was the revelation of what might be concealed within an action or behind it. So it was that he produced the most remarkable scenes imaginable, scenes only conceivable in the fifteenth century, half illustrations of moral precepts like the ballad broadsheets of later times, half didactic props to the conscience. In them a character defect is presented in dramatized fashion, though not with the simple naturalism of the later genre paintings but, instead, still with much of the solemn ceremoniousness of the Middle Ages, and it is precisely this that gives the moral lesson its force.

This holds true even for anger, contempt, and violence the worst ways men do evil, though also the most natural to them. With these, Bosch's approach—still ceremonial even when most unsparingly critical—goes over into open general destructiveness. Not only are objects of all sorts thrown wildly about, but ceremonial formality itself is put under dire strain and survives only as a kind of dumb-show of gesture. To complement this indulgence in the unrighteous. disorderly, and destructive, Bosch turns away from precious, deep-glowing colors and, especially when the scene is set in a landscape, opts instead for light and cold tones, often a sandy yellow. For interiors—generally small, boxlike rooms with walls painted slanting inward in this particular picture to accommodate the circular form used for the sequence of sins—the coloring remains dull, and gray permeates all the objects however much they may be meant to retain their full-bodied reality. Disorder, sheer waste, and destructiveness continue to be conspicuous even where the scene does not involve two persons in a clash of wills. Indeed, the distress is even more patent if the sin is not the consequence of violence and conflict but of one man's willingness to let

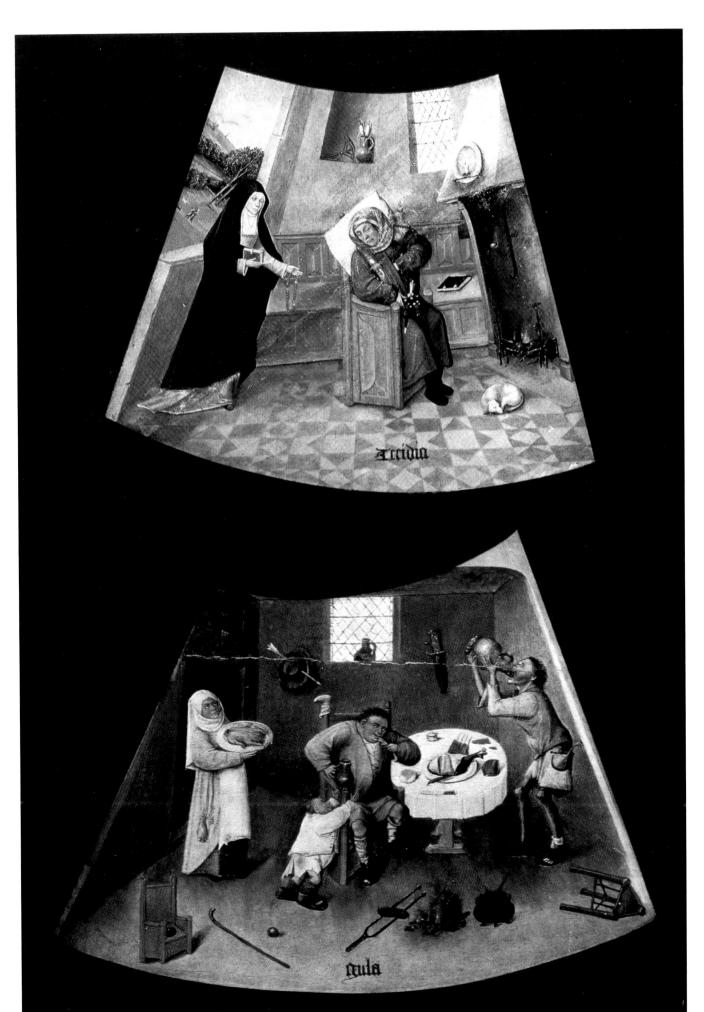

The Seven Deadly Sins

himself and his actions slide into gross disorder and to outrage all measure. Thus in the depiction of **Gula** (Gluttony) all four personages, even the already corrupted small child, are at one in their moral sickness, so everything about them lies in disorder and they can do no more than turn besotted, cowlike eyes on the one thing—food—that continues to interest them. Note, though, that on the wall hangs the same hat run through with an arrow which, in Bosch's later pictures, is often worn by torturers and relentless tormentors.

On the other hand, the way the world goes to ruin quietly and with composure—though these are only the outward appearances of something less admirable—is shown in the picture of **Accidia** (Sloth). A man sits phlegmatically, sleepily, before his fireplace, a book laid aside. What sin is there in that? "Indolence" says too little, "laziness" is much too crude. This is what the Middle Ages called a "monk's vice." And, still faithful to that tradition, Bosch introduces into the room an admonishing figure, a nun with rosary and book who is perhaps meant to stand for Faith and is certainly intended here to underscore the error of the man's ways. More precisely, with monks accidia took on the characteristics of the melancholia and paralysis of the will which all too often befall those pledged to the service of God. But in the everyday life of lay-persons it is of no less import, a

kind of creeping timidity that makes it impossible to come to grips with even the most urgent and essential activities. So it is that this picture of peaceful tranquility is deceptive. Under the guise of deep study or meditation it masks nothing less than a flight from the normal problems of life, though the gentleman here would scarcely own up to this. Bosch painted this sin in a hard and almost contemptuous manner difficult to justify today when, repressed and driven into neurosis as we are, it has become so widespread.

Another sin is viewed with somewhat more indulgence: Luxuria (Lust). In it we are shown how easily mutual dalliance can decay into the casual but confused concupiscence which makes it impossible to experience fidelity or any bond or even love itself, and ends at last in boredom. Through it alone does pleasure—still sought after in spite of everything—become tyranny, handicap, and sin, and this before there is a sign of the menace felt in the other illustrations of the deadly sins here. The personages here are more ceremonious in bearing than those in the other pictures. Two couples converse inside a tent as if taking counsel. Their courtly manner gives no more than a hint of what is to follow. Desire and seduction manifest themselves only with the greatest discretion. Yet there is a purely emblematical allusion to the discord that so often arises out of the indulgence of the senses: the two jesters who are otherwise virtually without connection with the scene, one of whom is dressed as a monk but is obviously the prey of jealousy and all too eager to pick a fight.

These scenes are not so much continuous and consistent actions as demonstrations, dramatizations, notations of traits pushed to excess, less stories than sketches of the chief characteristics jotted down quickly and set loosely side by side. Fittingly, then, they are painted roughly and without subtlety, though this in no way reduces their impact and effectiveness. We are given signals, not fully convincing tableaux of character. Here such tableaux are still in embryo, though eventually Bosch's imagination will extract from that sort of expression all its multiple and even hidden meanings. This depiction of the deadly sins is his earliest, still difficult and even awkward, attempt at characterization. A coldly accusing finger is pointed at each sin. Each is shown to be of our own making and merciless in its consequences. Yet, for just that reason, each brings the dual aspects of our world to our attention: that man is enemy to man, that each of us is powerless against the others. So it is that even in Bosch's earliest work the chief subject of his lifetime is already set forth: the difficulty of choosing between good and evil. The will to sin-here as in all of Bosch's works—is more the product of rash thoughtlessness, of perplexity, than of evil itself.

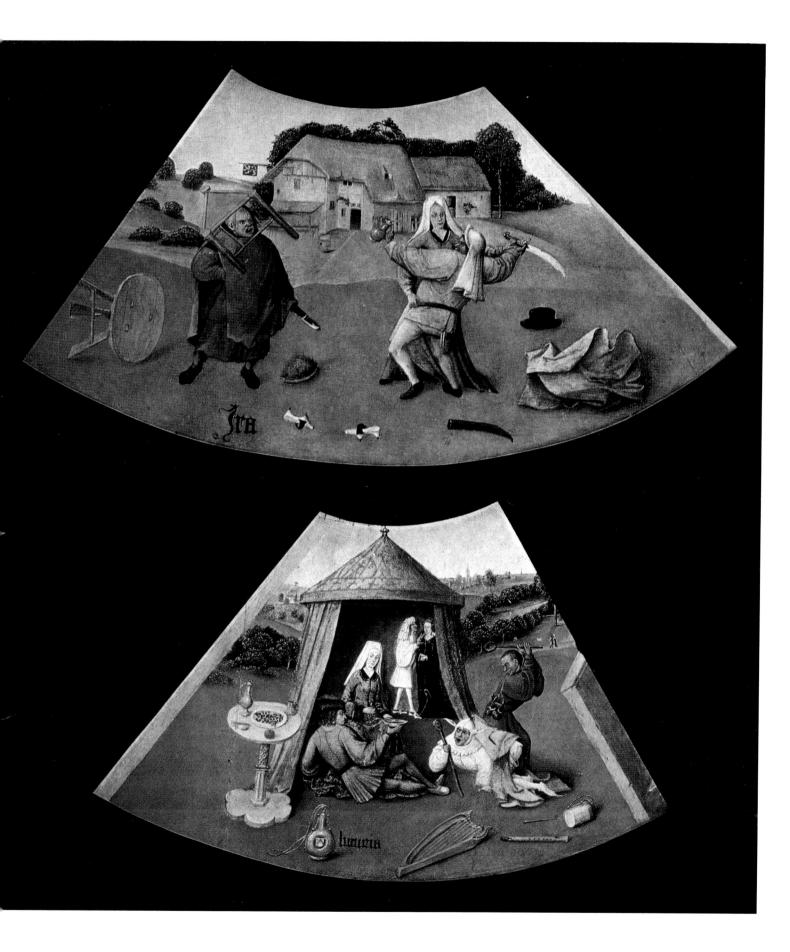

The Operation for the Stone (The Cure of Folly)

Is it perseverance or madness that has brought these four individuals together on a lawn apparently not far from a house? The stocky man whose skull is about to be cut into is the only one to look out of the picture, and his eyes speak of stupid silliness, though also of true distress. The others all make a show of being uninvolved in the impending violence and at most do their bit to convince the patient. The white-tonsured monk risks a few gestures and looks at his victim in a dictatorial, crafty, and anything but reassuring manner. The victim, however, is himself all too willing. The inscription above and below the picture reads: "Master, cut out the stone—my name is Tricked Cuckolded Impertinent Hound." So the man has given his consent. He is nonetheless tied to the chair with a thick roll of cloth, but this may suggest not so much violence as mere practical forethought in the midst of so much folly. One wonders about the nature

of his complaint. The consequences of too good living? Or is he stark mad? It does look as if he is surrounded by individuals who are genuinely mad and given over to absurdities and foolishnesses. The monk who addresses him so earnestly holds out helpfully a pewter pitcher—but what does it contain? And the master surgeon himself, an odd bird who has a coat of arms on his shoulder which certainly does not look like a guild emblem, wears a funnel on his head. This scarcely makes it easier to trust the virtuosity with which he may—or may not—wield his scalpel. His costume is less ludicrous than somehow suggestive of malignancy. And because the earthenware jug dangling from his belt is unusable and inappropriate there, it typifies the hollow vainness that Bosch so often attributes to this stage prop. But it is the nun, staring at the operation with gloating pleasure, who is the surest sign of sullen obstinacy and malice. The fact that a closed book is senselessly balanced on her head is the ultimate confirmation of this nasty brew of lunacy and sheer malignancy.

The language of this picture, even in its most intimate formal aspect, consists of exactly that double brew. Viewed as satirical anecdote, it mocks gullibility and the swindlers and tricksters it attracts. In writings of the time, medicine with all its secrets is often taken as the prime example of easily perpetrated fraud. This picture lends visible form to that notion: what is going on looks real and serious until one notices the funnel and book worn as headgear and realizes that something very much amiss is taking place. These are not conventional symbols but signals invented by Bosch to warn of what may be called booby traps. Here they are traps for the gullible. Since the suspicions of the well-fed, and probably well-off, gentleman are not aroused by the fantastic getups, he earns the painter's contempt no less than does the unscrupulous band to whom he has fallen victim. The man was quite likely an easy mark before this operation: this may well be his last time around. Hypochondriac or not, he is certainly also a self-centered fool.

Gullibility is one of the chief themes in Bosch's pictorial repertory. Many of his pictures illustrate the punishments the gullible may expect, and this is one of the earliest among them. Its authorship has often been questioned because of the relaxed, textured treatment of the landscape, which some experts consider too "advanced" without recognizing how much of it is, in fact, composed merely by repeating a single pattern. Yet precisely this, viewed in connection with the stiffly explicit metaphorical character of the figures, seems to me evidence that here Bosch was making the first break with the old-fashioned realism of the miniature he valued so highly and was reaching toward his own personal, and highly characteristic, formal language.

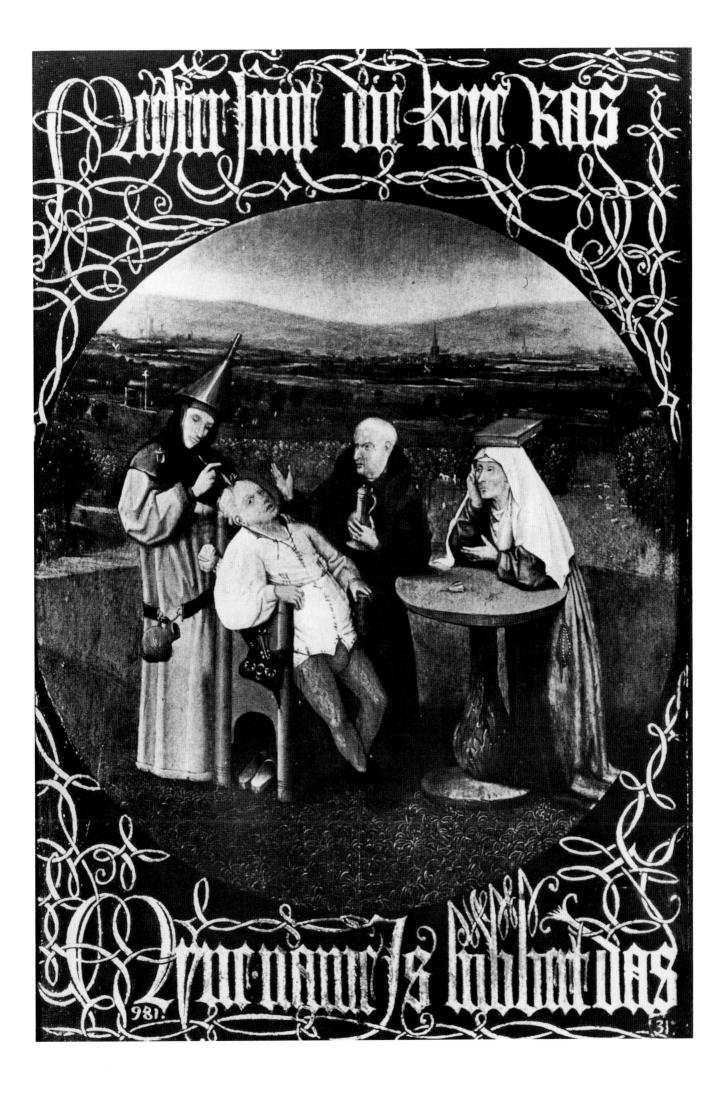

The Conjurer

They press forward from the background, these silly folk, so soon agape and agog to see the bit of magic offered for their befuddlement and to inspect close up the very peculiar paraphernalia on the very peculiar table: who can blame them for thinking of it as an altar table set up for mass? They stand doll-still, staring at the tricks or merely looking on, genteelly and without crowding and fanned out like the royals in a hand of cards. The most eagerly curious of the

lot (a man? a woman?) assumes an almost ninety-degree

stance to stare open-mouthed as he himself swallows

down or spits out the ultimate improbability—live frogs. He happens also to be the only figure so tall that, up straight, he would tower above the others by a head. Who or what is he? His red garment is of impressive cut and color, but nothing indicates if it is ecclesiastical or secular. He does seem to be some sort of high dignitary whose gullible stupidity is certainly out of keeping with his status and is another respect in which he surpasses those around him, for all that his fancy red headgear makes him look at least a doge, if not a pope. Which is why he is so much more remorselessly caricatured and held up to ridicule: his purse is being stolen and he does not even notice it. Only the child at his feet grasps what is going on and finds the incomprehensible behavior of the elderly gentleman more fascinating than the conjurer's surprises.

The action is set in a shallow space before a wall that catches little light, but is marked here and there with small tufts of weeds sketched in like written letters or words. As always in Bosch's early pictures, the background, even when it is a landscape, pushes to the fore the action we are meant to focus on. The protagonist here is the misshapen conjurer with stovepipe hat and beak-nosed, angular profile. Although the signs of evil frequent in Bosch's later paintings are still few here, there is an owl in the charlatan's basket and at the upper left a circular aperture in which sits a long-beaked bird. Nor is there any overt evil as yet, although already gathered here are faces with which we shall soon become familiar, some bloated fat, some stiff and staring, some self-righteously shabby genteel (among them another nun). A small group at least is held spellbound, if not yet by something unsavory at least by the too-easy promptings of illusion. If those who are bamboozled here had any idea of what an unreal, arbitrary, ever-and-again deceptive world it is in which they give themselves such airs, they too—like the foolish victim of the would-be brain surgeon—would be stretched on the rack. But not one of them has a serious thought in his head, and they are, and want only to be, happy as the day is long. So the evil that befalls them comes without their noticing—behind their backs.

Here then is an early example of the basic pictorial language of Bosch. It will become much more rich and varied, but already we find his characteristic trenchant physiognomic characterization, firm silhouetting of figures at the same time as many-leveled tonal values, and, not least, the counter position of a tight-packed group and an isolated attention-fixing point of attraction. These all indicate Bosch as author, rather than some imitator or copyist whose choices would be less discriminating; despite which there have been experts—recently set right by Tolnay—who insisted that this was a copy of a lost original.

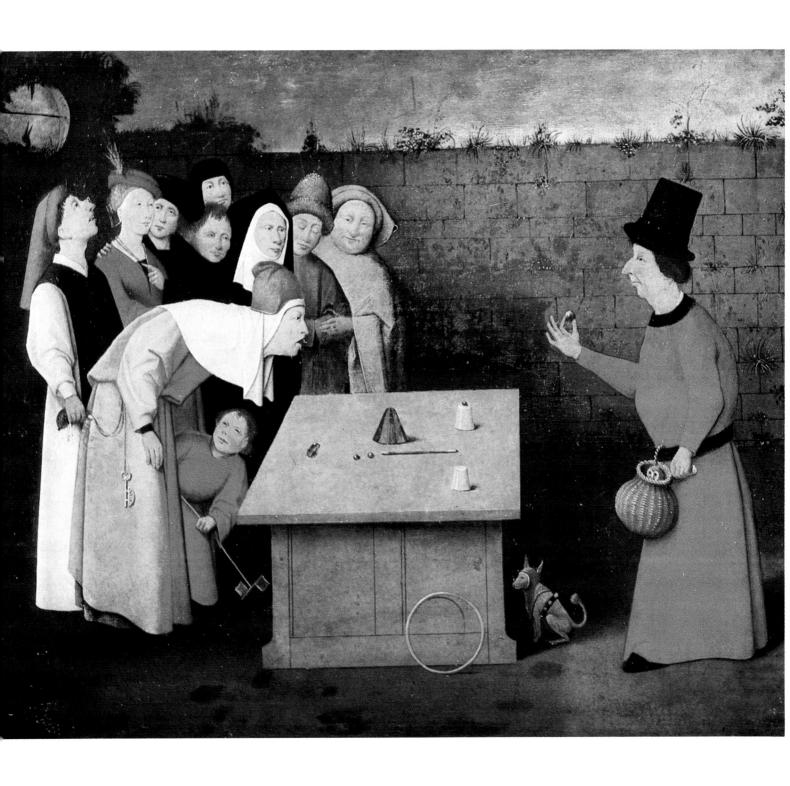

Ecce Homo

As standard a Biblical subject as is the beaten Christ exhibited to the rabid mob thirsting for blood, it can also be viewed as the confrontation of pitiable helplessness with a blindly fanatical force; and therefore as a moral exemplar of something forever present in the world, both before and after the Coming. As in **The Conjurer**, here too a crowd has come together, but whipped up here by other and more evil impulses. No longer merely fascinated, here they are people brought together by a mutual lust for action, by an

aggressiveness that seeks no other excuse for being: and Bosch paints them as a pack of beasts. However, his first concern is with constructing a proper stage, and for this he sets up a high base above which rises the hail of judgment. all of it in solid, neatly masoned stone whose coldness is part of the confrontation, though scarcely a match for the hard and icy-hearted boors who make up the crowd. On the other hand, the court is accomplice of the horde that acclaims it. Pilate shows himself undecided, but at the other side of the Man of Sorrows stands a dignitary from whose official headgear hang flaps like tongues and who conceals a heavy sword beneath his mantle, a man who is the very embodiment of the mob's abuse of Christ and who is, in every sense, their man. If even an innocent gathering like that in The Conjurer is, according to Tolnay, a single creature with many heads, a kind of weak-livered hydra easily overcome through the power of suggestion, then a malevolent throng like this is already beyond subduing and has been inflamed to a mass hatred.

Elsewhere in Late Gothic painting the mocking of the condemned Christ is confined to the ascent to Calvary where the minions of the law are shown venting their spite well beyond the call of duty. The subject of Pilate exhibiting Christ to the rebellious populace was an iconographical innovation of the fifteenth century and, in time, became more and more a devotional image focusing on Christ as Man of Sorrows. Bosch, however, remains unique in portraying not so much Christ's ordeal as the horror of a mob inflamed by words or even mere insinuations. Thus his picture is not a devotional image inviting compassion but a depiction of madness and the way hatred spreads to mobs, and its aim is to arouse the viewer's condemnation and indignation. The foreground solid, dense, with no escape—constitutes the entire picture. At most, the glimpse of a friendly marketplace is there to remind us that, compared with the chief event in the picture, everything amiable is no more than illusory and irrelevant. As transition between the foreground and the distant city there is a bridge, but it too is flawed and its four partly ruined stumps of columns say to us that this is no real way out. Indeed, the cityscape hangs there like a separate picture behind a picture. Nothing leads out and away from the action in the foreground, and there is scarcely more than a discontinuous optical changeover from one plane of the picture to the next. This work, another of those assigned to the early period extending to around 1490, already manifests a trait that, in the future, Bosch was to vary in such diverse ways: the capacity to view a spectacle as transitory but, at the same time, frozen in a tableau-vivant, and to combine realism in the depiction of human features with an almost weightless two-dimensional treatment of the physical reality.

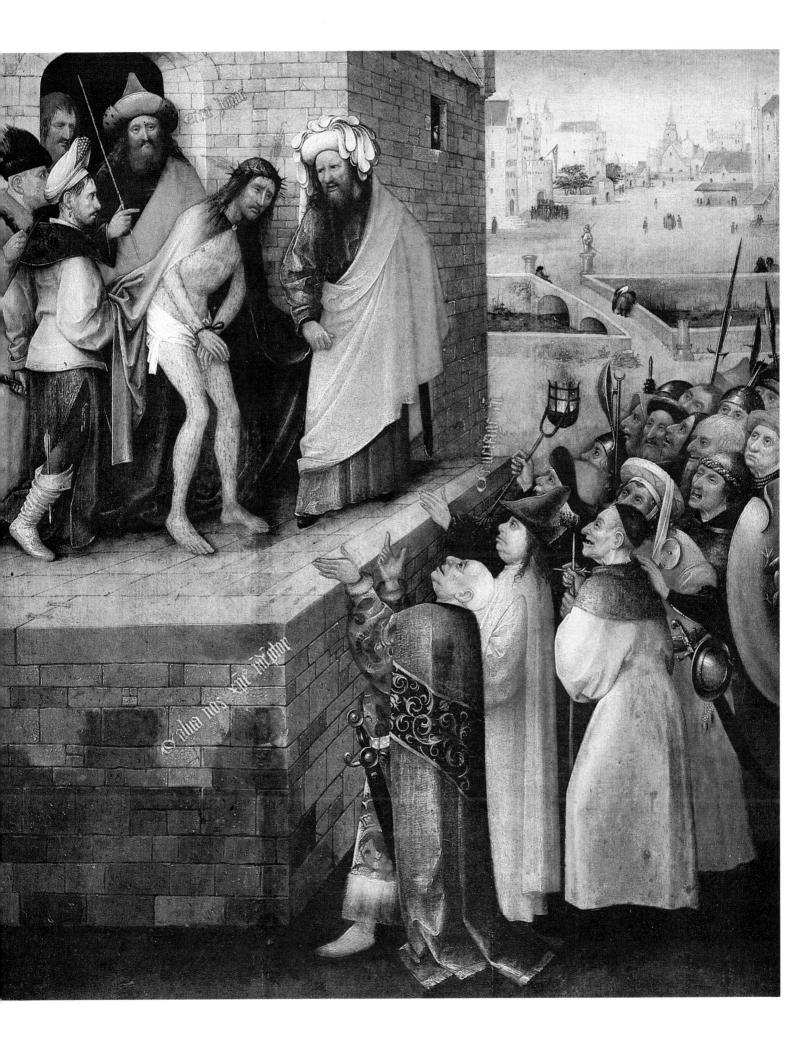

the Magi

The Adoration of

Probably no episode in the childhood of Christ was more often painted in the fifteenth century than this, in which the secular power, with all its exquisite and costly trappings, is brought face to face with the Holy Family who, although they are shown in a poor country place, retain much of the feeling of the long-traditional devotional image. Bosch scarcely

goes beyond that standard type, and yet, in some way the eye

barely discerns at first sight, he introduces into it a serious alteration. Here we no longer have the subtle and intricate interweaving of figures, the elegant crumbling masonry, and the gentle stretches of landscape that his predecessors painted. The place is more like the entrance to a mine pit, the house moldering and forlornly surrounded by a decaying gray wall. In it, however, everything takes place in an extraordinary mélange of excitement and circumspection.

Hastily fallen to his knees, the king clad in gold-green offers the Child a many-cylindered chalice. Joseph, whom other artists always relegated to the sidelines, is placed here behind a table (another innovation) and, gazing upward, quite certainly holds the exact center of the stage. He and the kneeling king catch the eye by their almost ecstatic gesticulating movements. In this simple, tranquil action, adored and adoring are alike translated into a deeply touched amazement. Almost nothing happens, but already there is that sharp, intense, searching sort of form that will be found in all the future fantasies of Bosch, whether remotely strange or secret and cryptic. So much the more astonishing, then, that the other two kings stand entirely apart at the right, untouched by any agitation and yet as if having themselves passed through some initiatory experience. They are the clearest demonstration of how everything in this picture is kept remote from everything else, and yet at the same time held in a mutual attraction.

Even at this early date the actions Bosch paints are not truly dramatic and, in consequence, are so much more explicit in their facial expressions, features, and gestures. Witness these two, so remote from it all and yet painted in the same pale, cool-pink tones used for the garments of Mary and Joseph. In fact, the polar extremes of that color are established in the shadowed deep rose of Melchior and the shimmering white of the Moor's garments. The latter illustrates another frequent artistic stratagem used by Bosch: on his sleeve is embroidered the scene of the Israelites gathering manna in the desert. This is one of the various ways in which Bosch ingeniously works a second picture into his main picture, in this case to convey an Old Testament allusion to the coming of the Savior and to the sacrament of His sacrificial death.

So here we have Bosch following the convention of a religious depiction and at the same time making it clear that the once firmly fixed hieratic gestures have now been taken over by a new human type whose new, disquieting character would receive its explanation only later, when great events would change the world. The picture is early, perhaps even before 1490, and in ancestry would seem most closely related to the high-arched, dry, pale forms of the Master of the Virgo inter Virgines.

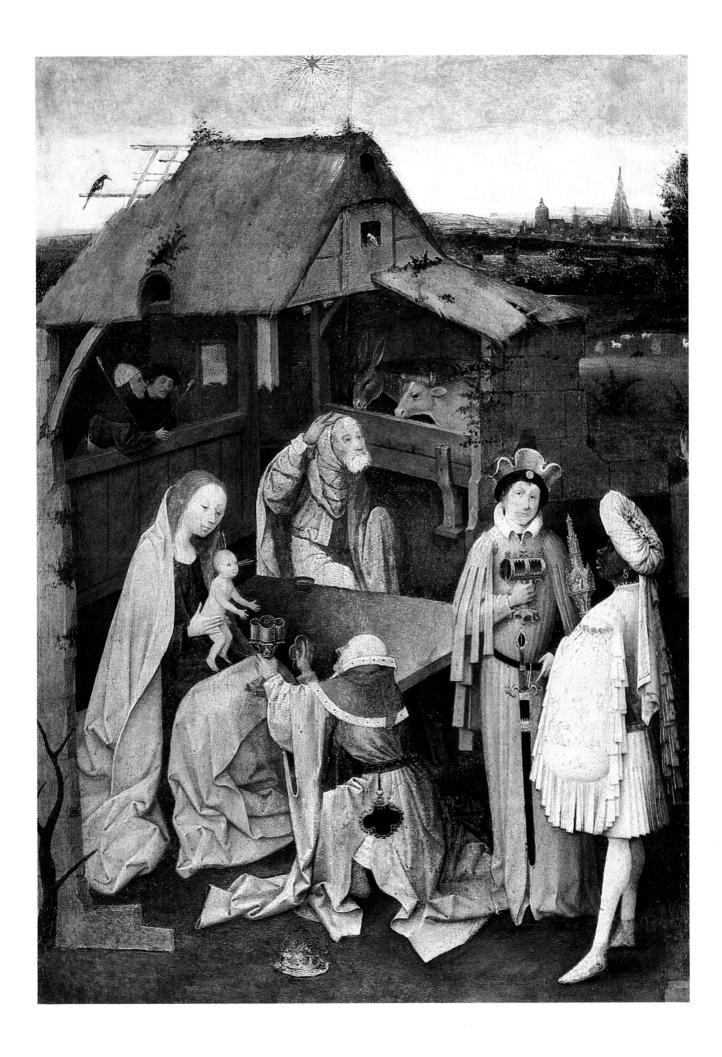

The Ascent to Calvary

This narrow picture was once the left wing of a triptych whose central panel was probably a Crucifixion and right wing a Deposition or Entombment, thus making it the first incident in the fatal progression extending across the entire altarpiece. In a medley of livid, glittering, and garish colors the executioners and populace push on, not so much horrible as obsessed with haste. The ludicrousness of some of the types depicted seems at first sight to mitigate the brutal aspect of the scene. Many of Bosch's pictures involve just such an action in progress passing by. Whatever is frightful here began before this transient moment. All decisions were made earlier, nor is there any marked clash of wills here. There are more gestures of fright than acts of brutality. However, both haste and terror are contained in meaningful patterns within this episode of the Crucifixion. This strikes a new tone that sets Bosch apart from all the painters of realistic martyrdoms in the previous decades, despite some similarity in volatile temperament with the comparable scene in the polyptych of 1437 by Hans Multscher.

The mockers spurring the heavy-burdened Christ on to Calvary move in great haste and so make up less of a compact band held together by mutual malignancy than in the scenes before Pilate. Here they have become themselves the driving force, lusting for the crucifixion. But brutal cruelty becomes all too evident in the Christ fainting under his burden, with nail-studded blocks attached to his feet. Cruelty does not stop there. It extends to the two thieves in the foreground who, terrified, have abandoned all hope. Here we have the profane strain within the Biblical theme. In the revolt of the one thief and the fear that drives the other to confession is written large the dreadful end awaiting all who are brought to execution.

When Bosch introduced cold realism into the traditional Passion scene, he was old-fashioned and modern at one and the same time. It is precisely this that lies behind the pictorial form which is written out on two lines, to be read still in the manner of the superimposed images of the miniatures from around 1400. The composition runs from above to below and culminates in the lower foreground, where lie a ladder and one cross while another is being set up. The farthest point to be reached by the procession is thus the nearest to us, the Mount of Calvary. The road is seen in panorama with the eye moving down from above, and it ends in the sharply etched scene of the despairing thieves, whose profane and therefore hopeless death is deliberately given the character of a senseless and irrelevant anecdote. The true meaning, that of redemption, is still on the way in the person of Christ. Scarcely ever before had despair and hope been brought together by any painter so closely and with such telling contrast.

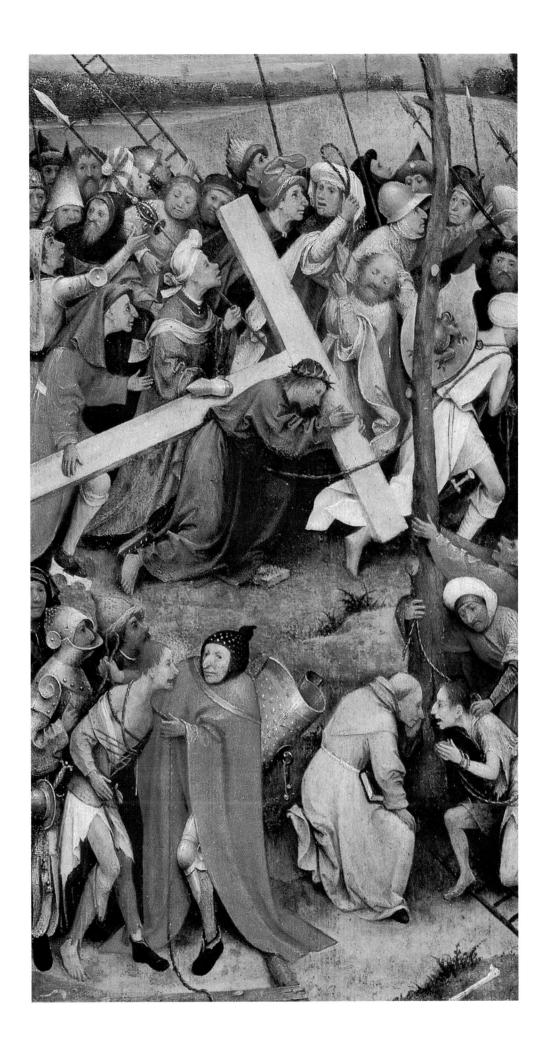

The Hay Wain (left wing)

The Hay Wain appears to be a picture of autumnal abundance, of a good harvest safely brought in, and of people who are self-reliant, generally provident, and to all intents and purposes stolid. Is it? Are they? Or is this not all a great deception, because the bounty is not for everyone to share in? Look closer. What at first seems enough and to spare only goads those who see it to frenetic greed and envy of everyone else. Even if the proverb that Tolnay adduced to explain it may not have been current in Bosch's time, it is entirely appropriate: The world is a stack of hay, and everyone snatches from it as much as he can.

At the front of the hay wain, where it is being pulled out of the central panel and toward the right wing, a strange crew makes its appearance (page 61). Pictorially it constitutes a junction where opposites are brought together in disturbing juxtaposition. Here the uncouth self-seekers from Bosch's early pictures of sins and passions join with the misbegotten creatures who inflict and propagate human misery, and who had previously appeared only in the roundel showing Hell in the lower left corner of The Seven Deadly Sins (figures 1–3). From the background, as from a justopened trap, pours a stream of figures who seem scarcely to know what they want nor what may be demanded of them. They are like a mob brought together by false rumor, but they are not even aware of what is happening nor, even less. that the place they have arrived at cannot be a stopping point. Their final destination is not shown in this central panel, but already one has a premonition of evil to come. The wagon rolls on. But who and what are they who pull it?

The mob streaming in from the rear seem to have had a great fright. They come, like blind moles, out of a hollow that could have been eaten open by termites and is overgrown with those extraordinary seed pods, gigantic apples. and mushroom caps which, appearing here for the first time in Bosch's work, will eventually become the usual signpost for all suspect and corrupting places. Here they mark the point of issue for a crowd throwing itself senselessly against the mountain of hay without even noticing that it rolls on like a juggernaut. They are not horses that pull this wagon, whose wheels have already crushed some, but the devil's brood, whom only the most innocent could take to be humans wearing masks (page 61). These are the demons newly invented by Bosch that usually have animal bodies natural or fantastic—and only occasionally human heads. Here they have hold of the shaft and rush ahead over the limbs and bodies of men. One has his foot caught in a tree trunk and whips about in the air an arm clutching a withered branch. They have the deformities of men themselves, and in their wretchedness are more evil than all the traditional crocodile-jawed, dragonlike devils of earlier art.

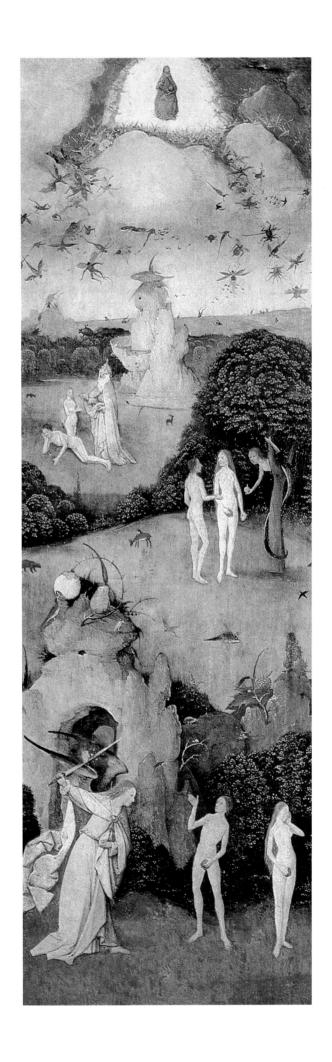

The Hay Wain

(detail of the central panel)

Whatever may be the fate of the wagon—to be demolished or to rot away in some undreamed-of place—we must look behind it to where a rearguard escort of the high and mighty of this world rides nobly forward, as if neither injustice nor destruction lies ahead but only the solemn course of such a life as should be but is not (page 59). Pope, emperor, princes, dignitaries accompany the hay wain as if it were a treasure, a monstrance, a holy relic. Neither doubt not fear do they express, but only a vast dignity indifferent to the turmoil surrounding them.

Theirs is the unfeeling indifference of those who do what they do with no misgivings; who countenance, and even secretly encourage, what goes on; who give their consent to what others do and let things end where they will. Which is exactly what Bosch means here, because at the feet of the Haves clamor, unregarded, the brute and violent herd of Have-Nots. So much strife and hatred is certainly not over a pocketful of hay. As much as any one man may have got his hands on, all the unapportioned and undistributed rest of it remains to tempt him. And so men covet and murder, and what each man takes is no more than the tiniest token in this all-embracing allegory of alienation and aggression. Indeed, things have gone so far that there in the foreground, just a few steps from all this turbulence, there is a veritable idyll of peace and plenty: nuns stuff a huge sack with their share or more of the hay (figure 21), and a monk as thick and huge as their sack is by no means dissuaded from swilling his fill by the rosary another nun holds up reprovingly before him. A fourth nun plays cat's cradle with the girdle of a rather dubious-looking, flirtatious chit of a lad puffing and squeezing away at his bagpipes. A quack doctor goes about his humbuggery, women fuss with household tasks that are obviously incongruous outdoors, and only a man in a stovepipe hat, a baby on his back like a papoose and a youngster at his side, appears determined to traverse the scene and leave this folly behind (figure 19). Appearances notwithstanding, all these figures strike us as accomplices, or at least as accomplished featherers of their own nests, not one of them a whit better than the blind horde running in front of the wagon and the unfeeling cortège that follows it.

These two scenes act as commas, or even brackets, around the hay wain and around the middle of the picture. The wagon is the focus of all this greed, but what it offers is at best transitory, and the wagon itself moves onward. One is reminded of the *trionfi*, the triumphal chariots of the signs and seasons that Francesco Cossa painted in Ferrara, though for all the rough similarity in composition there is an unbridgeable difference. In the Italian frescoes all is bliss and order reigns. Here there is disorder, and all man's endeavors will, fatally, come to naught. So too the pictorial

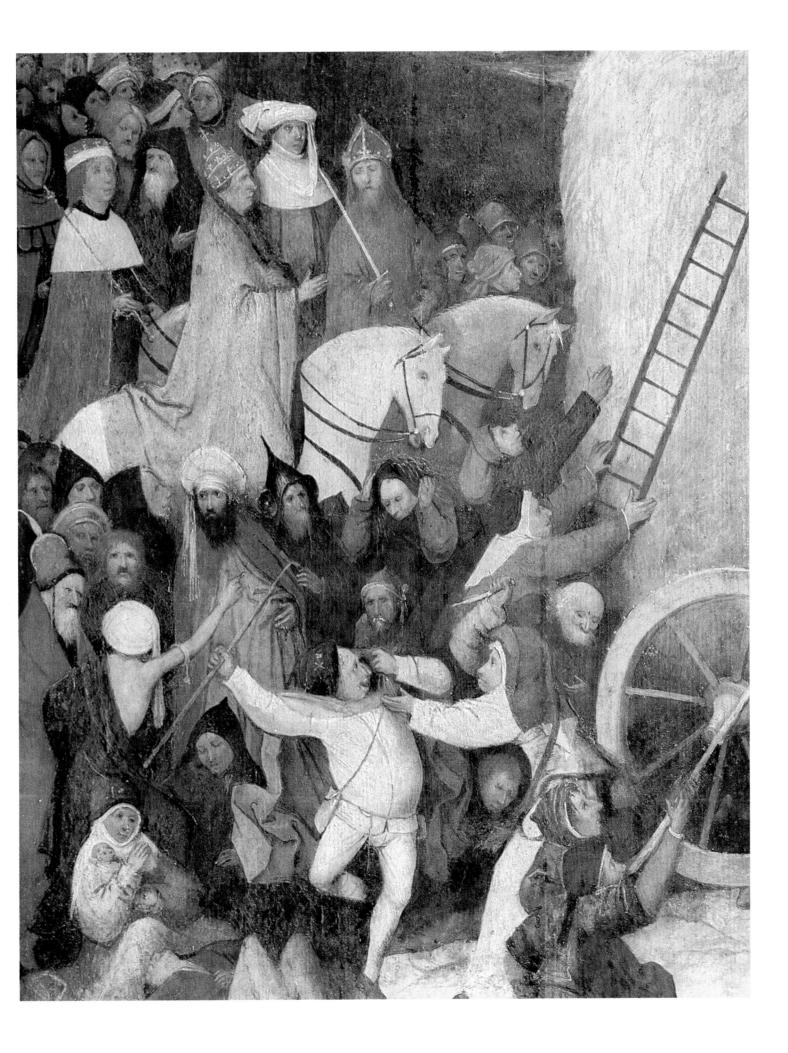

The Hay Wain (detail of the central panel)

form of the triptych itself. Painters before Bosch had given the central place of honor in their triptychs to the image of permanency, to the image to be venerated, which meant usually something from the Scriptures. Here for the first time ever we have, instead, the mere semblance of a happiness, an ordinary hay wagon that may be the focus of all this striving but soon will be impermanence itself, plundered and smashed or hauled away to somewhere or other. And when it is gone, what remains? The vain wastelands of universal violence.

Bosch reconceived even the form of the triptych. No longer is the central panel merely flanked by two wings to make three separate images. Instead a single, though tripartite, picture progresses from the left wing across the middle to the right wing, and this was a system Bosch abandoned only rarely thenceforth. Thus here the world—and the picture—begins in Paradise, which still lies calm and undisturbed.

That calm, however, is already threatened even before the first human pair begin to accustom themselves to the strange, though scarcely oppressive, law under which they have been assigned to live. The rebellious angels, transformed here into a swarm of evil insects, cast their shadow over the Garden. As yet, though, they have no power, no foothold there. The reddish ground, overgrown with a mild green, lies there as if still touched with rosy dawn. Even when the guilty pair are expelled from Paradise, they continue to be surrounded by peaceful shrubbery. But when we join them in looking back, we see not only the angel who has driven them out but also, behind him, the cavelike gate crowned by strange prickly fruits in lifeless stone, and difficult to imagine as ever having been alive. And yet, whatever fear, shame, and rebellion are to be read here are portrayed as weak emotions at best.

Thus what began with punishment for greed is seen to be only the first step in all the grim fury that makes up the rest of the picture of human life. And while all times in history may not have been as spectacularly chaotic as Bosch's hostile personages would make it seem, still there is in these scenes a smug pride in ownership that at least lets us sense the muddleheaded, seamy reverse side of the medal. But all this should not be taken simply as an event, an incident, some public disturbance that may have taken place somewhere sometime. To the contrary, The Hay Wain is a moral parable that gathers together into its allegory a thousand incidents that may well recur over and over again. It is a picture of modes of behavior to be found everywhere in the world and throughout history. It shows what could happen, and always in the most extreme form. So it presents us not with an anecdote but rather with a vague state of

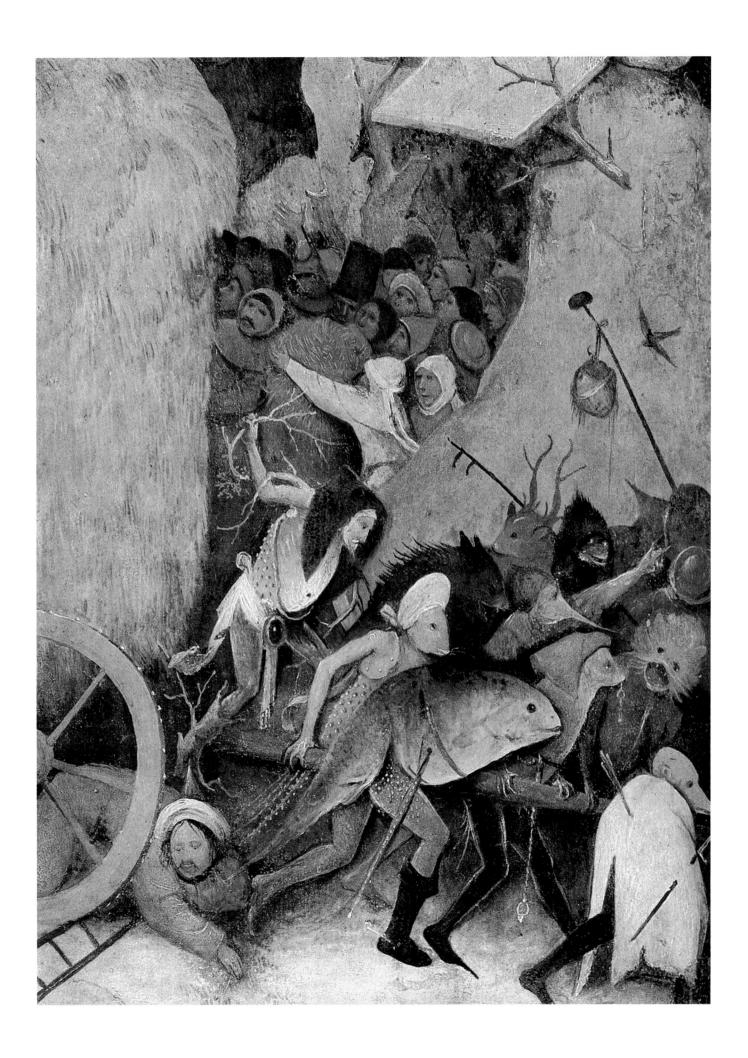

The Hay Wain (detail of the right wing)

being or frame of mind which, becalmed or in uproar, appears to elude the comprehension of the personages depicted. They do not seem to take fright at the thought that the urge to destroy may at any moment burst out anew and powerfully, especially since it is so very like the urge that leads to constructive activity. The picture as a whole should therefore be read thus: from the desolate but resigned curiosity that continues to spur on our first ancestors after their expulsion from the Garden, to the confused and powerful evil tumult around the hay wain, to final extinction in the black tower from which there is no escaping.

Then, suddenly, we see them, all the wild throng who had just been beating each other around the hay wain but who are now stripped naked and stamped with the mark of their vices, as if between one picture and the next a last judgment had taken place. It is in this that Bosch's gift of imagination resides, incomparable in his time: he shows us unrighteousness beginning almost surreptitiously, then hardening, finally going beyond the point of no return. This is why there is no need to depict any judgment here, why Christ looks on from the clouds almost despairingly and as if he expected nothing better from mankind, why punishment begins already on the road the hay wain travels. But it is also true that Hell, where men must abandon all hope, is no longer represented as it had been up to a few decades earlier, as the place of bloody vengeance ruled by a gigantic beast of prey. Here, instead, is a tower still under construction (frontispiece), perhaps being specially built to welcome the wretched naked creatures being dragged to its portal (page 63). Some of those sinners are driven along, some dragged head first, some half-swallowed by a fish's mouth with their legs following after. One of them is merely frightened by the proximity of a strange escort of animal-like creatures, another has been run through by a needle as long as a lance and rides an ox to the gate of Hell as if he himself were

determined to enter. An innovation that did not make headway before the start of the new century is the only vaguely defined, half flooded, half bridged-over area in the immediate foreground. The implacable end is thereby made to appear even more inescapable, because it looks as if the picture itself had lost its underpinnings, as if the ground had been pulled out from under it, so that a picture with a message becomes an optical illusion. Bosch was, in fact, the first to paint scenes poised on an unsound and unsteady base, as here where the foundation has crumbled away or been washed over by rising water.

So, too, violence pales into weak uncertainty. The violent acts of traditional Hells are obliterated here by a greater violence. This is the meaning of this tower, which is strangely narrow and such that one can only guess at what goes on in it and at how many cellars lie beneath it. Will it ever be completed? Or is the upward extension of the wall also only a feint? The gallows already in place could easily constitute the fitting top for this building. What need for zeal at such a job where no hope exists? But those who busy themselves here are mere instruments of a much mightier power. Whether this is truly the hellish afterlife or only an even more evil place than that of the hay wain remains a question. Certainly, there are no ways out: only the pit itself with all that goes on there. Yet, here also, there is no more envy and hurry-scurry, nothing of the rat-race which, despite everything, is still one way of wringing some joy out of life. All that is here is the gloom of half-finished walls, where the victims are locked away and no one can hear their cries. But there is menace from above too. Directly behind the building site, black and on the verge of collapse, stands a ruin of some sort in a landscape fallen prey to fire (frontispiece). But much goes on there too: instead of taking flight, black silhouettes of men must stay behind to stoke and fan the fire. At the foot of this flaming hearth stretches something typical of the whole picture: once again a dark water in which, pursued by monsters, men drown. Above, fire. Below, flood. A dual and contradictory evil from which there is no escape, and it marks the first appearance of a motif often recurring in Bosch's work.

There are two versions of this triptych, both claimed as the original. The one in the Escorial is more gloomy in color and therefore strikes one as more solid. For our part we are more impressed by the Prado version reproduced here. Its coloring is brighter, colder, and livelier, despite signs of damage in several places, and best fits the virtually ethereal lightness of the figures, a quality anticipated in some earlier works but only here beginning to be used freely. This alone is responsible for this first drama of the temperaments that Bosch painted no later than the 1490s.

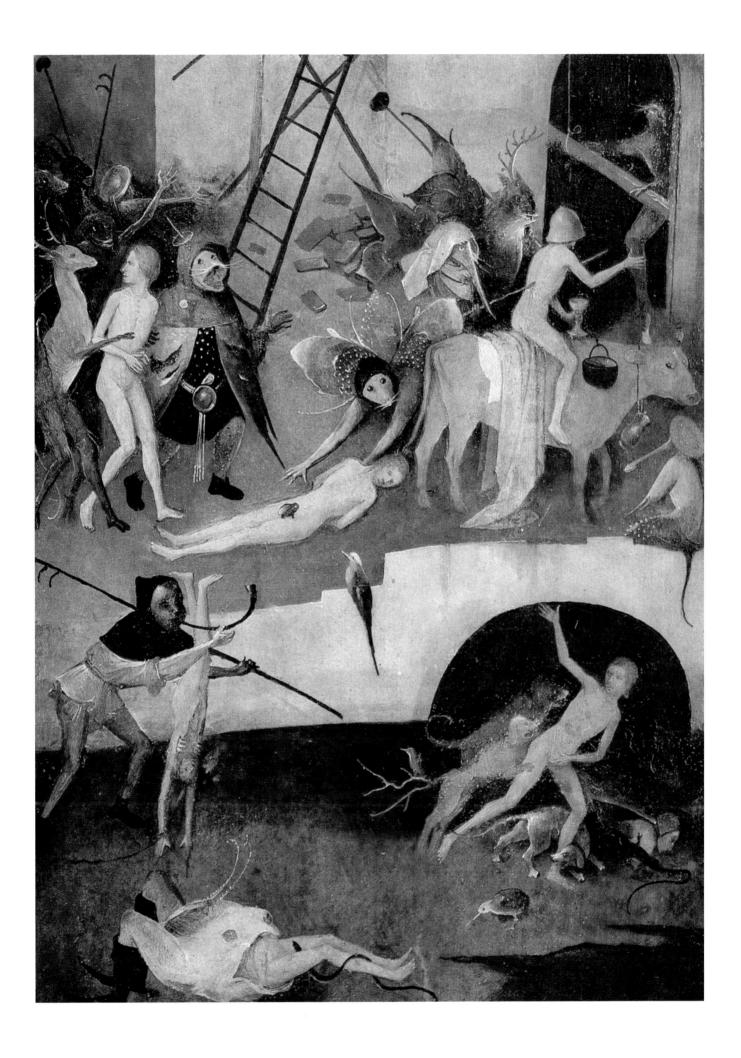

Death and the Miser (detail)

This is the first of the Four Last Things: Death, Judgment, Hell, Heaven. But simple comparison with the deathbed scene in the roundel on The Seven Deadly Sins (figure 2) shows a great difference. In the earlier work the dying man is surrounded by familiars and priests in prayer; here he is abandoned to his own choices. The angel pointing the way to Heaven has just as little hold over him as the gray devil who pops up from under the bed curtain to offer him a sack of gold: he has eyes only for the arrow that Death points at him from the half-opened door. A miser is dying, but the weak and indecisive movements of his arms and hands make it all too evident that he is the very last to understand that even now it is not too late to choose between damnation and a friendlier afterlife. Everything here seems slippery and unsure. And what is going on with the money chest at the foot of the bed? Is this not the same man, but at that earlier age when he held his beads with one hand and with the other stowed away his gold in a chest propped open by a dagger? Ambiguity and irresolution set the tone of the entire composition. The tall, narrow picture was certainly a wing of a lost triptych, perhaps an exterior panel, though the predominance of gray in the coloring is not sufficient to make it a grisaille. Throughout the picture the color tends to bleach out while remaining still within a quiet paleness and clarity used ever more effectively in Bosch's subsequent work. Here, more than ever before, hatching is used as a means of shading. As for the question of whether it was the exterior of a triptych shutter, the room with its sharply delineated perspective does suggest this. The portion of it seen here shows how unfathomably, but at the same time firmly, the basic outlines of the room are defined, making it virtually a trap closed on its occupant.

This becomes even clearer when we look at the canopy over the bed, the vault of the ceiling, and especially the structure in the lower foreground that projects conspicuously in front of the columns that seem to frame the entire picture (figure 25). If we assume that, when the shutters of the original triptych were closed, one saw immediately alongside this picture another such room or another half of this room, then the pictorial space created thereby would have been entirely unlike the zone of space enclosing the figures like an angular nest in the works of the Master of Flémalle. Here, much more, the spatial conception is of the sort that has been described as "a section isolated from larger spatial concatenations." Bosch is that sort of North Netherlandish painter within whose pictorial spaces both natural and fantastic creatures are imprisoned and flung about, and his settings, unlike those of Memling, were never mere backdrops or accessories.

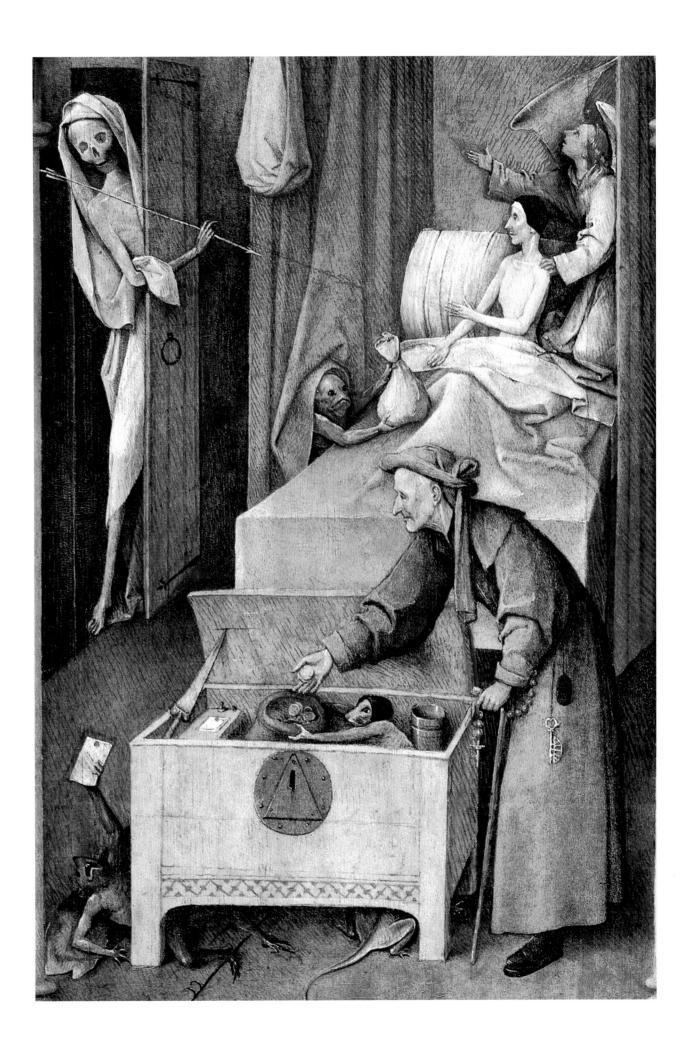

The Ship of Fools

Like the ship, the entire picture is afloat in a liquid element. It is hard to say if this unseaworthy vessel drifts in a shallow inlet or on the open sea, though that uncertainty may only be due to the much-obliterated state of the color in the background. Since the panel is high and narrow, it too is supposed to have been part of a diptych or triptych now lost. However, it is difficult to think of a subject that could have been combined with it, either to match this scene of folly or to make a diametrical contrast, the more so since this scene is unrelated to any iconographical tradition and contains no allusions to the Bible or any known moralistic text. Certainly the monk and nun make up the central focus of an overtly satirical picture. It remains unclear if they are singing to each other or, with others of their silly company, are bobbing at the cake dangling between them. Whichever it may be, nothing here is to be taken as realistic. Everything becomes a sign alluding to something else: the swimmers, the fool on the mast, the man losing his dinner overboard, the one who crawls about in the bottom of the boat with a huge jug on a cord and over whom a woman is leaning—none of them can be taken as literal and real. Is the subject gluttony or lunacy? Certainly the small handful of cherries is more likely to exasperate the already desperate desire of these madmen than to satisfy their stomachs, as Cinotti points out. Be that as it may, the entire picture is a riddle composed of ordinary everyday acts and gestures, and its source is not, as one might expect, Sebastian Brant's satirical novel with the same title but a Netherlandish poem from 1413 (which has been reprinted by Baldass).

This is the most celebrated, but also the most external or even superficial, of all Bosch's paintings. There is apparently

nothing complicated about it; the people depicted are simple folk. And nonetheless it is full of puzzles: hard nuts, one might say, and not for cracking. Here Bosch shows us everything from the outside. Outwardly everything looks clear and unproblematic, nothing more than a group of people larking about in a boat headed for the open sea. But the boat itself (like the so-called Ship of the Church in earlier pictures) is no longer seaworthy. Is it really under way? Or merely becalmed in a swamp alongside a bush out of which (or so it has been supposed) a robber clambers up to cut down from the mast a chicken all ready for roasting? But both bush and tree grow in the skiff itself, and the bush is the same as the one sheltering the lovers on top of the hav wain we saw earlier (figure 20). A topsy-turvy world where all the things and people are nonetheless at their ease, though all of it is foolish, mad, and ominously unwholesome. From the top of the mast-tree glowers an owl—or a head impaled. And once again, as so often, Bosch has painted a picture with no base, no ground to stand on: everything is in flux, the outcome unsure.

Much as we should like to pin down such a picture more precisely in terms of its antecedents and especially its sources, it is a work that is by no means superficial and is not entirely convincingly explained by any source that can be found. The fact is, with pictures it is obviously always best to trust less to literary origins and to look instead for whatever traditional or widely diffused images might be related. That even this highly eccentric-seeming Ship of Fools has to do with some activity connected with either the deadly sins or the seasons is suggested by an exploration of the new iconography of the months introduced at the end of the fourteenth century. As Pächt shows, depictions of the activities of each month had been done mostly in the form of wall paintings until the fifteenth century, when they began to appear in manuscript miniatures. There are Books of Hours from the time when Bosch began his career in which, as Cuttler found, the month of May was generally illustrated with a boating party. From the same period there are also pictures of groups of monks in boats, and since the devils always busy themselves with such lusty companies, these would appear to be meant as disreputable. It is a safe assumption that, in Bosch's time, such an association of boat trips with sinful monks was widespread. Nevertheless much remains to be explained here, especially since in another source one finds a monk and nun cooperating (or worse) in some blasphemous action. In which case the cake suspended from above would be the host and the board between the two an altar table set with chalice and paten. Yet there are others in the picture, and their only message seems to be that "where ignorance is bliss, 'tis folly to be wise."

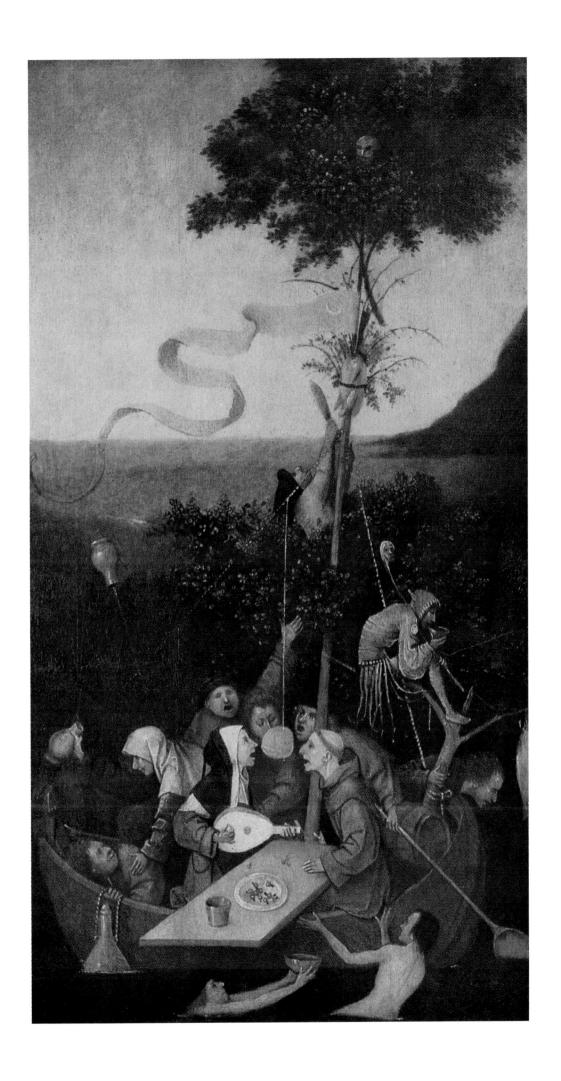

Ecce Homo

One can scarcely say what sort of place it is where Christ is being mocked here. It has something of a mud-walled structure whose poorly engineered and very insecure terrace rises above a dark archway that seems less an entrance than cellar vaulting. The rear wall, in unrealistic gold, is the ground of the painting itself. According to the well-reasoned argument of Tolnay, what we have here is a fragment, the upper left corner and, in fact, the first episode of a depiction of the Passion originally something like four times as large as this. However the rest of it may have been laid out, this fragment is another of those compositions to be read in two superimposed lines, a principle Bosch borrowed from the earlier miniaturists, though he made of it something new which, nowhere more than here, points to future trends. Moreover, never before had such thorough use been made of the clinging, fully enveloping, almost viscous material that seems to garb the hateful and ferocious mob. A match for the harum-scarum wave line of the parapet between them, the crowds above and below it are disposed like different phases of a single wave. The exhausted Christ, almost unable to stand, and the no less weak Pilate, who bends to the will of the bawling, squawling rabblement acclaiming him, both seem to be spared by the wave and vet almost engulfed by it.

One should not admire the subtly thin painting technique without taking into account that, for all the old-fashioned and somewhat affected use of light and dark, the colors here have a new character that is more than just painterly. They should be understood as a medium, one that takes hold of all the figures in equal measure. So it is that they all seem immersed in an element that is humid, swamplike, viscously engulfing, and in ferment. No one escapes it, neither tormentors nor tormented. Through the entire picture, twisting and squirming like a mollusk in its coiled shell, wallows a mass in which, almost by accident, there are human faces, bloated as in a rotting corpse, some with oily, porous eyes, others as if extinguished, pale, bleached-out. Everywhere there is this apparently self-generating humidity, and from it, as if a swarm of insects were bringing in a strange epidemic, stick out spikes and prickles. But what it means is that everything has been beaten and battered, not alone the Man of Sorrows but also those who scourged him. This is the origin of that feeling of extreme debilitation, of enervation, which is the real strength of this picture. What is in ferment here is not the spawn of anxious dreams but is itself an alien world, one that threatens to become all too real.

The picture must date from not long after **The Hay Wain**. It offers the rudiments of the signs and images that were eventually to become the basic stuff of Bosch's depictions of temptations, penitences, and delights.

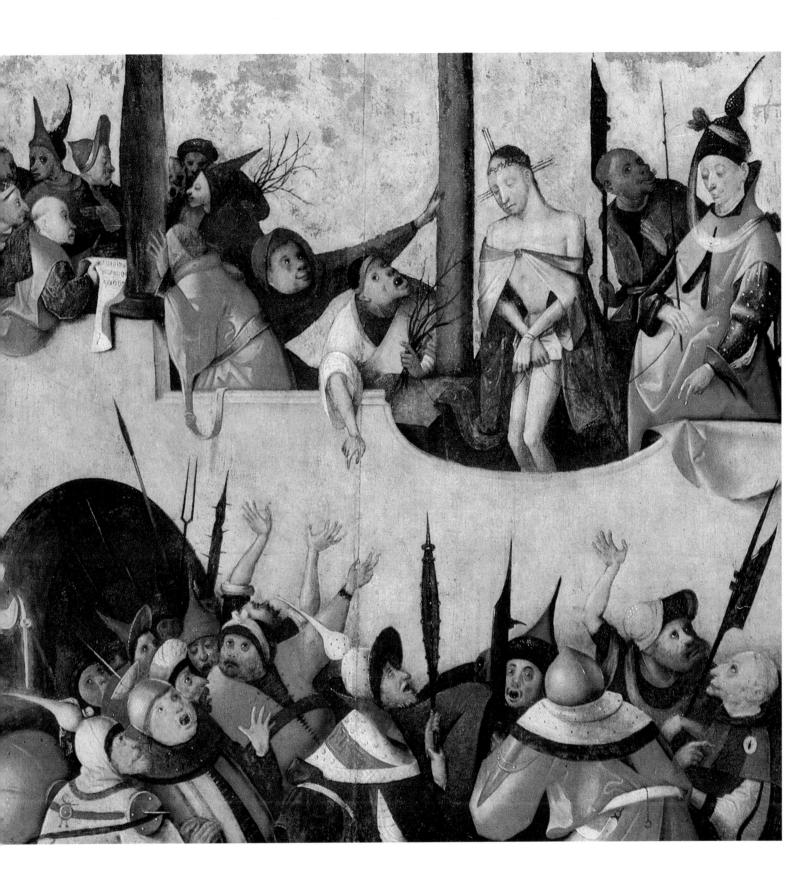

The Temptations of Saint Anthony (detail of the left wing)

This is a picture whose strangeness is due in part at least to its ever-changing and disconcerting landscape and architectural settings. It is impossible to be certain where one is or why even one should be there. The only thing certain is that one is seeing three experiences undergone by Saint Anthony during the years he lived as a hermit, from the end of the third century well into the fourth. The place is full of the most extraordinary things, not so much a wild and desert land as one that is uncertain and unsafe, flooded over and in flames, studded here and there with ruins or bizarre buildings. A picture like this must first be grasped as a whole before one can see its details rightly.

For all that this is a triptych, a movement leads across it, and although one is tempted to look first and most at the central panel one is soon caught up in the innovation Bosch introduced into at least his three major triptychs, and finds that there is no choice but to read the three panels as a unity from left to right. However, unlike **The Hay Wain** and **The Garden of Delights**, what we have here is not the universal course of events under divine dispensation, which drives the mass of mankind forward through fortunate and unfortunate efforts, through good as well as evil. Instead, it is the ordeal of one man, a saintly hermit, set forth in three different scenes of temptation and torture. Neither the beginning nor the end of his tormented existence is to be read here, but only the steadfast composure—call it asceticism or contemplation—which is the lesson of his legend.

As we know from the biography by Athanasius, the life Anthony chose was one of such steadfastness as to be almost deadeningly monotonous, relieved only by those rare occasions when the hermits felt called on to leave the Egyptian deserts and to pit their orthodoxy against the upholders of the Arian heresy. But what attracted Bosch was the true content of this man's life: the resistance he put up to onslaughts against his virtue which, admittedly, came mostly as visions, so that the saint scarcely had much occasion to become familiar with the real world, the flesh, and real devils. Those visions provided the stuff for monstrous images only conceivable by a painter, and among painters only by Bosch, images that no one ever saw, or will see, in real life, but that are, nonetheless, more than subjective fancies. In the Legenda Aurea, the medieval compilation recounting the lives of the saints, one can read how holy men chose to struggle openly against such images rather than merely to suppress them with the aid of nobler thoughts, but it was Bosch who first gave them visible reality in paint.

The story begins on the left wing, where Anthony is carried high into the air by a monstrous winged frog surrounded by flying boats and fishes apparently not at all uneasy in that alien element. Athanasius tells how the saint, one day while

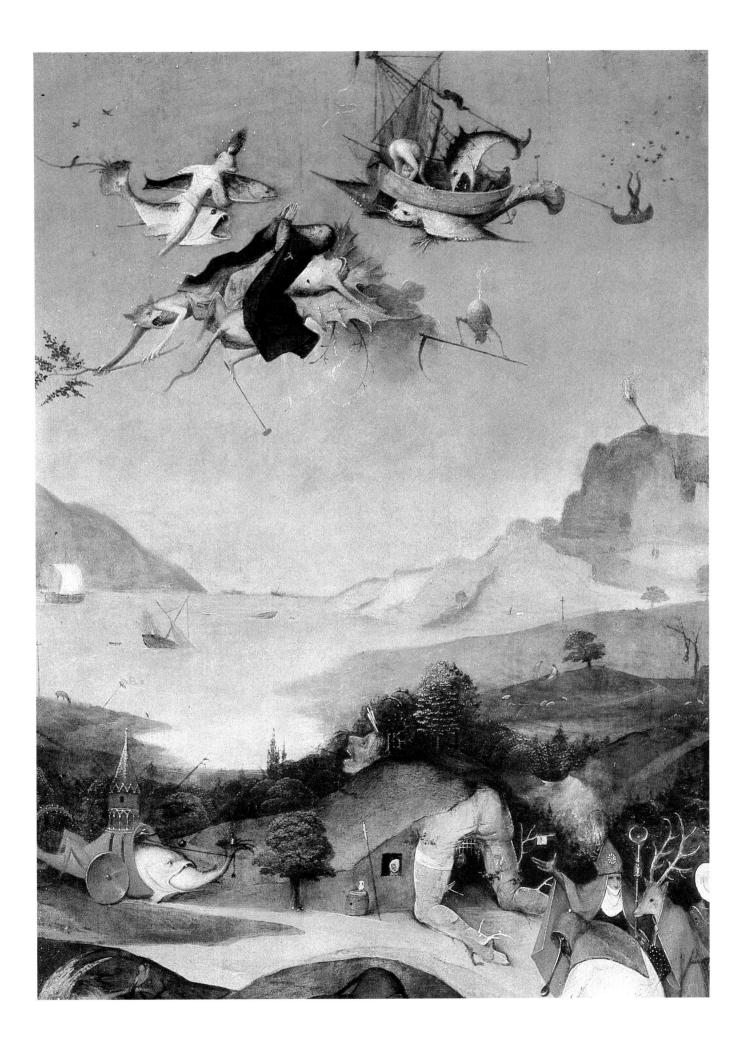

The Temptations of Saint Anthony

(detail of the central panel)

at prayer, entered into an ecstatic state and was transported into the skies. But there the good spirits who had seized him aloft were opposed by frighteningly enraged creatures of evil who wished to bar the way to Anthony.

It is this portion of the text only that Bosch chose to illustrate, reducing the saint's glimpse of the beyond to a fight with demons. But even that is less horrible than menacing, and therefore more a spiritual trial than a physical ordeal for the unswervingly devout hermit. In the lower part of the same panel the unconscious saint is dragged away by two monks and an elderly man, and in the middle plane the eye takes in both the lower reaches of the sky and an earth delivered over to all sorts of strange disorder (page 71). Here Bosch proves his great imaginative power. What happens in the heavens likewise oppresses the land below. In the bay there are realistic disasters, with sinking ships. On the mountaintop burns a gigantic torch: who planted it there and now lies in wait behind the mountain to perpetrate more deadly acts? And who shot a thick arrow into the brow of the poor giant who has crawled so painfully between house and hill? Is the giant himself only evil, does he illustrate punishment meted out to the foolish, or is he rather the victim of dangers not revealed to us? All writers on Bosch agree in seeing in all deformed or monstrous figures, this one among them, no more than a symbol of sin and unrighteousness. To me, on the contrary, this giant provides the occasion for an observation of some consequence, namely that Bosch tended to see the world more as subject to mad misproportions than as ruled by sin.

Long before Gulliver and his travels, Bosch painted as if convinced of the disproportionality of the world. Though this may give rise to evil, Bosch nevertheless never flatly viewed the world under what Tolnay sees as the sway of evil. For one thing, his pictures were always meant as warnings against evil, in the same way as the life of Anthony, as recounted by Athanasius, involved a constant coming to terms between the personal rigor the saint strove for and his fear of the confusing influences that came to him from the world. So it is that here (pages 71, 73) men with all their signs of rank march side by side with others dressed like men but with animal heads or enigmatic, caricatured faces. In like manner is the fish that swallows another and rolls along overland on feet and wheels like a caterpillar tractor, and whose hindquarters end like a scorpion's but seem really to be more like some ingenious contrivance in metal (page 71). What appear to be wheels are, in fact, armored shields, and while the beast is by and large metamorphosed into a typical fifteenth-century wagon for the transport of arms, nevertheless it bears on its back a pointed church steeple. Is it important to know if this armored fish "means" envy, lust,

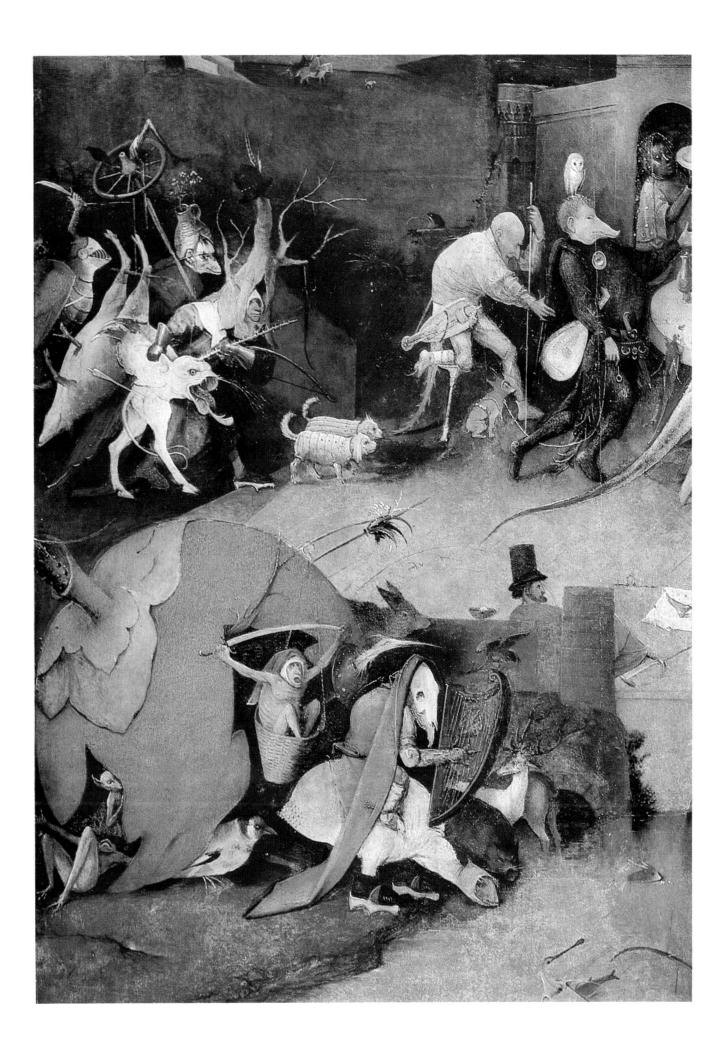

(detail of the central panel)

or contempt for the Church? The fact that such signs are meant to disconcert us and, wherever they appear, to signify lack of measure and proportion, is surely enough, and especially because the images Bosch invented sprang fullgrown from his head without predecessors or prototypes.

If Anthony is scarcely conscious here of being ravished into the heavens, in the central panel he finds himself hemmed in between two dramatically radiant personages who mete out some sort of drink or potion and those frightful misshapen creatures who are present here in increased number (page 75). There he is fully alert and unmoved. Some unholy ritual is being forced on him. The setting is not what one would expect for a religious fanatic but is, in fact, the ruined fortress on the Nile that he elected for his hermitage. Now it is under attack. A crucifix may stand in the ruin of a tower, but what goes on in its proximity is not veneration but blasphemy. There are no obvious signs of resistance or opposition. Hard pressed and helpless the saint may be, but he is not about to surrender. He holds fast and, Castelli tells us, has attained that insensibility which comes through mystic contemplation and constitutes its unique strength. whose goal is not defeat of an enemy but self-control, and which aims not to triumph but to stand firm, nothing more and nothing less.

This is how Bosch painted it. The terrain, in Tolnay's description, is a magical space less subject to the law of gravity than to the power of attraction between things. Looking at the center of the picture where the saint is kneeling, the landscape itself turns out to be an even more rigorous ordeal than the retinue of monsters, some bloated, some starkly maimed, which look as if swamp or parched wasteland could have produced them by spontaneous generation. This place is no fortunate isle but is rather a kind of jetty beneath which the waters flow, and which itself floats perilously between mold and flame. There is a glitter over everything, though whether it comes from fire or from putrescence one cannot say. This is the strait gate where there are no more choices, nothing to do but hang on. And this then is the meaning of these temptations: not an unleashing of demons without limit but, far more, the testing and establishing of the limit that the tempted saint himself constitutes by his self-mastery and endurance. And so the horrors of Hell meet their master, learn that with this man they cannot do what they please.

How much further Bosch went in this picture than in all his earlier ones is shown in the fact that here the Devil himself is no longer a presence. Temptation is neither Hell nor Last Judgment. The monstrousness of these weird beings is of this world. All living creatures conspire in its making. So the wild eruptions that surround Anthony are

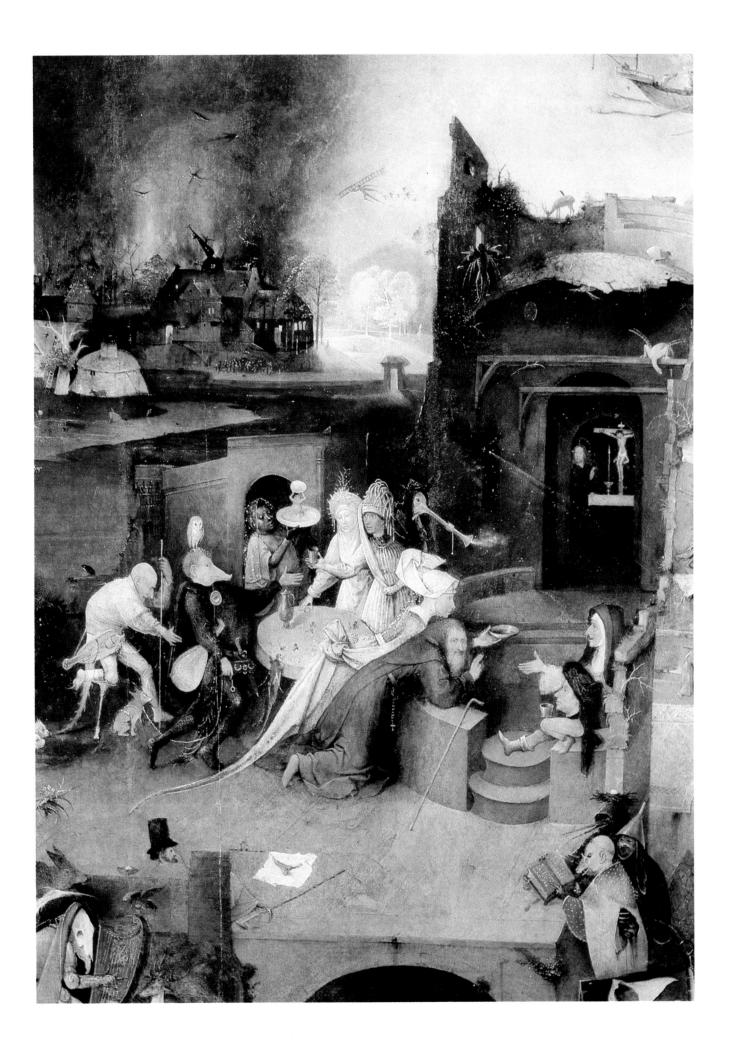

(detail of the central panel)

not fancies of his brain but realities he knows all too well. though set down here in the form of riddles. The man with stovepipe hat and the pig-headed sham priest mumbling his psalms from a blue hymnal are not makers of hallucinations but makers of mischief, Anthony's opposite numbers, spawns of evil who, disguised to pass unnoticed as men, every day and everywhere in the world do whatever harm is in their power. But just what can they do? They are always ready in pursuit of their own happiness but, even more, to track down that of others, to disturb it and do away with it. Finally that obdurate madness is reached in which no one knows any more how much of it all he crams into himself; and yet everyone does it, each behaving as if he lived only by and for himself on a silent, lifeless earth where it has become a matter of course to grab and smash and overthrow whatever one may come across. That nonetheless, along with this, survive other individuals whom the world casts out, who set before our eyes misfortune, undeserved disfigurement, deformities, the misery of feeble-mindedness, would at first thought seem virtually miraculous. But it is precisely this that dulls the perception of those who are not themselves thus afflicted, and who in consequence can look more casually at some place in the world which is safe for them, or at least offers them the illusion that they might be able to dwell there unmolested.

This is what lies behind the great procession that sweeps across the entire picture and holds up to our gaze startling but gloomy specimens of utter woe alongside arrogantly smug living horrors. The enigmatic images of the temptation let us perceive behind them the war of all against all, but also the self-righteousness that insists on drawing a discreet curtain over everything wrong. So for Bosch it is not the world that is evil but only individuals, and it is they, and their deceitful phantasms, that he paints, not the allpervading activity of a wicked world such as is imagined by the narrow mind of many an ascetic. On the other hand, whatever is truly weak in that world falls prey to disorder as to a gang of robbers. It is this alone which shows itself as evil, this alone can be warded off, and by nothing more than an eye that does not fear to look on it. Anthony turns his back on the perfervid panoply of this anti-Christian ritual to look instead, if Baldass is right, out of the picture and toward the inmates of some Antonite hospital for which this triptych may have been painted.

More than in any earlier work by Bosch, this picture floats on unsure ground. Even without this it would still be a tissue of ambiguities where the strangest things are glimpsed behind and through the legend of the saint's temptations. There are pictures within pictures, such as the Old Testament scenes on the round shaft of the tower built

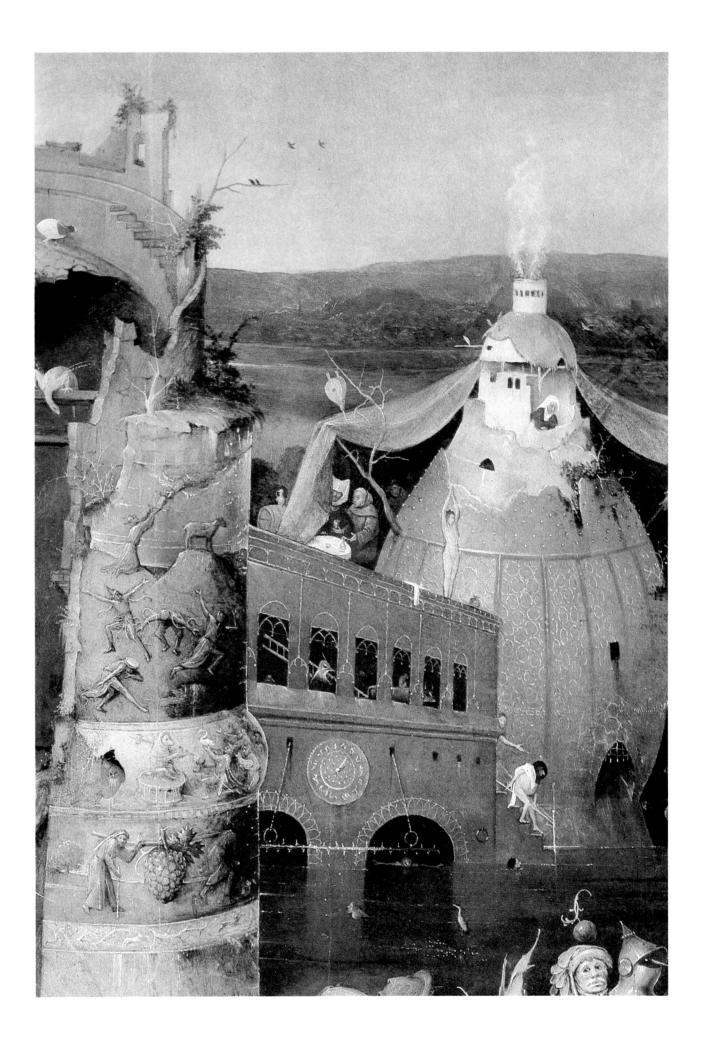

(detail of the central panel)

over water, which is connected to a covered arched bridge where phantasmagoric things go on that seem scarcely in any way connected with Anthony and his trials (page 77). Noteworthy parallels with the astrological imagery of the time have been detected by C. D. Cuttler in both structures as well as in certain generalized figures in the cortège that approaches them. However, the confusion that partly harass-es Anthony, partly spreads away from him into infinite remoteness, proves itself to be truly menacing through a single, but often repeated, motif: the receptacle form husk or bowl or vessel—which disquises, locks away, or opens wide whatever its content may be. Hocus-pocus and solid fact make for an ambiguity that permeates the entire picture. The tower before which the action is played is typical of this, partly opening up new vistas, partly leading into darkness. In ruins, moth-eaten with nooks and crannies, the tower is encased in a shell or peel of reliefs where one sees scouts returning from the Promised Land with a gigantic cluster of grapes, a heathen sacrifice, worshipers dancing before the calf of gold, and Moses the lawgiver: episodes showing that there was a time, long ago, when good and evil could still be distinguished from each other. The ruin itself already half takes on the disturbing receptacle-like form, the unsure covered bridge leads away into a glassy, fragile, thin-walled darkness, an edifice that has something of both a vessel and a cave, and defies the viewer to decide if it rests on dry land or floats. The egglike tower, from whose cracked top emerges a cupola with cylindrical lantern, wears a casing that seems to cloak still more obscurities.

But description can do no more than make clear the significant part that the constantly recurring shell or bowl or husk form must have played in Bosch's fancies. Present already in earlier pictures, here it becomes strikingly evident. There are a number of dead trees encasing something living or already marked down for death. The form, striking enough in itself, must have had for Bosch a special meaning difficult for us to unravel. At the very least it must be connected with that bi-tonality, that ambiguity, which hovers between concealment and disclosure, between deception and truth, and is a source of the suspense haunting most of his pictures. It denotes, however unclearly, the skepticism with which the artist sought his own stance between the discarded medieval fear of demons and the unbounded enthusiasm for a world yet to come.

Unsteadily and all at sixes and sevens, an armed cavalcade makes its way through the water (page 79). In their midst, sidesaddle on a gigantic mouse, a woman encased in pared-back bark and pale as a cadaver clutches a corpselike infant in her arms: is she in flight, kidnapped, or can this be a parody of the cortège of the three magi?

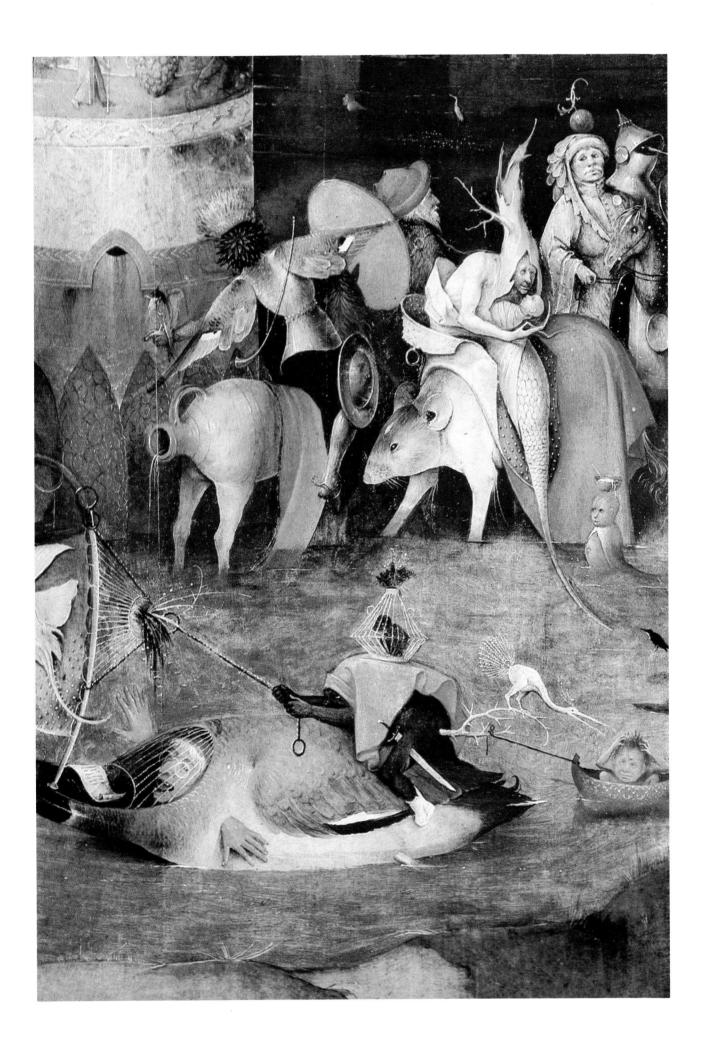

The Temptations of Saint Anthony (detail of the right wing)

On the right wing the action takes place, as so often with Bosch, mostly in water or at least lapped by it. In the distance gigantic, bizarre, fortified buildings come right to the water's edge, merely fantastic inventions on the part of Bosch no doubt, but not unrelated to Islamic architectural forms. Is it the city to which Anthony was led, as the Vitae patrum tells it, by the "Queen," a demon disguised as a beautiful woman, whom he had watched bathing in a stream deep in the desert? This is what at least one commentator thinks, but it might just as well be meant to recall Alexandria where, according to the biography by Athanasius, Anthony effected many miracles. More striking to me are the hordes of warriors (likewise identified in the biography as a diabolical apparition) because this would make the city the locale of the saint's ordeals. None of these possibilities can be proved, though the flames bursting out of the beehive cupola do make the third of them more likely.

Where, however, is there any temptation in this wing? Not, I think, in the hollow tree transformed into a tent by the drapery hung over it (page 81) nor in the table (page 83) where three nudes—come a long way from their classical model—busy themselves with stunts of trumpeting, balancing, and swordplay. The naked woman in the tree is no temptress, but rather, in alliance with the old woman in the scalloped headdress, a participant in a fertility rite, perhaps to create the homunculus, as Castelli has proposed. The table is certainly no symbol of high living or self-indulgence here, and the three nudes are not likely to be demons if only because one of them has had his neck run through by the dagger of an animal-demon. Anthony sits turned away from all this, sheltering in his mantle as if within a cave. His entire pose and manner recall the early-medieval depictions of the Evangelists, so he seems more a saint inspired than a victim of temptations. So this Anthony—the third, as it were is removed from the turmoil of temptation and can be said to embody a backward glance over the entire triptych.

Look backward as he may, our own eyes traverse the three wings in the opposite direction, from left to right, to meet his where he sits quietly on an outcropping of rock, and in their progress they take in also the landscape from above downward, with its roads and bodies of water. The half-light, brownish green and brownish blue, swallows up all shriller tones of yellow, red, and stony gleaming blue. Here we are in the country of magic, whether it be that of chthonian cults or, as Combe thinks, of the alchemist's arts of metamorphosis. Only high up, in the farthest distance, do we sense a land unenslaved by sorcery. On this right wing, behind the two strange cupolas, there lies an ordinary, everyday Netherlandish town. And so the triptych concludes in retrospection and meditation. Whatever one finds in it, it

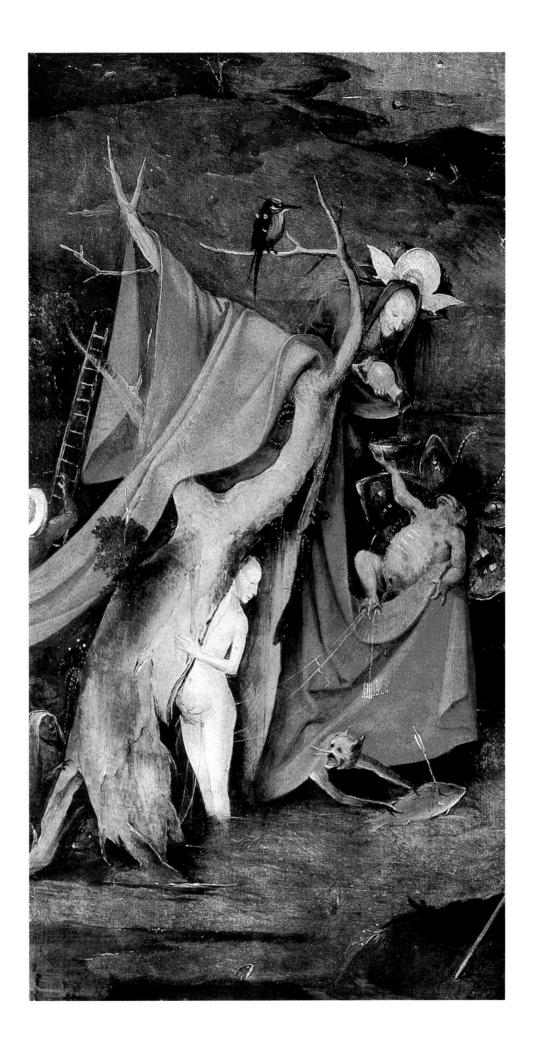

(detail of the right wing)

has less to do with vices than with human misery and fears. And least of all does it aim to attack the superstitions still widespread among the folk. Rather it is a reminder of the example of the hermits and monks who, long before, had been the first to triumph over the chaos and confusion of worldly existence, which was a lesson not uncalled for in Bosch's time, in those decades before the Reformation.

When the triptych was restored in 1970 the results were not unexpected, though nonetheless admirable. Certainly there could be no major change in aspect, since at no time was the picture ever seriously damaged or repainted, except for a few places in the foreground. But the real color was revealed, and every bit of this many-sided painting showed itself once again to be wholly permeated with light and executed with a finesse as enchanting as it was unsuspected. The special quality of this work had always been recognized to be the way its scenic setting flowed gently back and forth in wavelike curves through all three panels. Now it could

be seen that this was not merely a matter of the overall grayish green ground tones over which sharper colors were laid to make the figures stand out. Apart even from these, now one sees surging and lustrous waves of color often illuminated by their own shimmer or lurid gleam. Entirely unexpected was the quality of the distant landscape on the left wing, humidly blue and yet transparently lucid in its finest details and with a wonderful yellow-greenish flow across the surfaces of water like a sheet of algae (page 71). Here yellow itself plays a special role, replacing the gilt backgrounds that had by and large been abandoned by then. The almost rectangular mountain with the blazing torch at its summit stands greenish blue against the sky, while the ground at the bridge is of a bluish gray almost like water. Most remarkably, a grayish blue tonal film covers the surfaces right across the middle panel and into the upper half of the right wing. Yet, for all that this tone tends to envelop everything, when it touches certain details of the parade of cripples it gives them real definition and reinforces the gray, and when it goes over to a gray-blue stony tone it affects portions of the architecture in the same manner.

It is precisely this tendency of a thin film of tone to attract other tones on surfaces that were considerably duller before cleaning that now makes it possible to consider the unbroken broad expanses in the left wing of the Vienna **Last Judgment** (figure 42) as not so untypical of Bosch as has been claimed, though it is still not certain to what extent they have been repainted.

Most fascinating, however, especially on the right wing here, but somewhat also on the left one, are the moldy moss tones shot through with rust colors. The hollow tree sheltering a naked woman on the right wing (page 81) is painted in such a way as to make it seem that Bosch was already in full possession of the forceful painterly approach characteristic of the sixteenth century, though the triptych dates only from the very outset of that century. Without suggesting direct influence, one is put in mind of Baldung Grien or the Altdorfer of the paintings on the legend of Saint Quirinus. Well before both those artists, Bosch was impelled to paint in this way, juxtaposing the mysterious monotony of grisaille with luridly etched or flaming colors. This was exactly like those German painters who drew away from the chaotic use of color typical of the Late Gothic period and set themselves against simple objective realism; in spite of which, in their approach, all objects were rendered in a hard and sharp manner, never passively and dully but always in full, bright light. It is in this respect that Bosch and Altdorfer invite comparison, although their similarity really involves no more than a basic approach to certain elementary principles, and there was no influence in either direction.

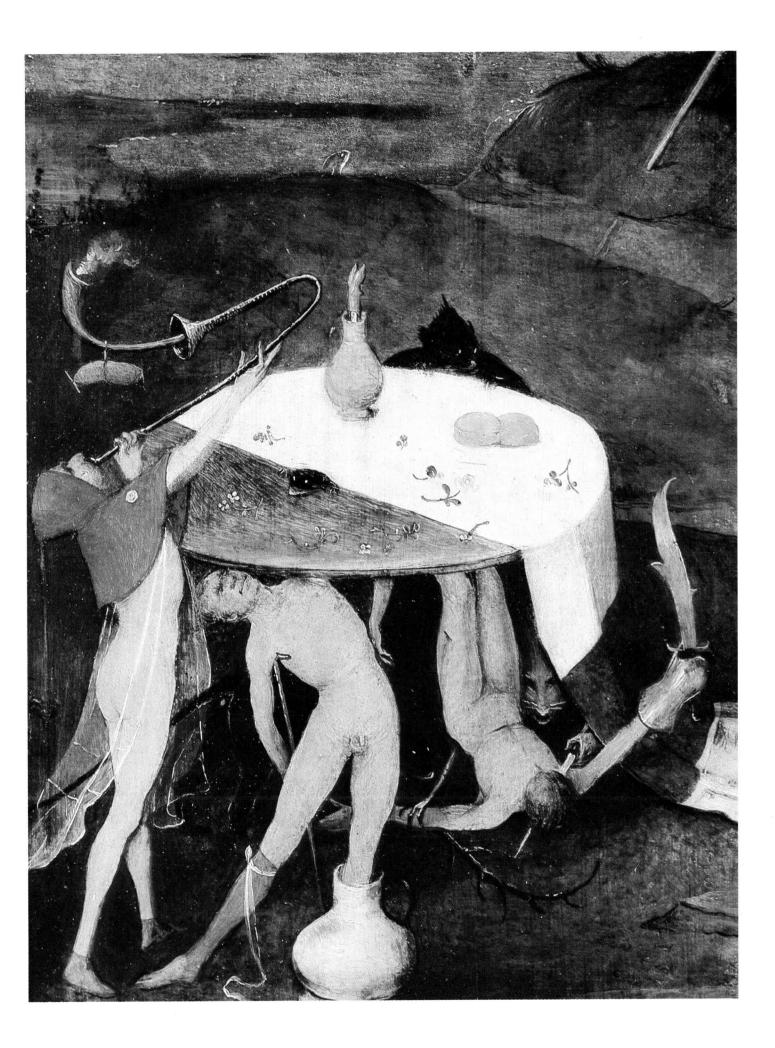

The Last Judgment (central panel)

This is certainly the Last Judgment, but it does look as if practically no one passed the test and was saved, except for a couple flying heavenward and one man whom an angel rushes away to safety from the arrows of a black devil. According to both Biblical and artistic tradition, when the Last Judgment is visited upon the earth, the dead arise and are separated off as either saved or damned, but neither Hell nor Heaven is the actual locale of judgment. Here, however, the only nod to the standard iconography is the solemn apparition of Christ as Judge surrounded by angels and saints in a night-blue sky barely touched by dawn. Even in that there is a minor alteration: the Virgin and Saint John always fulfill the function of intercessors for mankind before the throne of the Judge, but here they are relegated to a post behind and above him. But that also has its meaning: the time for intercession has passed. On earth one sees nothing of the terrified astonishment that must have greeted the word of the Judge, though it was spoken no more than an instant before, and already his command is being executed in the direst and most terrifying manner.

What we see is not Hell, so it must be earth doing duty for the grimmer place. And once again Bosch has smashed a pictorial tradition, converting it into a depiction of every conceivable form of violence. But violence has been on earth from the start, and the verdict of the Lord is only the period placed at the close of human history, which itself has always been full of the very things that make up Hell. The conception may still be Christian, but it is strangely altered. For ages the Last Judgments on the walls of churches had made much of frightful and grandiose monsters, but whatever horror was done was at the orders of the Power beyond earth. This would seem to be so here too, since Christ thrones over all. But here, for the first time, Bosch leaves the condemned mortals alone and face to face with terror, to endure martyrdoms such as would seem to be among Hell's fiercest punishments. In Bosch's depiction, however, there are no devils, only humans disguised as monsters. Therefore there is no one to call a halt to this reign of terror. These are no longer targets for temptation but sinners delivered over to punishment, and for the last and irrevocable time. Thus Bosch painted a place of torment deliberately without wishing to make it clear if it was Hell itself or merely hell on earth. Only on the right wing do we see the real and official Hell, indicated by an arched gateway under which stands the head devil in person (figure 43).

The terrain seen in the central panel plunges mountainously down before us, steep as stairs. Yet it is no infernal pit but, instead, a hill country with numerous concave terraces, traversed by valleys, dwindling out into broad sheets of water, and all of it shot with hissing fires. Again we have a

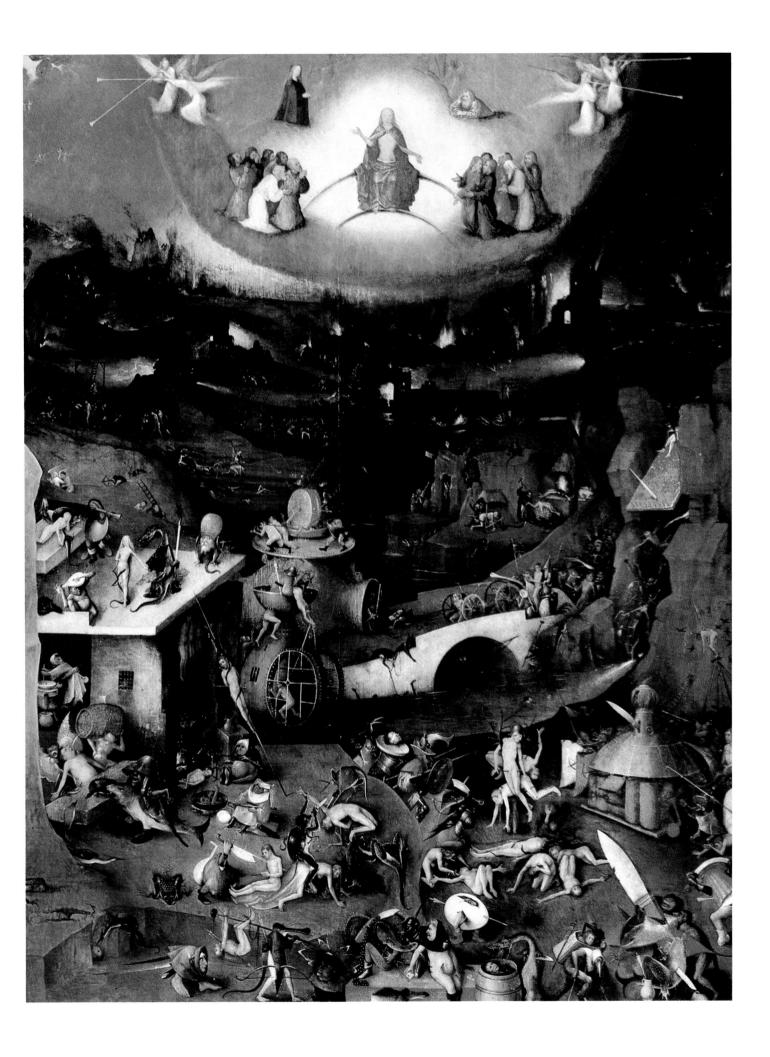

The Last Judgment (detail of the central panel)

war of elements, as in the right wing of The Hay Wain. which likewise was difficult to identify with certainty as Hell. Here, though, one thing must be sure; consumed by fire. lapped by waters, this is still no more than a land of infertile rust-brown clay. There are unsafe islands of clay, and a gorge coming down from the right and ending in a bridge becomes a passage through which condemned sinners are driven. Directly next to it others are pushed through a cleft, where they are then lifted up by a millwheel fitted out with tall spikes which drops them helpless into the water. Above the cleft hangs what would appear to be a trap door poised to fall, rather as in The Hay Wain, though there those who passed under it could still hope for escape instead of the watery end they have here. Nevertheless, for most of the sinners the agony is more protracted. Here the art of creating anxiety-arousing images is different again from that in The Hay Wain. Nothing is hidden away out of sight; those who might nourish false hopes cannot even pretend not to know what lies ahead. Here it is no longer man against man, here man is delivered over to monsters and their machines of martyrdom.

As the eye travels to the foreground the picture becomes increasingly a kind of industrial landscape and vast arsenal. and nothing of what happens there is in the least reassuring. The arts and crafts practiced are those of torture. Thus one recognizes in the blue house on the left (page 85) that certain capital sins are illustrated there along with their predestined punishments: a gluttonous fat man (page 89) is forced to drink well beyond the point of disgust from a barrel of freshly made latrine sewage. And, as if that were not enough, at the stone table in front of him gather repugnant creatures intended less to punish the sinner than to upset us as viewers. We react not with fear but with revulsion when we see a fish, bestridden by a loud-mouthed. behelmeted storm trooper consisting only of head and legs, as it greedily sinks its teeth into a lizard or toad, the more so when in addition to fins, it sports two legs firmly planted in sturdy shoes. Interestingly enough, most of the monsters, whether dragons carrying tall candles or birds with trumpets for beaks (page 87), are shoed and booted. On the flat rooftop these hybrids surround voluptuaries who, strangely, appear less frightened than perplexed.

Nature disfigured seems itself already a kind of punishment, at least for us who look at the picture. Not so much punishment, though, as warning against immoderation and indulgence to the point of satiety. Here one senses clearly that, without glossing over the humorous aspect of it all, Bosch is nevertheless duly respectful of the mysterious and supernatural. No matter how far they deviate from nature, the numerous amphibians that dominate the picture move

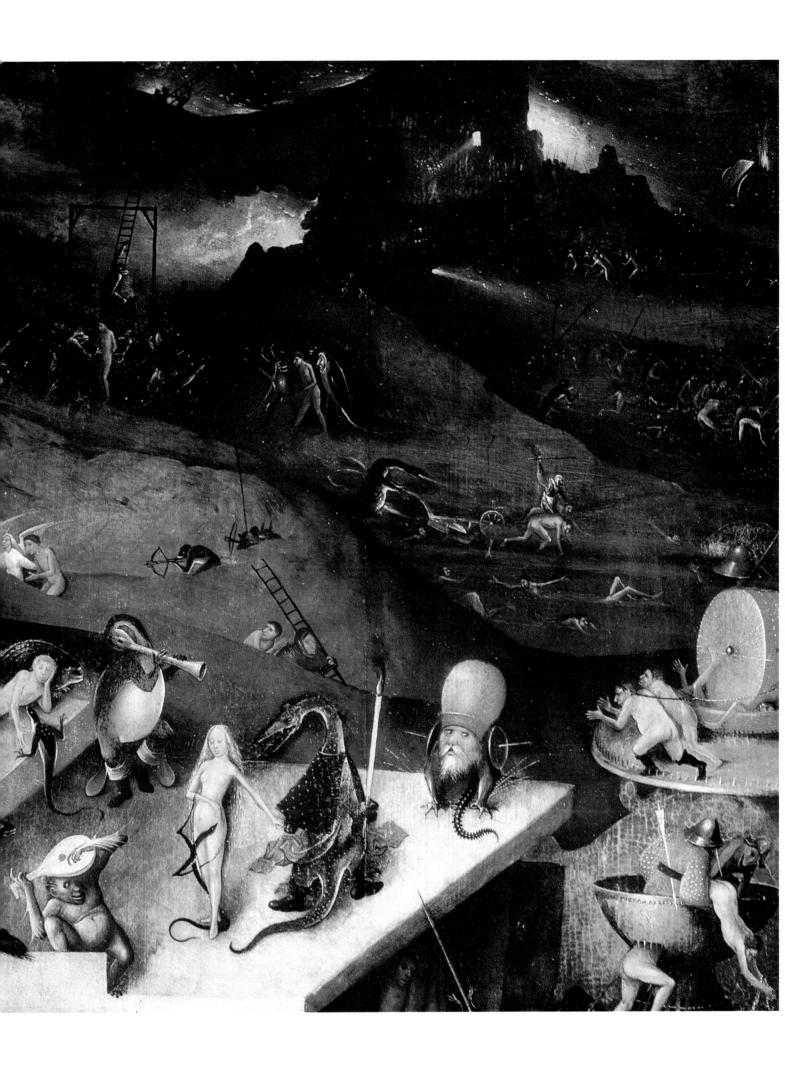

The Last Judgment (detail of the central panel)

about like true cold-blooded animals. It is not that they themselves inflict torments but that they are signs of direst apprehension. Other monsters—those compounded of insect forms, weapons, and menacing mechanisms, or else trunkless crawling beasts consisting of nothing but head and legs—are the ones who kill, running their victims through with sharp instruments. Sometimes they lurk in hiding, as in the house made up of thick green tree trunks and having an upside-down pot for a cupola, from whose lantern a knife blade sticks up like a guillotine (page 91). Nor in all this should it be forgotten that even the ground, humid and stoneless and as if cut up by the knife and rising high at the left margin like a termite mound, is itself an instrument of death: some are condemned to be buried alive in it, and often only a hand stretches out in supplication.

All this becomes so much worse on the right wing [figure 43]. There the infernal torment becomes outright execution. This is seen in two things: in the all-too-visible despair often voiced in an open scream, and in the various immensely huge monsters who either swallow down or burn everything in their way. The landscape is traversed by hordes of onward-rushing humans and even a ship that will never again sail the waters. Here and there one might think of the traditional scenes of punishment in Hell, but there is nothing old-fashioned left in this most magnificent, most starkly individual, outpouring of inventions that Bosch ever devised for any of his Hells. This is true also of the central panel, though it is much more accentuated in the right wing.

The opinion is widely diffused among experts that this triptych cannot have been painted by Bosch himself, but only by some very accomplished copyist—a notion helped along by the fact that in several places the picture has been repainted (and at an early date), while in others the layer of paint appears to have burst open. On the other hand, the changes, second thoughts, and reworkings that Münz detected when the painting was cleaned in the 1950s are strong evidence against the hand of a copyist. If it were only a matter of the really exaggerated number of tortures depicted, one could explain them as a tendency on the part of an imitator to compile a virtual anthology of everything found in Bosch. But the inventions here are so incisive and arresting that no imitator could have conceived them, no matter how much he might have delighted in the curious and bizarre. Nor can I concur in Tolnay's dismissal of certain details as lifeless and therefore worthy only of some hypothetical skillful copyist. One need only look at the lower middle of the central panel (page 91) where, behind the foremost wavelike mound of earth, three armored creatures ride out in a cavalcade so determined and wild as to be comparable only with the one in the Lisbon

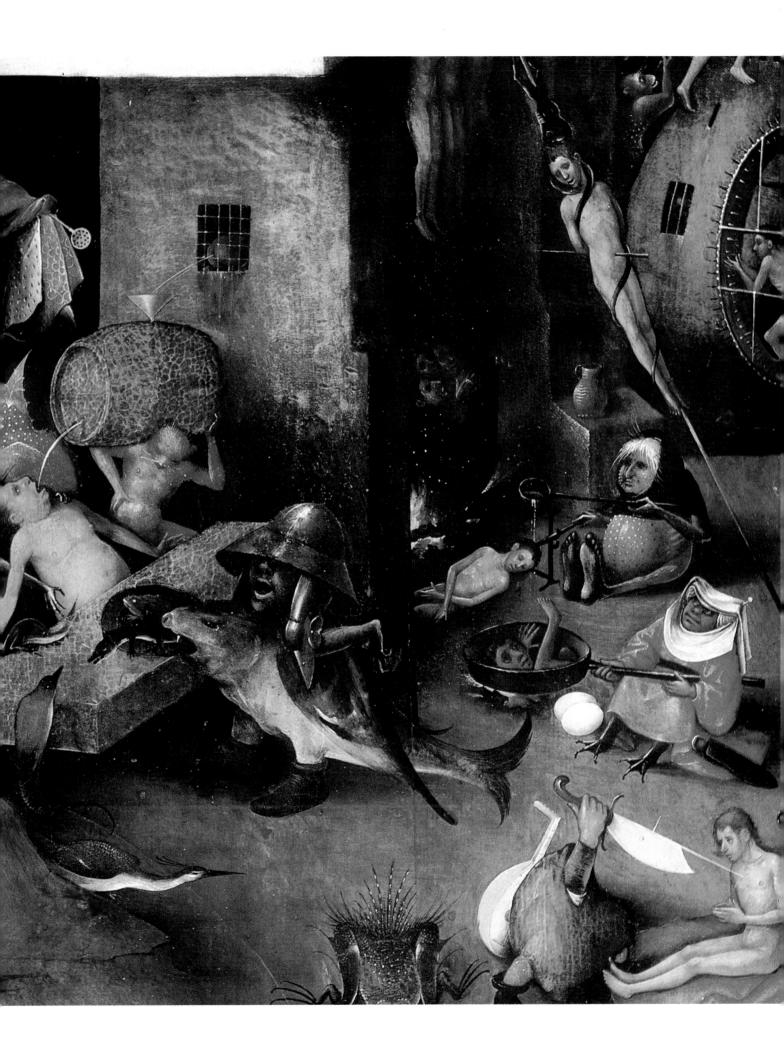

The Last Judgment (detail of the central panel)

Temptations of Saint Anthony (page 79). The trio are astride an animal wearing a red blanket or shell from which emerges a blue turtle head. They are not so much aiming at something in particular as giving vent to their great energy. Their spears are at the ready. The foremost knight, blue-faced, sports a red hat whose crown turns out to be a rat's head looking upward and gulping down a fish. The two other heads are in closed helmets. On top of the second one sits a round blue disk on which lies a decapitated gray head with bandaged eyes, and astride the third helmet sits a sharp-beaked bird (not seen in this reproduction). Before them runs a naked, fat, helmeted guard wielding a chopping knife with an arm that grows out of a bird. Whatever additional repainting may yet be detected, here form and invention are equally impressive.

The broad, flat surfaces of the left wing, the Paradise (figure 42), are however so untypical of Bosch as to arouse suspicion about their original state. To my mind at least the treatment of these flat areas and the baked-clay color of the rocks accord perfectly well with the landscape in the central panel and also anticipate the thinly painted, shelllike surfaces in the artist's later works. Hence the date we propose: soon after the Lisbon Saint Anthony. Other possible evidence for that dating may be the gray sea with its lightgreen shore. Finally, I cannot conceive that a copyist could paint the combat between the angels which God the Father gazes down on while the Son (as later in The Garden of **Delights**) is himself dispatched to institute the short-lived covenant with mankind. This war in Heaven is most extraordinarily rendered in grisaille. As always when Bosch painted in gray, here again he avoided any impression of stony immobility. Generally he reserved gray for any decisive event or action taking place within a confused or obscure context. Thus it is that the first damnation occurs in the midst of rain and hail, and the angels become a gray plague of insects. With Bosch gray is always a constituent factor of reality itself and in no way detracts from that reality.

All considered, it seems to me clear that only the very slightest doubt of Bosch's own hand in this picture can remain. Among the doubters I find arguments that are not demonstrable, while the claim of authenticity that Friedländer made a good while back seems to have become more and more accepted.

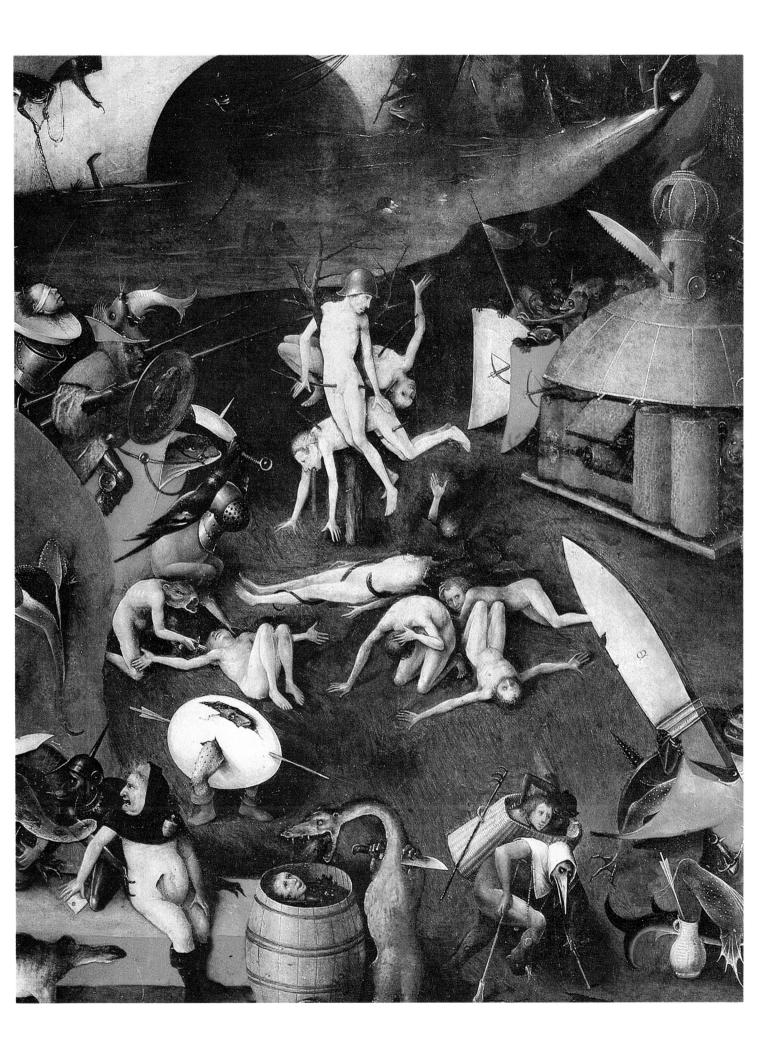

Saint Jerome in Penitence

The fact that here the saint is no longer portrayed as seeker or scholar suggests that Bosch had moved a step further both in iconography (Tolnay considers the face-downward stretched-out figure of Jerome to be an innovation by Bosch) and in the conception of landscape. The remote and tranquil land reaches farther into the foreground than ever before. Nonetheless, there is a zone of darkness, almost a gulf or abyss, before the eye comes to the principal scene, which is itself thickly and rankly overgrown, as if to show us explicitly

what nature is like viewed up close. Within it—imprisoned in it—lies the saint in the midst of all sorts of objects strewn around or cast away, among them the cardinal's mantle and hat that legend says he earned later, but also the book he abandons to embrace the crucifix. Everything lies at random here and is, so to speak, enclosed, embedded, in some way shut off: the deeply shadowed purple-red of the burst-open fruit in the water, the sunken moistly saturated green, the toy lion lapping at the water, and, below the erratically heaped-up rocks, the wasted body of the saint himself lying as if within a mussel-shell of earth. Though presumably in a meditative state, the praying saint sprawls on the ground as if himself cast away like everything roundabout him, prey to doubt and struggle. What may be expressed here is something to be read in his biography, the tension as well as the dispersal of effort that marked his life. Compared with the Lisbon Saint Anthony and also with the Jerome in the Altarpiece of the Hermits (figure 44), here the saint has more clearly shaken off his helpless perplexity and gone to the ultimate consequences of absorption in meditative thought.

But there is likewise a new vehemence and intensity in Bosch's approach to painting. His paint—up to now so morbid, translucent, and vibrant—is increasingly transformed into color phenomena that give the impression of being not plastic but heated through and through and solidly fused. Mineral and succulently soft qualities interpenetrate. Everything stonelike seems split through and penetrated by natural growths. What I described above in a more objective context as "strewn around or cast away" appears elsewhere in the picture and proves to be a new art of spreading images out before one's eyes. This dispersion, however, is contrasted with the high-piled and interwedged plant and rock forms that make of the left side of this picture a virtual tower of imaginary natural elements. The use of vertical forms in alternation with a broad, flowing dissemination of elements is already in essence the visual principle which was to find endless labyrinthine ways that literally burst with images in The Garden of Delights. Here, though, Jerome is still the central and distinctive element. Yet the promise of things to come, the first germ cell of Bosch's stress on infinite pictorial imagery, is already plain to see. The aspect of such figurations was to become ever more diversified. This picture even has a kind of face in the animal skull, before which stands a tooth of rock twined over with wild vines, and this note carries over to the almost calligraphic thorns that crown its brow. All of which brings us to date this picture at the beginning of the sixteenth century, close in time to The Garden of Delights, as Combe also recognized.

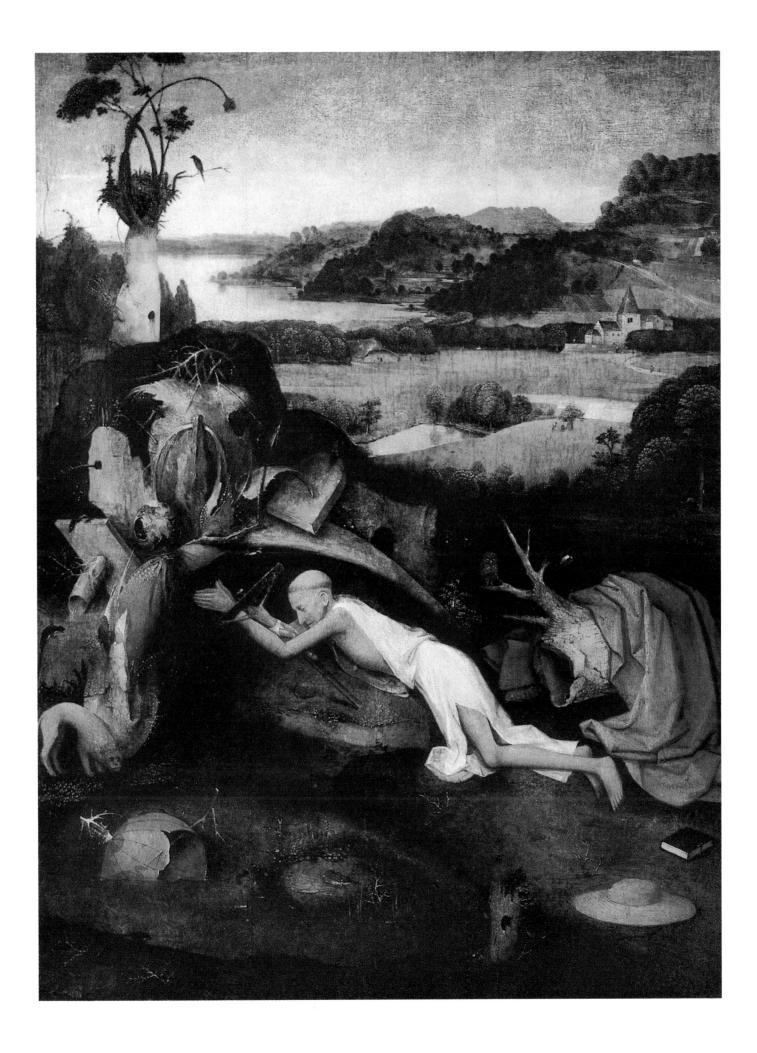

Saint Christopher with the Christ Child

In Bosch's fantastic world giants do not count among the monsters. In any case, as the Golden Legend tells it, Christopher was a quite unmythical giant and, indeed, not too bright nor even aware of having any special and superhuman strength. Incapable, deep down, of standing on his own, he could think of nothing better than to seek out for himself the mightiest of masters. But each time one of those great powers evinced respect for another he was disappointed, gave notice, and looked elsewhere. This was the total extent of his independence and so he became a seeker, a vagabond. Until one day a hermit counseled him to serve in another way: to betake him to a great river and there help the folk across—at one and the same time ferry and ferryman—because not otherwise would he find the truly mightiest of all masters. And so it came about, and the Child he carried across was the Master of Masters and on his shoulders weighed "heavy as the whole world."

What intrigued Bosch was the enigmatic side of the story rather than the addition of one more to so many portraits of the uncouth, but good-natured, giant. With Bosch, the man who towers above the landscape is gentle and circumspect,

more thoughtful than merely glorying in his own strength. Instead of plodding stoutly ahead, he walks with that peculiar bent-knee gait that Bosch always gave to pilgrims and wanderers, as if the water were unsafe (though, the fact is, it scarcely ripples and hardly reaches higher than his ankles). But then, as Fraenger has pointed out, there is something weird about the murky green and stagnant water itself: unmoving as lead, it is the river of death. This is the new way Bosch found to paint the terrible stream which. the legend said, had brought death to so many. To my mind. one must recognize the significant fact that this is no longer a landscape of our living world. Certainly, the farthest reaches of the picture are made up of the shallow waters of a land lying close to the sea, and it is just such a land as Bosch himself knew. But the terrain to the fore, that overtowered by the giant, takes on a different aspect because of the many peculiar places and things along its banks. What are we meant to understand from the half-ruined farmstead where a dragon rears up from behind a wall? And the gallows-tree where a man is stringing up a bear? The Capuchin monk at the water's edge may be less of a problem and represent no more than a decorative note—yet what are we to make of the fact that what is presumably his dwelling is, in fact, a huge pitcher hanging in a tree? What we lack is the overall context that would bring all together. but this is a secret that Bosch reserves for himself in what we see is another of his riddle-pictures; nor are there any clues in Bible or legend. It is not enough to hypothesize that the fish may signify Lent, that the pitcher—cracked as it is—may refer to a life of idle vanity, as would likewise the dovecote and the beehive being raided by a greedy climber. Here even Fraenger could do no more than surmise and speculate. To appreciate the unique imagination of Bosch, we are obliged to take all these indications into account thus the large piece of bark that half envelops the dead crown of the tree, and which returns so often in Bosch's paintings, is another symbol. But for what? For concealment and suspense somehow or other, but that does not tell us the why and what and wherefore.

What remains is nonetheless a picture recounting a legend about the mysterious power that rules the world. The flying and billowing drapery of the Ferryman of Christ transforms even his unsteady gait into a single soaring movement under the weight of the Child. From that point the picture plummets steeply downward in a way matched only by the two wings of **The Garden of Delights**, where a sequence of events moving through time likewise leads the eye downward. Here, however, there are no halts in the continuity and the only scale of measure is the figure looming high above the landscape.

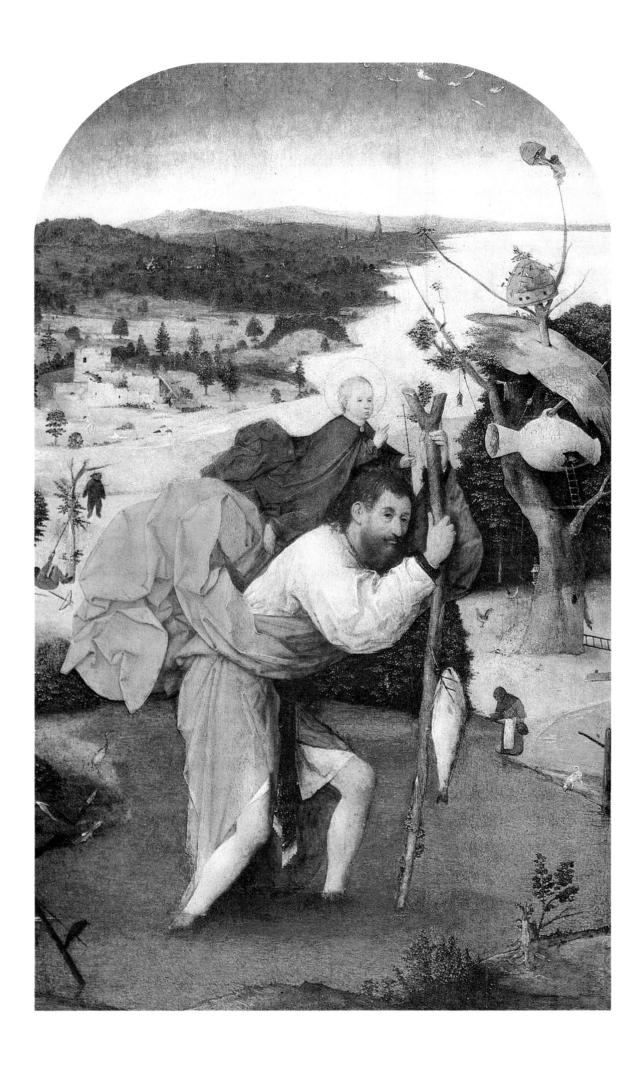

The Garden of Delights (upper part of the left wing)

The Garden of Delights is crammed with clues to what has happened or should happen, but despite the unflagging efforts of scholars to decode its sign language we can still read no more than isolated details. The picture as a whole in consequence remains even more a tissue of riddles. Should we take heart from the fact that a few of the hard knots have been once and for all unraveled? Or should we not resign ourselves to admitting that an artist who paints such pictures aims deliberately at a language that defies translation? Yet there is much value still, I think, in discerning and describing the purely visual aspects of even such an enigmatic work. Riddles may remain, because to look at, examine, and explain the picture in visual terms can be at most only a first step toward its interpretation. That there should continue to be such puzzles is, in fact, a tribute to the creative imagination and to that of Bosch in particular. As evidence that the problems are far from solved we can point to the fact that the triptych has had many and very different names foisted on it, from the early one of The Vicissitudes of Life to The Thousand Year Reich—the Adamitic realm of the future that Fraenger has professed to see in it.

Where one finds Paradise and Hell in this "garden" seemed obvious to its early viewers: in the wings. But then the question arose whether it is bliss that the central panel depicts or deprayed orgy. Whatever the answer proposed, the picture has continued to be no more definable and no less dazzling and distinct. And in one case as in the other the central panel—from which the triptych has always taken its name—must, in fact, be at best an intermediary step, an unsure and unstable interlude between two extremes, between the beginning and the end that we see on the two wings. It seems to me that our insight into this picture is not forcibly diminished by realizing that we shall probably never know for sure just what its true content is, and meanwhile each and every attempt to explain it is of some help at least.

Right at the outset one postulate must be accepted: that the ever-changing and never-certain way of the world is present everywhere in the triptych, if only by implication. Even the Garden of Eden is far from usual: it is not God the Father, the Creator, who is in charge here, but Christ who brings Eve to Adam. The latter, unlike his usual depictions, is already awake and beholds his predestined mate and equal. From the start, sight itself is made into a significant motif, and throughout the triptych it will be the most important act, of more moment than any other. Everywhere in the work the mutual gaze will be the clearest form of contact between individuals. Whatever happens, each time it is from sight—whether joyous and sensual or terrified—that it proceeds, and it does not matter if it truly takes place or is

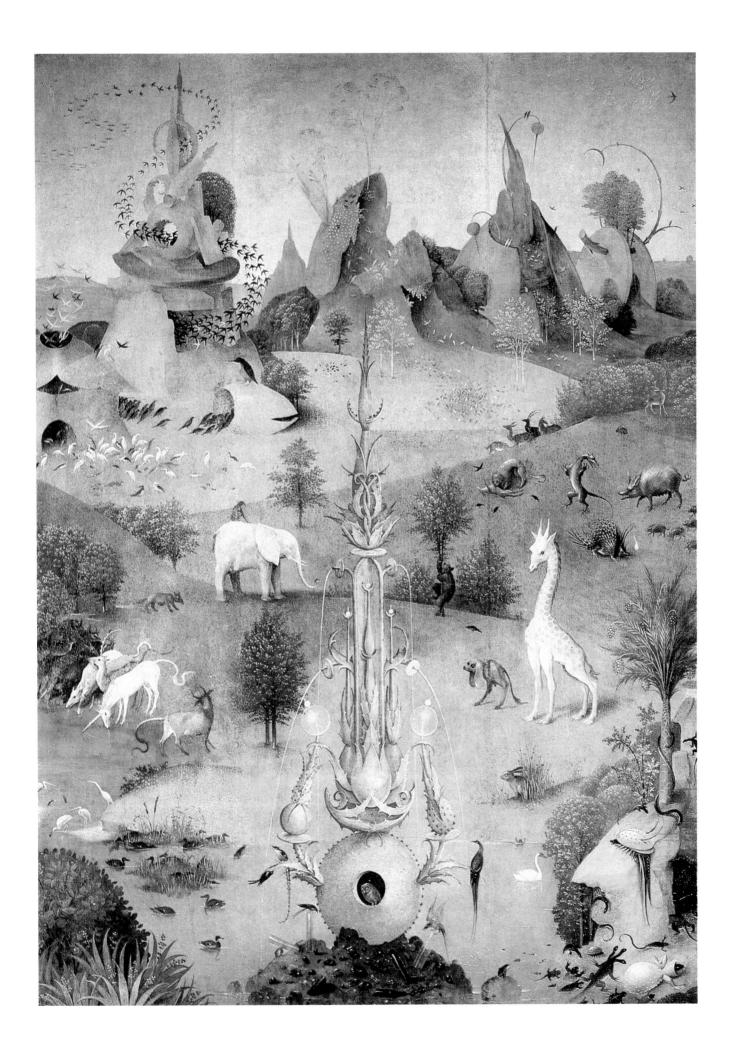

still in the realm of expectation. Indeed, expectancy lends its tang to all the movements, all the self-absorption, all the emotions in this picture which, throughout its known history, have been the cause that "delight" has always been associated with it. Thus, to paint in this manner the first pair of humans is to make seeing and desiring one and the same act. For which reason it is also significant that the sin and expulsion are not explicitly depicted in this Eden. True, there is a bizarre, swollen, exotic tree close by Adam, but it is more likely to represent a concentrate of all the trees of whose fruit the pair may eat with impunity. On the other hand, the baleful forbidden tree is a palm at some distance from them, halfway up the picture on the far right, encircled by a serpent and located in that part of the garden which, unlike the foreground, is touched with weirdness.

The entire background of this left wing is a landscape not without portents of the exile to come (page 97), most notably the presence in the midst of peaceable animals of others that are inimical, or are out for prey, or whose deformed appearance bodes no good: look at that long-eared, two-legged dog prancing around upright as man, and likewise the flesh-colored gleaming tabernacle (if that is what it is) poised on a hollowed-out millwheel and rising from the pond. Despite its vegetable form, it is so ingeniously artificial (Tolnay calls it "flamboyant," which is another justification for a late dating of the triptych) that one cannot help but think of the landscape around it as gripped in some unparadisiacal spell, an impression that becomes stronger the farther the eye travels into the distant background. There the mountains strike one as artificial accumulations if not outright constructions, not dwellings but already hollowed out as if to serve as refuges in case of need. Since man had never invented anything before the Fall, these strange heaps are here chiefly to testify to the artist's imaginative invention, and while one is guite naturally led to try to explain them, up to now no one has been able to detect any recognizable symbolism here except in those animals or grotesque monstrosities which are expressly emphasized. This sort of shell-like, receptacle-like edifice, however, remains here as elsewhere Bosch's secret.

In the blue distance rise prickly mountain peaks, but even they are given strange guise with smooth casings that seem to throttle them, or with sides that prove to be grinding mill-wheels. The forms themselves are storm-tossed: peaks shoot high like explosions that have ripped open the boilerlike casings to leave, still standing, edifices that are products of nature gone mad. But because this cannot be a true natural growth and its forms can scarcely have been chosen just to permit swarms of birds to inscribe lovely curves in and out of them, they are probably cautionary signs of what we

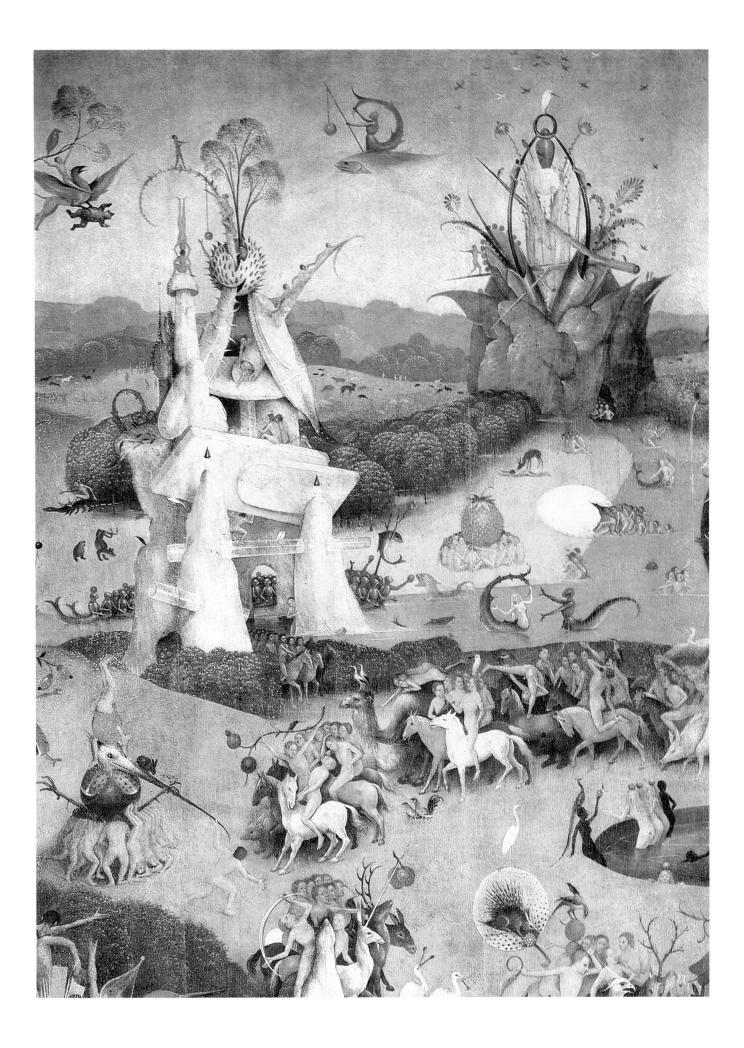

must be prepared to read throughout this triptych. Certainly, here already we must recognize the vicissitudes of existence that appear everywhere in these three panels and which are by no means always happy.

Nevertheless, for the time being there are grounds for viewing such fantastic constructions as embodiments of wishful thinking of a more optimistic, if not more selfassured, character. When we follow the horizon line of this landscape we find that it goes over without interruption into the central panel. This must mean that the action begun on the left wing is carried further there, in time as well as space, as we have already seen in two of the large triptychs. Here again there are constructions that serve to confine the action to the area running forward right down to the lower margin of the panel. These, however, are composites of new and thoroughly unfamiliar forms. By no means mere decorative accessories to the foreground scene, they are rather the origin and starting point for everything that is taking place. Moreover, here they are more like real buildings than natural outgrowths, though their reality is of the very nature of fantasy itself. Stretching out and up, and at the same time frozen static, these bold inventions in shell, glass, and crystallized, petrified vegetation are monument-like, threedimensional towers which, though they defy every rule of architecture, really could have been built, even in the past.

And this is true not only of the precisely spherical "house" from which rises a cylindrical tower, nor of the swelling, red, oval bodies mounted on it, which would seem to be fashioned out of modern synthetic plastics or could just as readily be internal organs ripped from some giant animal body, but also of the other four edifices, which likewise appear to be ingeniously cast from some artificial material. Of those farthest to the rear, the blue-and-pink one left of center (page 99) looks like clouds frozen into rock, and the entirely pink one right of center (page 101) seems as if formed in some sort of pink clay and then blasted through by sharply pointed bluish green shapes resembling nothing so much as bombs. The one to the fore on the right (page 101) resembles a spherical fort bristling with gray, screwlike alabaster tubes and covered over with pink barklike roofs. The entirely pink one on the left (page 99) looks like a funeral monument erected out of odds and ends found in nature, with amazing excrescences which Combe interpreted as allusions to alchemy but Tolnay thought outright sexual.

Both scholars are, in fact, close to the truth, since the arts of metamorphosis, ecstatic transport, and delight are all part of the theme here, whether it is interpreted as an admonition against sin or as voluntary abandonment to it. At any rate, apart from all questions of their possible

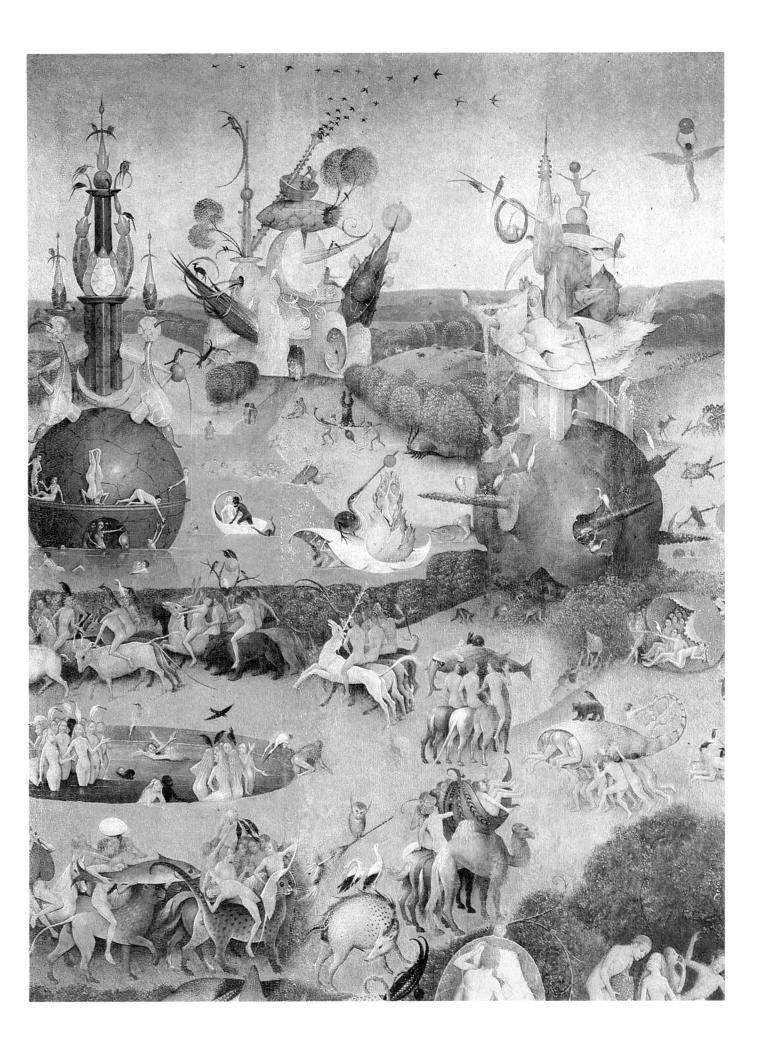

existence in reality, these fantastic buildings have a particular function in the picture as a whole: to delimit the body of water with its four rivers flowing in or out and to offer their hollow interiors as shelter to the bewitched humans. The naked figures seek shelter also on the banks and in the sea, gathering in throngs in or around fruits, shells, and a giant egg, or floating about in boats that sometimes are live mythical creatures, while never straying far from the waterlogged and besotting world in which Bosch portrays the old parable that all life arose out of the swamps. At the same time, however, the distant zone with these edifices is the fountainhead of the entire painting. It is there that one must begin to read this picture whose action flows easily forward and to all sides in increasingly astounding manifestations.

Whatever the literally countless signs and secrets may signify, they are not set in the kind of peaceful, familiar landscape that we find at some place or other in all previous pictures by Bosch (except for the Vienna Last Judgment), the sort of landscape the painter himself could have looked at any day of his life. Here the terrain is new and without precedent or model: one symbolic sign follows fast on another and without flagging, to make a radically metamorphosed utopia. True, in the farthest distance there is a line of hills that may well belong to our normal world. But anyone who so much as casts an eye on the quadrangle staked out by the strange towers is irresistibly caught up in a movement that takes him away from the real world and into the densely interwoven scene in the foreground.

Viewed as a whole, however, this is not a labyrinth but a topography of zones carefully set off against each other. Like the tower area, the zone in front of it is still firmly delimited, though not by opening out to the four points of the compass but, much more, by close concentration about the round pool where the women bathe. Here we have the first point in the picture where a dynamic movement appears to be unleashed: the savage but controlled circling chase of the troops who, mounted on wild, domesticated, or fabulous beasts, reveal their separate naked ecstasies while yet submitting to the disciplined frenzy of the mass. The consequence is a strange ritual which also has a formal function in the picture, circumscribing a firm oval movement which only a few figures remain isolated from or are still struggling to join. Only in the third and foremost zone are the nude couples and groups free to disport themselves at will, alone and often transported out of themselves and already succumbing to distraught dissipation. This is also characterized visually by the large, round fruits that recur throughout the zone, often glassily transparent or afloat like boats or rolling across the meadow. Shells and shelters for lovers, they not only envelop the amorous couples but

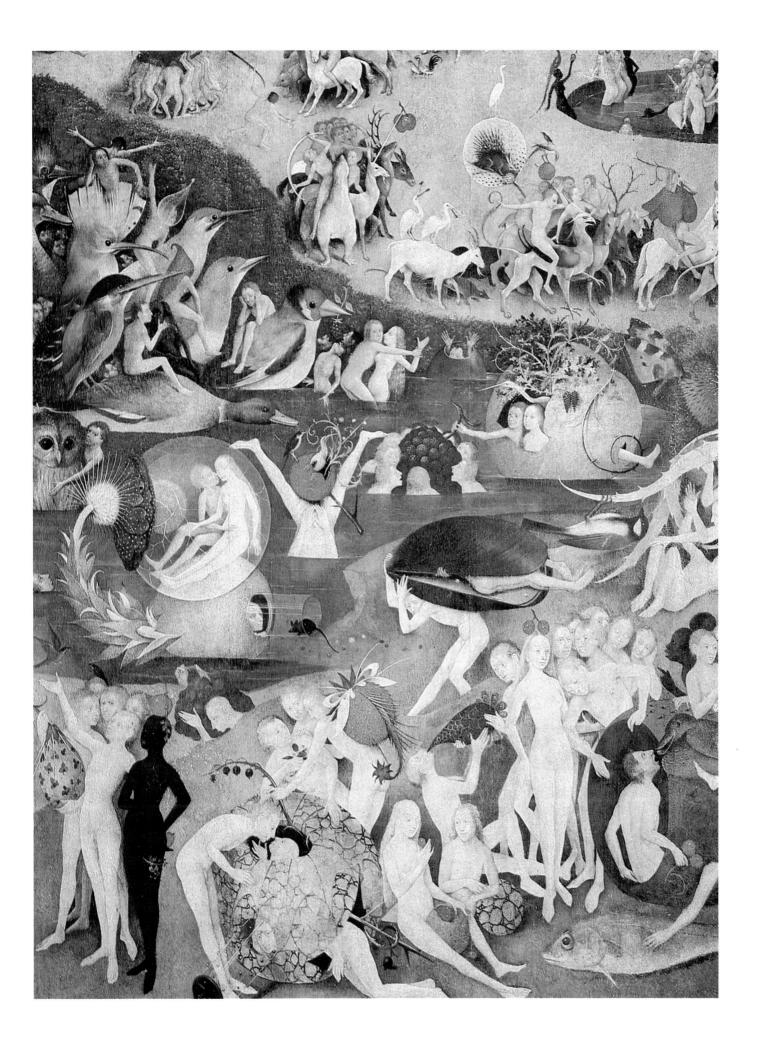

are at the same time the secret signs of the desires to which they give themselves over.

Among Bosch's triptychs this is the first to have no solid three-dimensional central focus but, instead, a distant wide trough or depression that provides the only firm base for everything that crowds into it. This, however, does not vitiate the compositional structure of the picture. The three zones remain distinct for all that there are transitions here and there, and only the last of them, the foremost plane, shows everything as if suspended and intermingled, cropping up or dying away, and often both at once. An enchantment comes over everyone, but holds each individual so inexorably that he can scarcely be aware of anything except himself and his deepest desires. Here is the meaning of this composition, which is less a tangled thicket of human bodies than a depiction of the vast terrain of their wide-soaring hopes. Yet it accords with this that so much is hidden, telescoped. disguised, covered over. A hushed hesitancy and, within it, a quest after the unexpected—these make up the chief theme of the picture. The enormously oversized birds at first seem a menace, but they do no more than toy with the fruits they have sought out, or else bestow them on the naked humans. Similarly, the cramped tents or towers of coral or some glassy material in which a number of individuals forgather for erotic purposes have the same significance of helping and sharing. But the claim that one can detect compulsion or confinement or even repressed desires in these acts and structures—as if Bosch had anticipated psychoanalysis is scarcely borne out by the unswerving rightness of the artist's fantasies. Wherever his figures drift about in fruits converted into boats or betake themselves to hollow chambers, shells, or husks as shelters for their amorous activities, there is nothing suggestive of forbidden acts and their consequences but, on the contrary, only and always of joy and its quick passing: a murmur of regret, perhaps, but never grim remorse.

Fraenger was right insofar as he sensed a joyfulness in all these nudes, however much they may strike us as frail, unhinged, and forever insecure and almost hunted. On the other hand, he was intractably convinced that this picture of a land of sinless love was meant to be doctrinaire, an illustration of nothing less than the return to guiltless sexuality as proposed by the Adamite sect. And yet there is more here than the naive enthusiasm of an off-beat cult. Fraenger himself conceded that, in the midst of this celebration of joy, there is death and extinction, and even expressly pointed out how certain figures turn away, hope abandoned, from the very pleasure to which they had been clinging with such passion a moment earlier. This is because the evil inherent in death is a principle present from the outset in sin, and

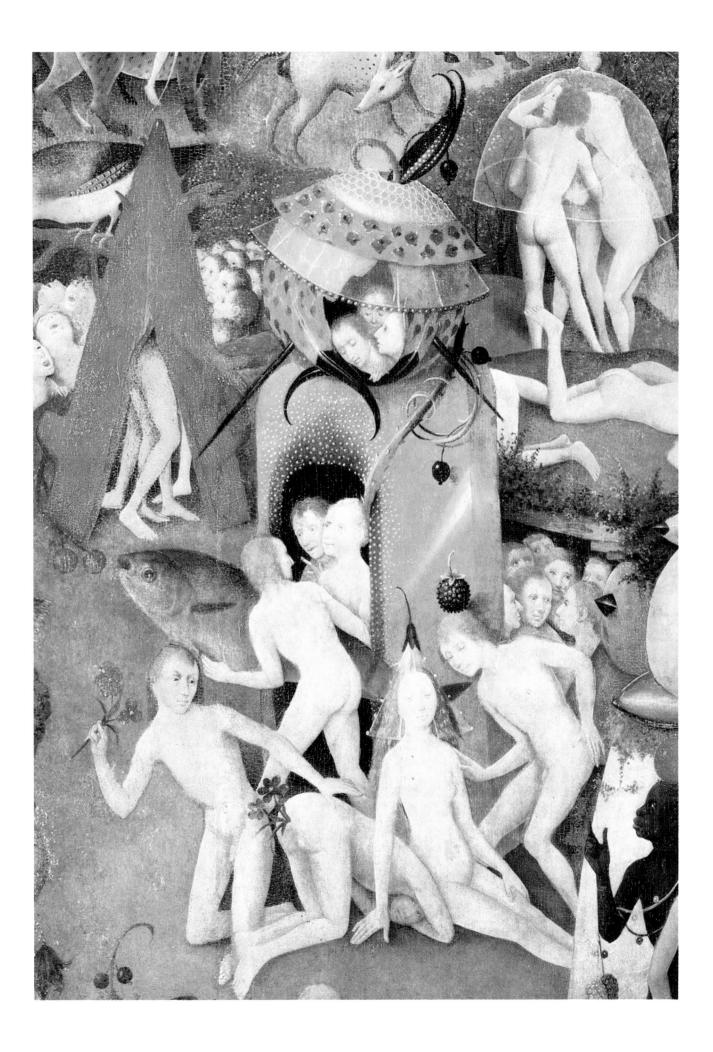

The Garden of Delights (detail of the right wing)

so is not its consequence. Unwittingly, convinced as he was that he had grasped the true meaning of the picture, Fraenger stimulated others to look more closely at this work, notably Gombrich, who drew evidence for his own explanation from close reading not only of Genesis but also of the Gospel According to Saint Matthew and the *Historia Scholastica*.

What we see, he says, is the state of mankind on the eve of the Flood, when men still pursued pleasure with no thought of the morrow, their only sin the unawareness of sin. This overcomes the puzzling problem arising from the fact that, in this triptych, the left wing quite definitely depicts Paradise, though already with certain extravagances of nature and many hybrids formed by strange couplings, while the middle panel shows another paradise, this one morally more free, virtually libertine, and concerned only with man himself. As Gombrich sees it, in no way whatsoever do the three pictures present a continuous tale of decline and fall. and thus the central picture is not a new paradise centered on the satisfaction of pleasure but, instead, a phase of earlier history preceding the first purely earthly catastrophe, however fantastic the guise in which it is represented. Let anyone who wishes claim to recognize in isolated details however many excesses and vices he can name. The fact will yet remain that there is nothing supernatural or moralistic here, but only a balance held between attraction and satiety, with no awareness whatsoever of sinning nor even a hint of the unease that compunction might arouse. There is no place here yet for the feeling for the fragility of transitory things. Instead it is with a skeptical and almost indifferent coolness that whatever is impermanent is crystallized into something precious and forever incorruptible. It is also true, however, as Castelli insists, that something to be read in the figures' faces, behavior, and gestures suggests the following: although most of these unclothed human beings share a common interest, each denies his neighbors, pushes them away impetuously, or is no more than passingly aware of their presence. Each man who, while in the throes of personal experience no longer has use for anyone else, celebrates his own experience and inclinations, overlooking those of other men or at most putting them to personal profit. Hence the distraught, and virtually unconscious, instinctual animation that pervades this picture.

Whatever enigmas may be at work here may perhaps be interpreted (in the way that connoisseurs of secret languages always attempt) as symptoms. This would mean, however, that one aims to assess the acts of people under a spell as pursuits that can be traced consistently to their logical conclusions. But since this does not result in a real explanation, it seems to me better to think of the general range of what takes place here in terms of the different

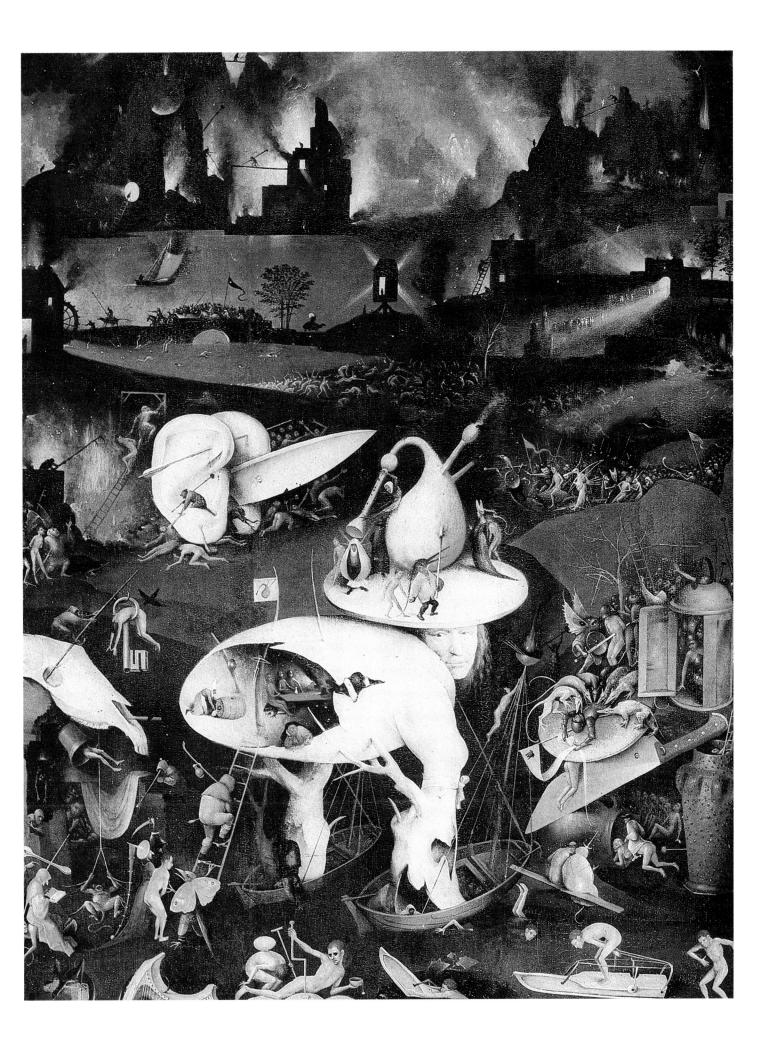

The Garden of Delights (detail of the right wing)

degrees of hardness—of firmness, if you will—of the reality which is consistently implicit in everything in the picture. Thus, among the amorous and pleasure-bent creatures in this central panel there prevails a flowing and pliable quality. In only a few places do hard, cold, stiff forms thrust themselves into the picture, and they are there to encase and protect the vulnerable nude figures. Now, we must see just how this changes, since a look at the triptych as a whole tells us that it does.

If Gombrich's thesis is right, this exuberant false paradise should be succeeded in the third picture by the Flood itself representing a kind of hell. This, however, is not the case. There is no flood. Not even the hell we do have there is the old familiar one: it is no fiery pit, but Earth itself in flames (page 107). What little by little pushes forward here, seething and clanking, seems to be nothing other than war and arson. Hordes of armed men race into the scene, their naked victims rush on helplessly before them, many only to be crushed beneath a monstrous juggernaut made up of two giant ears flanking a huge knife. But then the terrain changes to ice and not many can escape across it: a few slip and slide about, others crash through. Those who do succeed are not much better off. They reach terra firma, true enough, but only to become imprisoned between colossal instruments which once meant no more than delight and music, or they end up tortured, crushed, impaled on an overturned table, or devoured by the bird-headed specimen enthroned on his royal toilet. The tormentors are not devils of the traditional sort but those agglomerates invented by Bosch out of parts of wild beasts, reptiles, and armor-plated mechanisms. Each of those monsters is a phantasm, but the greatest of all bestraddles the center of the picture with, for legs, two dead tree-trunks planted in two light skiffs, for body an egg burst open, and for head a melancholy human face looking out at us from beneath a millwheel-hat.

On the faces of the prisoners can be read their immediate fear and also the anxiety that has long clutched them by the throat. Strangling and stabbing are the only order of the day, though here and there debauchery and lust break through the anguish. This is no longer a hell, just as the Paradise was no paradise. It is a land where men undergo martyrdom. Take away the phantasms and, what with natural and human disasters, with earthquakes and invasions, the violence that goes on here can appear at any place on earth at any time, though scarcely in such outlandish guise. The inhabitants of Bosch's Paradise are not expelled, no one is coerced into his Hell. Both—like the land of lustful delights between them—are long views of extreme cases. Their implements may be crude or as fiendishly ingenious as in this high and original art, but in either case they signify reality. However the picture may be interpreted, it bears within itself some undefined past and an equally undefined future, both present by implication, though transposed into a pictorial idiom designed to conceal and to intensify at one and the same time. It is not lust that is arraigned here, since punishment is largely reserved for those guilty of covetousness and self-seeking (as Fraenger has it), outgrowths of that absorption in the self that Castelli pointed to as the source of distraction and eventual destruction. One might well imagine that what is seen here is real and justified punishment. But those whom Bosch permits to administer punishment in his picture are no longer proxies of a higher authority who act in the name of the faith and the last judgment. On the contrary, they have arrogated the right to judge without themselves being judges, to exercise authority without any claim to such authority and without being themselves superior to authority. And so revenge replaces justice as punishment for human wrongs, and punishment becomes wanton destruction.

Foundation, dispersion, destruction: these are the ways of the world, *la variedad del mundo*, as the Escorial inventory of 1593 put it, and they determined the terrain in this picture. The composition of the entire triptych is rich in depressions and niches reached in an easy descent. In the right wing the nightdark valleys and the panic-driven multitudes scurrying back and forth end up in a precipitous declivity which becomes more and more solid earth. The color, whether coolly bright or darkly cold, appears as a gleaming thin epidermis, and this is typical of the late works presumed to date from around 1510.

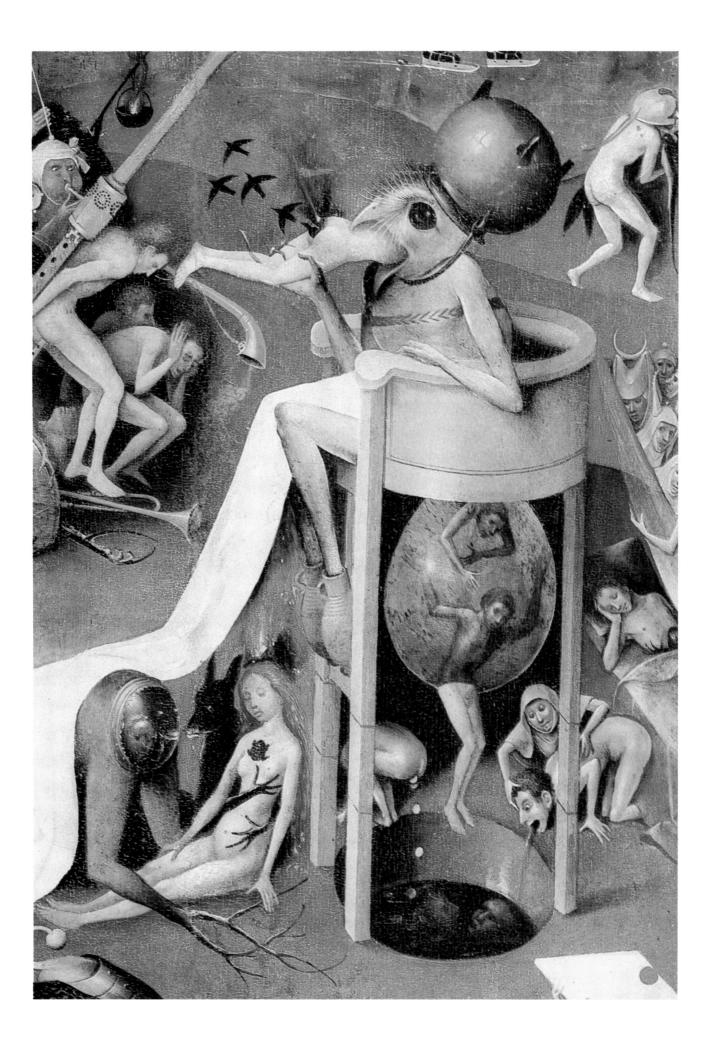

The Last Judgment (detail of fragment)

Against a bluish brown ground, a double action: naked bodies clamber out of graves or crevices at the summons of the trumpets of Judgment, others are pounced upon by ferocious monsters in shapes borrowed from birds, toads, insects, and other such real creatures. This fragment of a Last Judgment entered the Nuremberg museum unrecognized a century and a half ago, and it took more than a hundred years, and its transfer to Munich, before it was recognized as being by Bosch. It is conjectured, rightly I think, that this is what survives of a picture on that subject which, according to a document in the archives of Lille, was commissioned from Bosch in 1504 by Philip the Fair of Burgundy. One is tempted to try to reconstruct mentally what the picture must have looked like complete, considering how impressive and elegant is this small remnant made up of forms of the most tensely spanned energy. If it was part of a triptych, as is likely, then the fragment would have come from some place in the lower right of the central panel. As for the wings, we can imagine them like those on other triptychs by Bosch, but that is not certain since the iconography of the portion we have is so unlike anything else that survives of the artist's work. There is a clue in a stretch of cloth lying puffed up in the lower left corner of this panel. This, as has quite reasonably been deduced, may be the end of a mantle worn by a tall figure, most probably an Archangel Michael weighing souls on his scales.

That would make it a picture rather like the **Last Judgment** painted shortly after 1450 by Rogier van der

Weyden for the hospital in Beaune, a work which is one of
the most restrainedly formal and uncapricious among that
artist's paintings, and which is therefore very close to the
softly flowing International Gothic style which Bosch, in
his late years, seems often to have had in mind again.
Otherwise, however, there would have been very little
comparable in the two works, even apart from the fact that
Bosch's picture must have been very much smaller, for all
that it is supposed to have measured about eight feet in
width. Nevertheless they have one thing in common: the
abrupt, explosive emergence out of bare ground of the
dead with their earth-brown colored bodies, though with
Rogier the scene is not dark night as here.

Nothing of the sort had come from the brush of Bosch before this, nothing of what we can call this *swimming* through earth, this emergence of hands, heads, legs as if parts were still imprisoned in the ground. In **The Garden of Delights** likewise, naked bodies emerged from another element, water, where they were half-afloat, half-drowning, though most were equally helpless as those here. Certainly, there it was still daylight, but already there were the same delicate, vaguely befuddled, almost enervated-seeming,

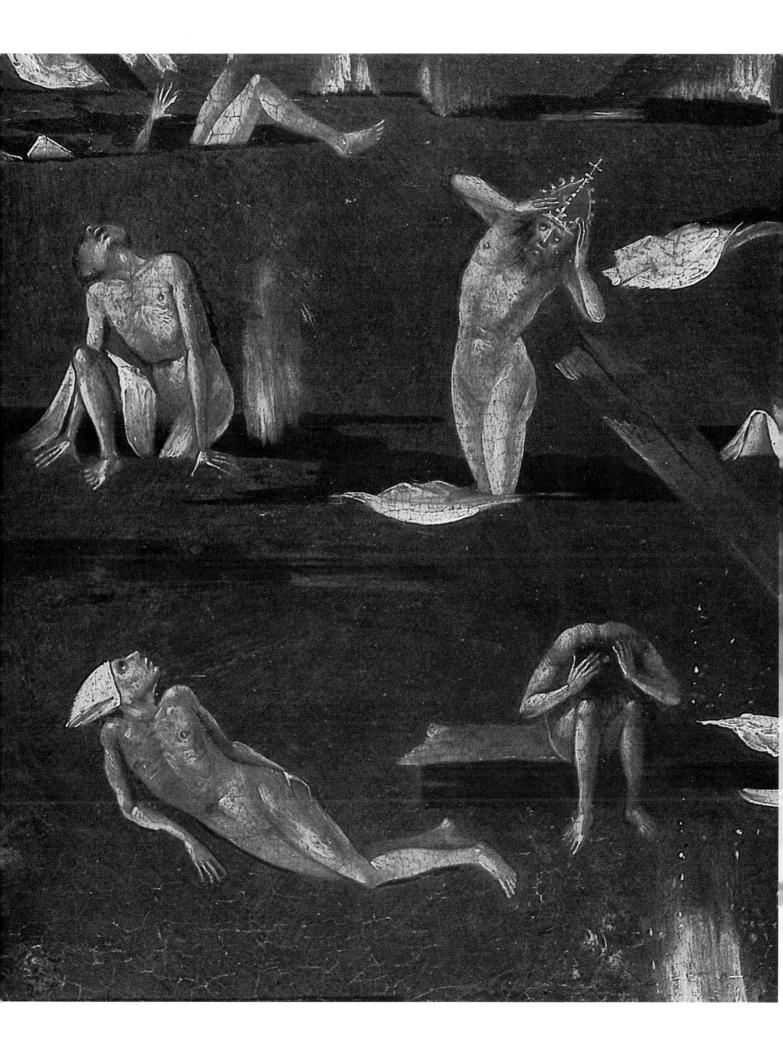

The Last Judgment (detail of fragment)

slender bodies as here. Now, though, a sharper light picks out the naked flesh and makes it gleam in the night. Even so, one factor dominates in both pictures, though one speaks of joy and the other of terror: a benumbed confusion in which the naked and the dead alike scarcely know where or who they are. In the pleasure garden conscious awareness was fainting away, here it is returning to the long-dead, but we sense in both states the same intoxicated mental confusion. What is more, in both pictures there is a delicate and finely articulated way of painting which induces us to date them both in the same period, around 1510.

The theme itself introduces something not found previously in Bosch's pictures: the death that comes with world's end, the life that begins only with eternity. Before this Bosch had never depicted the precise boundary between them. So this picture too is no scene of Hell as we know it from his other works. At most it is no more than the prelude to Hell. The dead, still sleep-drunk, are only beginning to come alive. And yet immediately every gesture betrays their clear awareness of what now awaits them. It is astonishing to find here something which painters had scarcely observed before this: the way some men stare upward in terror while others collapse in a whimper and hide their heads. These are the gestures of desolation and were virtually alien to the Northern pictorial vocabulary, though in Italy, between Andrea del Castagno and the aged Michelangelo, one finds heads sunk in exhaustion, foreshortened and bent so far forward as to appear hanged, or heads so lost in themselves as to expect nothing more from life except nothingness

itself. What we have here, then, is a truly marvelous picture where, with no prototypes to go by, the artist succeeded in expressing both of those psychological states.

Thenceforth there were to be no models for Bosch's other incomparable inventions. Here there is yet another innovation, this one in what we can call the mise en scène. There is a precise and real delimitation between the justawakened and terrified consciousness of men to whom tokens of their onetime earthly dignities are no longer of any help whatsoever and the beginning of a sudden, new, infernal life for them. The waking dead are given brief respite among their tombs, then are snatched away to become victims anew. Nightmare creatures swoop down, a few stand clustered in a group awaiting their turn—squat, stocky scoundrels, more mouse or beetle than man, and among whom there is one with four feet who could be a very fat woman in a full cloak. Set apart from these others by their greater activity are long-curved, tapering, insectlike bugbears. One, a creature all legs with back-turned face in lieu of rump, races along with a weeping nude woman clutched in his—its—red arms. The picture is an every-which-way tumult of harpooning, stinging fauna, of swift and explosive movements, and each leaves so little of its body still recognizable that one soon perceives no more than the insane grimaces of aggression. Thus, here too, there is an urgent tendency toward pure, weightless, nonrepresentational function. And this is a way of painting so sharply etched, so incisive and soft at one and the same time, as not to be matched even in The Garden of Delights.

It is sometimes remarked that the evil creatures are strewn across this picture like designs on a carpet. This strikes me as faulty observation. While the background is painted to show the darkness of damnation, it is not a mere two-dimensional and undefined ground. For one thing, the extension of the terrain broken up by graves can be judged by the flames that shoot out of the ground at intervals. In addition, one makes out not only furrows or wavelike mounds but even an occasional hillock of some height.

This is a real "end-game": all attack, no resistance. It would seem as if Bosch never really knew more than two themes—the difficulty of choosing, the failure to choose; the one Temptation, the other Execution. This much at least can be read in this surviving fragment of a picture: the whole must have been a great work in which the master may well have surpassed even himself. This one can say because there is in it a cool majesty only comparable with that of Rogier's altarpiece in Beaune, for all that that work belongs to a different style and time and is patently as unique in its artist's entire production as we have every reason to presume this must have been among all of Bosch's creations.

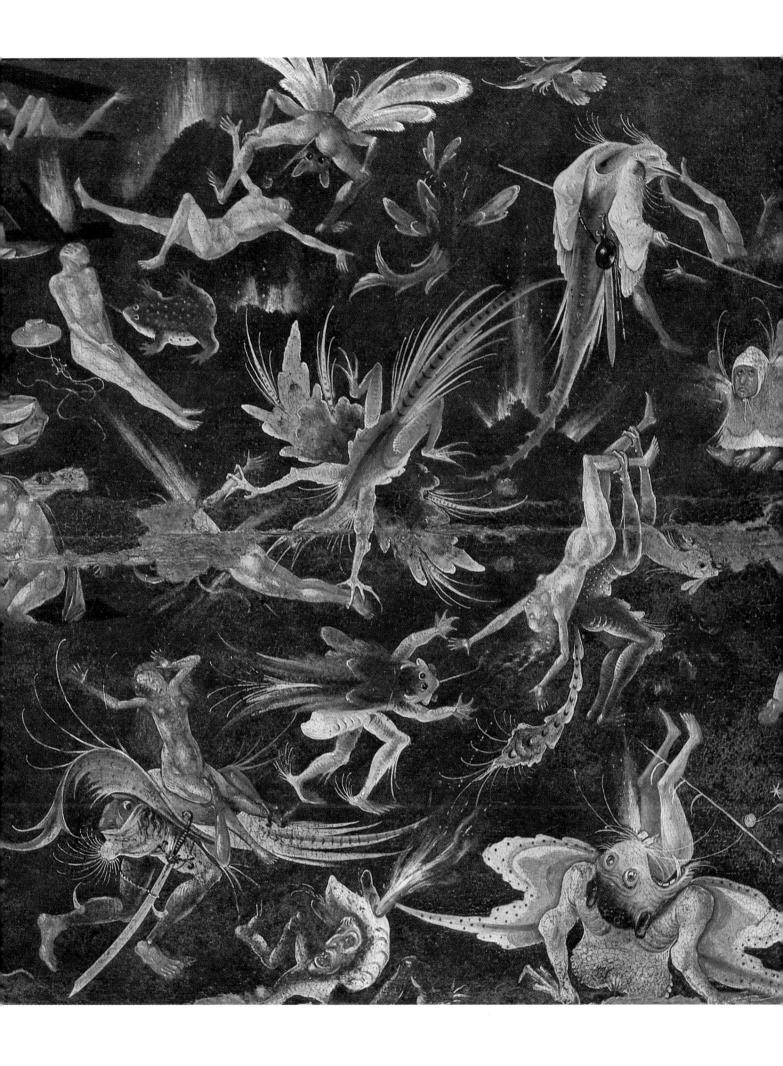

Christ Carrying the Cross (detail)

Veronica, looking down at the cloth with the imprint of the martyred Savior's face on it, is moving out of the picture. Her blood-drained face is no less bright in tone than those of the dark throng moving in the opposite direction, but it lacks the glow of life, is livid, seems almost artificial, even inanimate and gemlike as if carved from some soft stone. The other faces swarming around the meek and gentle countenance of Christ are contrastingly lurid—made up of the crude, sickswollen, ulcerated stuff of human cruelty if not, like the two thieves, already almost crushed by it. One senses rather than sees that the mob is moving through space toward the right. Nevertheless, the composition as a whole gives the impression of being circular, closely crowded and tightly squeezed, though not without some feeling of space. The figures swirl around almost as if in a boiling pot. It is not so much that they push and shove as that each of them exudes a feeling of loathing, menace, rage, or resignation.

It is only natural to recall here the drawings by Leonardo da Vinci of hypertrophic deformed heads, but they should by no means be thought of as in any way related to the heads in this picture, though they too are more than caricatures. By nature, caricature must dig its claws into everyday life. Here, though, we have uncouth, sick-minded zealots whose single thought is to destroy: wax models of the unimaginable, perfect specimens of the farthest extremes. The monsters and mechanisms of terror that Bosch had used before now retreat into the human features of these heads which take over the diabolical functions of their predecessors. They have encapsulated themselves like cysts in these scarecrow physiognomies and proceeded to act on their own. Now we have phantoms in human guise.

All this is only speculative. But as so often with pictures that are willfully enigmatic and at the same time of great power, as in this case, the decisive factor is not so much the phenomena they depict but rather, simply put, the medium itself, so that it is the way those phenomena are laid out which eventually proves more revealing. Here space depends for its evocation on threatening gestures, twists and turns, and dragging movements, and it truly does exist. The heads rising brightly out of it would give the impression of being there for themselves alone, as in a relief, were it not for their often opalescent and prismatic play of color. But

precisely because of this coloring nothing here really suggests sculptural relief but, instead, a more organically explosive form. The darkness between the prominently projecting heads is nothing other than the space itself, narrow and constricted. At the close of his life Bosch strove to contain his pictures within a clear and dry tegument. Here he reached back again to a close-packed, three-dimensional, crowded scene and sought to burst it open and, eventually, to illuminate it in this way, to deck it in brightness. The heads push their way to the fore and drag up their own space in their tow. Here, then, begins the changed aspect of a world that neither hopes for anything—even the worst as in the past nor puts its trust in the cool cerebrality of the Renaissance, which by then had arrived in the North.

Thus these heads are foretaste and signal of a moment and, indeed, of an entire situation in art which is out of kilter. off balance, and must first of all find its way back to its lost limits, even if now those should prove more rigid. At the least, however, these heads do make up a kind of simple showcard of exemplars of biting caricature. For none of the heads is present in and for itself. Instead, each has a precise target for its attack, just as its opponent, its counterpart and target, itself has its own foothold from which to resist that attack. Only the fathead under a helmet at the right looks ahead out of the picture toward a place where the action—the bearing of the Christ Carrying the Cross (continued from page 114)

Cross to Golgotha—is to continue. Otherwise the tangled

conglomeration of heads is itself the action, itself the scene. Yet all the contraction is far from a negation of space. It is

much more a mixture of plastic values with particles of space on the way to becoming almost palpable, a mixture that threatens to explode from within. Another enigma of the picture is that all this takes place in a way that anticipated the Mannerists who were to turn space itself into a nightmare, in part through foreshortening and compression, in part by suggesting infinity. With them, as already with Bosch here, space is in consequence each time not so much an area to be crossed as itself an aggressive factor that forces itself upon the eye of the viewer as much as the figures in the picture themselves. Whence also the repetitive and very strange interweaving of a considerable number of heads.

The previous spatial diversity typical of Bosch begins here to coalesce into a single field. In this picture the field is narrow and not easy to define, still immersed in the deep furrows and folds of the darkness from which patches of brightness are propelled forward almost wildly. Nonetheless. it has already become a perspective network in which Christ is carried along. Unlike all the other half-figure compositions, this one belongs among the last works of our artist, though one cannot be more precise than that.

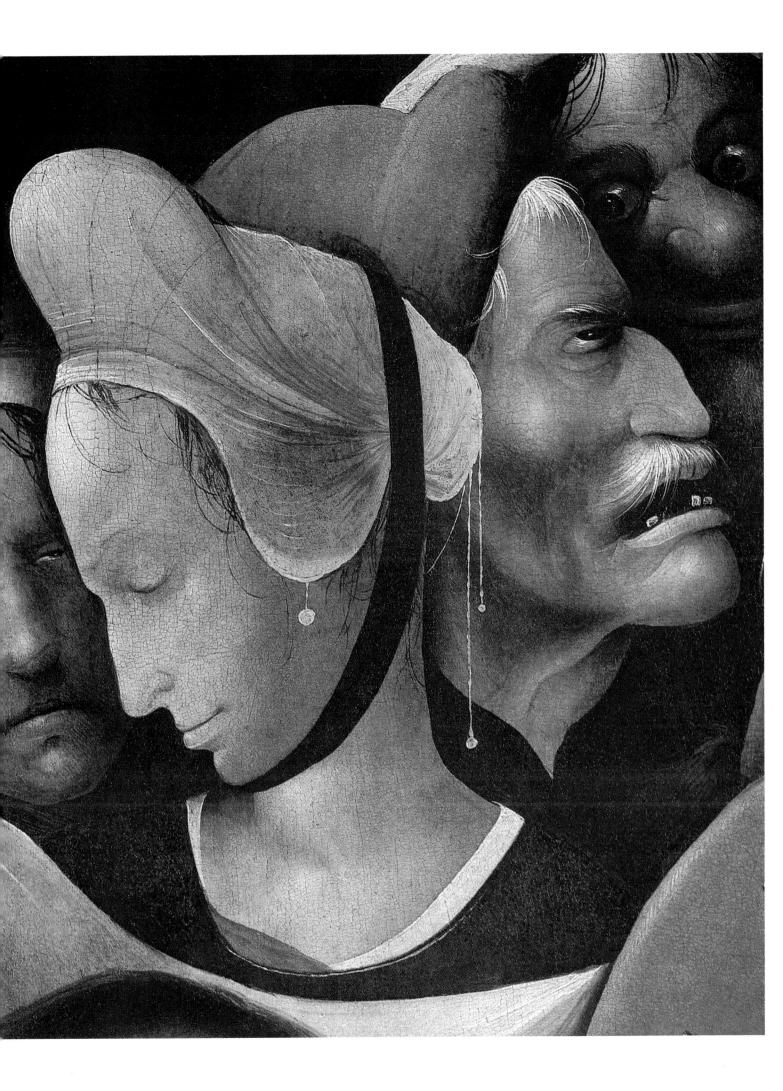

The Adoration of the Magi (detail of the central panel)

This is a highly ceremonious picture, yet everything ceremonial in it is at best no more than a secondary strand, perhaps at the most a smokescreen. On closer and more patient inspection the entire scale of values becomes altered, and it even proves in the end to be the most fleetly and easily laid-out of all Bosch's pictures. The triptych begins with an actual ceremony on the outside of its shutters which, when closed, show a shallow altar area with Pope Gregory saying Mass in the company of attendants and other worshipers while before him appear, miraculously, the episodes of the Passion of Christ. Were it not for the Passion scenes that surround the altar itself, and notably that of Golgotha at the top, which grows out of and away from the altar to become an independent landscape fading into its own remote distance, one would scarcely think of Bosch here. With the shutters open, the central panel shows the visit of the Kings, an episode from the first days of the life of the Redeemer, and thus the legendary Mass of Saint Gregory constitutes the echo and quintessence of the first devotion paid to the newborn King of Kings.

Apposite or not, the three chief panels of the triptych do for the most part preserve a basic ceremonial and solemn character. This is partly because here, as in no other of Bosch's altarpieces, a pair of donors are portrayed on the wings, kneeling at the feet of their respective patron saints Peter and Agnes. So here at least Bosch renounced precisely what we have described as his great innovation: the continuous progression from the left wing across the central panel and over to the right wing. This meant that the action depicted always had a culmination, which derived from everything that preceded it; not, however, in the sense of a simple story with beginning, middle. and end but, instead, in accord with the promises and predictions that direct the universal history of mankind toward either salvation or damnation. Here, on the contrary, we have the old conventional form of triptych with the devotional image in the center flanked by wings with worshipers whose attention is directed inward from either side. The veneration of the newborn Savior by the Kings is itself an old image long used in the cycles on the life of Christ. However, for something like a century before Bosch's time the accent had been shifted from the humble poverty of the Holy Family to the sumptuous appearance of the three Kings and the subject had itself become detached from the full cycles to be used on its own for devotional pictures. Thus we have every reason to assume that here the artist was perfectly content to revert to the conventional form.

Yet there is more. The ceremonial manner of the three great lords has a serenity and majesty such as to make the

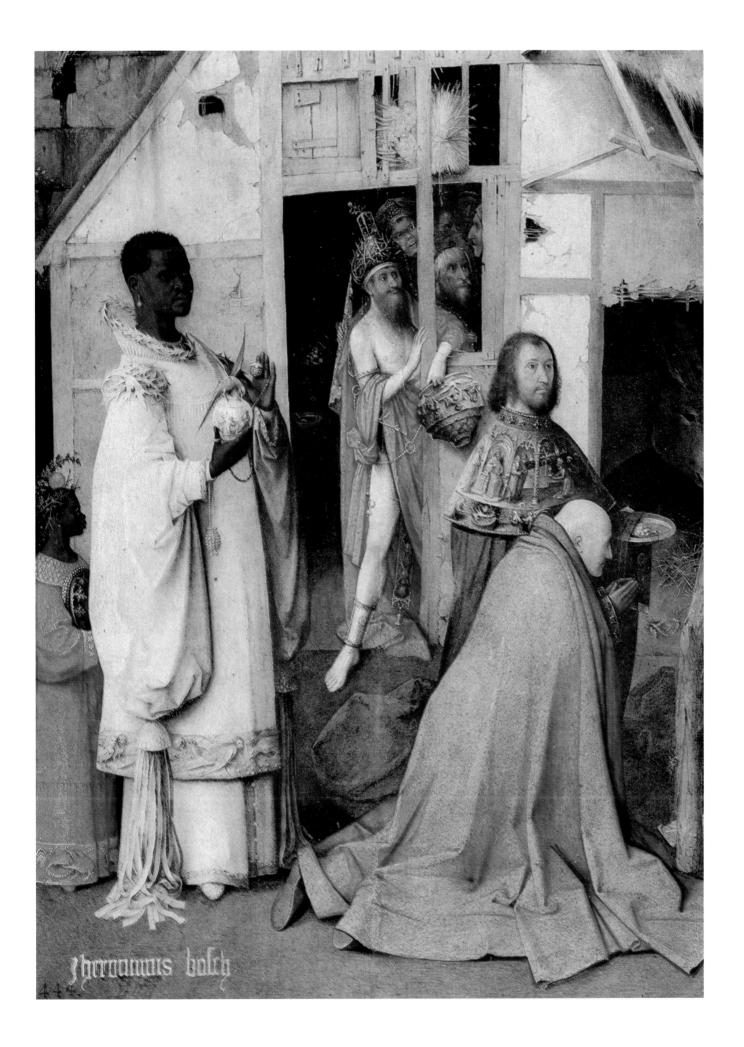

The Adoration of the Magi (detail of the central panel)

dwellers in the miserable stable overlook their absurd finery. And it is precisely this which makes us recognize here not a mere display of riches but signs of something else, something anything but conventional. Even the embroidery on the hems of the garments of the Moorish King Caspar and his attendant is, to say the least, odd: birds with human heads, sirens, fish gulping down other fish. Over and beyond any reminiscence of ancient depictions of animals, there is something specific implied here for which so far the scholars have not found any explanation, and it would seem to allude in some way to the still unconverted heathens of faraway places. Less problematical are the heavy collar that Melchior wears, apparently cast in metal like armor, and the sculptured scene on the gold lid lying on the ground in front of the kneeling Balthasar (see figure 60), both of which illustrate episodes from the Old Testament which are generally interpreted as prefigurations of redemption through Christ. But we are less concerned with the subjects of these pictures within the picture than with the fact that these art objects are presented baldly as such, as objects in themselves alien to the picture and conspicuous as sore thumbs. Now, from the start we have seen that Bosch pursued one unchanging aim: to set before us signs, for the most part signs of unrest. This is the origin of all the pictures in which he represented violence, temptation, menace, anxiety, delight, and blessedness not only as actions but unfailingly also through signs which either laid bare the inner significance of the subject or disquised it even more profoundly. In the guise of such signs appeared the alien or hostile powers Bosch saw as the scourge of the universe, whether they be called Terror or Devil or Tyranny or Misery. We have seen also how these signs grew up throughout his work, only to be reabsorbed in his late years (though there are occasional earlier instances also), and this picture is a prime example of such a process.

A rather special means of disguising such signs and the error attendant on them, of making them only half-evident or even of apparently glossing over them, is to transform them into preciously crafted objects of art. The consequence is a scarcely noticeable oscillation between art and nature. How is it, for instance, with the gold vessel on whose lid is depicted Abraham's sacrifice? Do the toads crawling beneath it belong to art or to nature? Are they craft works or, as always before in pictures, living creatures? The question must remain open, but at least it shows, along with other examples, Bosch's predilection for bewildering the viewer, by confusing his monstrous creatures—alive, however much invented by him—with such man-made counterfeits. And then too we must look at the

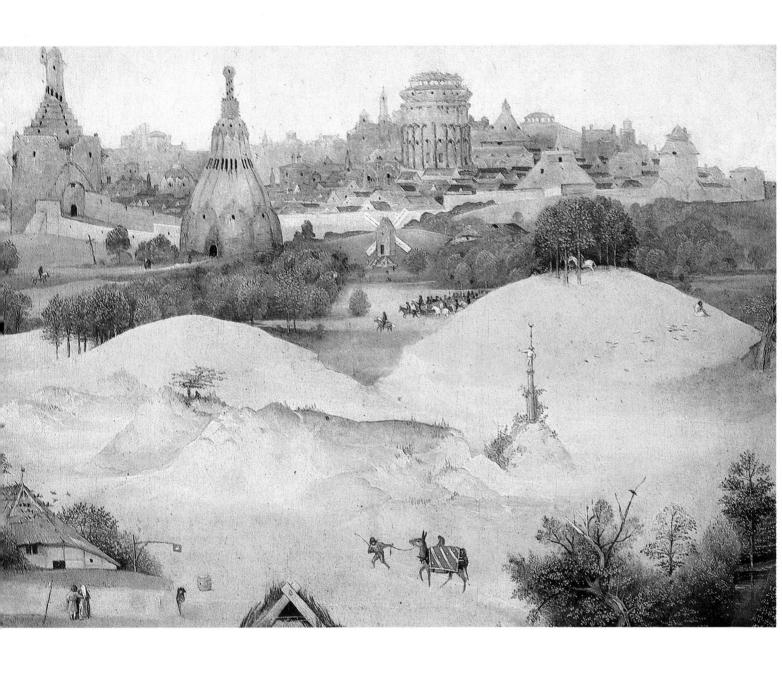

The Adoration of the Magi (detail of the central panel)

Kings' escort and decide if these men are really part of the familiar tale and not a phantasmagoria of strange intruders alien to it all. Who is the bearded naked man with a wound on his leg, strange bracelets on both arm and leg, a red mantle half-on, half-off? In an illuminating essay Lotte Brand-Philip explained him as the Messiah of the Jews announced in the prophetic writings and the Talmud, but changed over here into the Antichrist. Though Tolnay considers this reading open to dispute, it remains obvious that the personage is one of those strange great powers so often the source of disquiet in Bosch's pictures. He wears a crown or, more likely, a turban wound around with prickly twigs topped by a cylindrical glass. It is not in this alone but also in his enthralled but ecstatic gaze that he resembles the mystic pseudo-priest conducting the initiatory ritual in the Lisbon Temptations. More puzzling is the object dangling from his hand, not the crown of either of the two kings who stand or kneel in front of him but probably. Fraenger says, the carrying-case for a crown. In it we again have a finely crafted piece of metalwork and, what is more, its reliefs picture the demons of ancient lore. In this light the heads seen behind this strange personage take on a different meaning: not mere attendants but men who are surly and protesting like those in the earlier Ecce Homo (page 51), or outright bloodthirsty villains as in the Ghent Christ Carrying the Cross (figure 59).

So what at first appeared a picture of pomp and ceremony proves to be something quite different. And inevitably there must be other oddities in it, other unearthly secrets so easy to overlook in this lightly floating and clear manner of painting. Indeed, one is most struck by the bright clarity of the picture and finds oneself admiring it for its painterly finesse. But since we already know that there are some very odd things in the content of the picture, singularities begin to reveal themselves that the unaided eye would not detect. The strange individual is looking out from a thatchroofed, half-timbered hut, and clay, beams, plaster, and straw are painted with all the delight that an artist with Bosch's eye for real things would take. But, as Brand-Philip points out, above the Anti-Messiah and from behind the rafters shines a false star of straw, while the true star

of Bethlehem gleams high above the distant landscape. Since Bosch's painting so often contains hidden and even extrapainterly significances, we would err in admiring these clear-toned, extremely delicate fluctuations in color for themselves, though it remains notable that this same way of painting was not to be matched for more than a century to come, and then by Pieter Saenredam.

Still, in all, it makes no sense only to track down the out-of-the-way symptoms. But in our progress through Bosch's work we came upon a significant basic form, that of the receptacle, be it shell or bowl or sheath or husk, and were led to suspect that, although it is sometimes no more than an isolated and circumscribed motif, it could also become the basis for an entire picture. As it happens, as a curious and isolated motif it becomes increasingly rare in Bosch's late works. For which reason, precisely in such a picture as this, everyone who has eyes to see finds himself tempted to regard everything—buildings and landscape alike—as no more than a single thin, smooth covering drawn over something invisible. Naturally one can explain this away as merely the new achievement of the artist's late years, to paint smoothly gliding surfaces of light and to reduce all three-dimensional modeling to a minimum. But, from his early work on, Bosch exploited his weightless way of painting as the means of defining every gesture and feature more harshly and aggressively while seeking out, along with this, forms that are hollow, masking, and concealing. Anyone who has observed this process will not let himself be dissuaded from recognizing in such a clear and bright painting as this considerably more than mere optical play with light.

Many writers have observed how very thin-shelled the hut is, not only in the way it is painted but even more in its conception, and how carefully all its details are drawn. Only when one compares it with the partition of thin slats in the Dijon Nativity of the Master of Flémalle (Robert Campin) the painting from almost a century earlier which is always adduced as the inspiration for the picture in hand here does one grasp fully that Bosch's hut is quite different, being constructed rather as a half-hollowed-out shell or bowl. Further comparison with the Campin picture yields nothing, even if there are figures—in that case, angels—on the roof, and especially not if one considers the exquisite modeling of the women in attendance. How differently do Bosch's shepherd couple sprawl on the roof! How unexpectedly beautiful the shimmering of palest bluish pink or mouse gray over a greenish tone in their garments! They do not at all strike one as having just clambered up there, but rather as if they have been lying there forever, their only and unceasing activity the satisfaction of their curiosity.

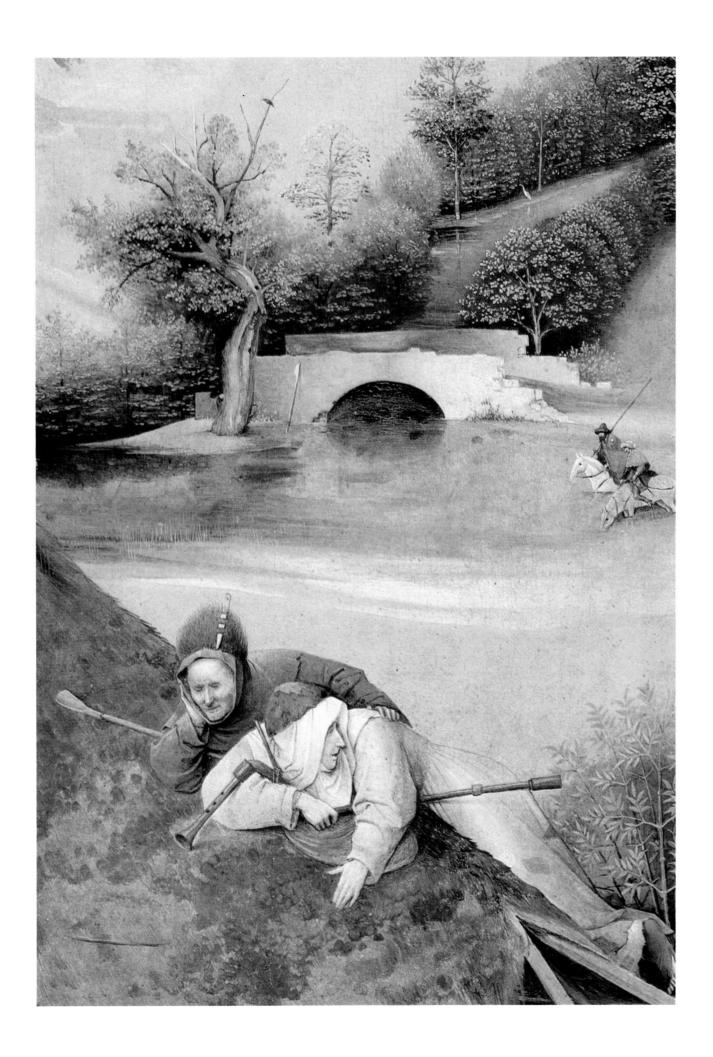

The Adoration of the Magi (detail of the right wing)

There is no point in trying to explain them on a story-telling basis as representatives of the gross and uncomprehending and indifferent world. On the other hand, Mia Cinotti shows her judgment and perspicacity in speaking of these shepherds as "the spiritual progeny of the unquiet and everwatchful spying monsters of the emblematic compositions." We can go further still. Here the innovator who often drew upon the very oldest sources proved himself in his element: iconographically these are reclining figures such as were found not only in the fairly recent International Gothic style but also in Early Gothic and Late Romanesque art, while at the same time, in terms of their meaning, they are irresistibly striking though enigmatic examples of Bosch's use of a veiling and disguising form. Similarly, the landscape behind them with its lightly sketched-in, almost evaporating, stretch of water has the appearance of a thinly covered surface that could suddenly break open, as we have seen elsewhere and earlier in Bosch's pictorial vocabulary. And into it, from one side and the other, sweep squadrons of horsemen almost as if in flight, just as one last saw them a century earlier in the miniatures of the Chantilly Très Riches Heures du Duc de Berry.

Whatever such a harking back to the past may imply, it calls for yet another observation. Although the background landscape is sharply set off from the action in the foreground, one cannot even begin to speak of it as a backcloth separated off or added to the scene in the manner customary before Bosch and even in his early years. Rather, the landscape seems so much to float away into the distance and at the same time to flow forward from the farthest reaches that the action in the hut directly before our eyes almost gives the effect of conclusion and by-product, so to speak, of the landscape itself. So much the more so since, from the lower margin virtually to the faraway city, the same strawy, loamy tone extends to, and unifies, all three components of the triptych, even despite the unaccustomed emphasis on the center.

This thin veil of sandy yellow covers the entire terrain. Halfway to the city the familiar dunes take on the wild character of desert land, as Tolnay puts it (page 119). Yet this desert luminosity and, within it, the stylized

stippled form used for all the trees are so interrelated that a more sublime union of smooth surface and plastic projection can scarcely be imagined. This too is why this steeply sloping terrain, dotted with only a few clumps of trees. strikes us as both familiar and exotic. On the other hand, the city in the distance—perhaps an imaginative allusion to the homelands of the three monarchs—is implacably foreign with its monstrously colossal edifices in the shape of rotundas, mausoleums, and stupas inspired by Rome and Asia in equal measure. Only closer inspection reveals that within this precinct of an age long gone is embedded a homely and cheerful-looking town of the artist's own time—which, in these circumstances, is no less unexpected than the windmill in the fields outside the walls. Around this bit of the present Bosch painted such an exotic immensity of buildings as no one in his time had seen in life or contrived in art. At such an early date this is already one of those architectural landscapes whose haunting strangeness lies in the fact that its fantastic edifices are less imaginative creations that someone sometime might design and build than monumental and highly voluminous buildings of a bygone time, but already in a ruinous state. In a word, even what Bosch only intuited, and though it was still in the future, he envisaged as something long forgotten. And, in terms of art, here too, in the prescience of this dream-architecture painting, years were to go by before a Maerten van Heemskerck would appear and rival Bosch's uniqueness.

Elsewhere, however, and notably on the right wing, before the city at the mouth of the river is reached, the world is not only alien but even inhospitable. Trees are blasted by the wind, wanderers on the road assailed by savage beasts (page 123). These are no more than the mishaps of life, but nature herself shows her dangerous side. There are none of Bosch's monsters here, or if there are they are well hidden. But is there not something uncanny about the earth itself? Although it exhibits no signs of evil for the moment—for the moment caught in this picture—perhaps it simply masks everything Bosch had, since his early years, depicted in miniature and is itself a single vast receptacle for something unidentified. Much as the signs of menace may be by and large reabsorbed in this late work, they are not entirely absent. The overall, seemingly dispersed, remote stillness here is also a sign, in that original sense promoted by Bosch. Whatever happens goes unnoticed in a vast and empty world, and what the signs of that world indicate is this: we are unaware of what goes on, and he who knows does not wish to know. And this is the same message we find on the outer shutters of The Hay Wain (figure 22).

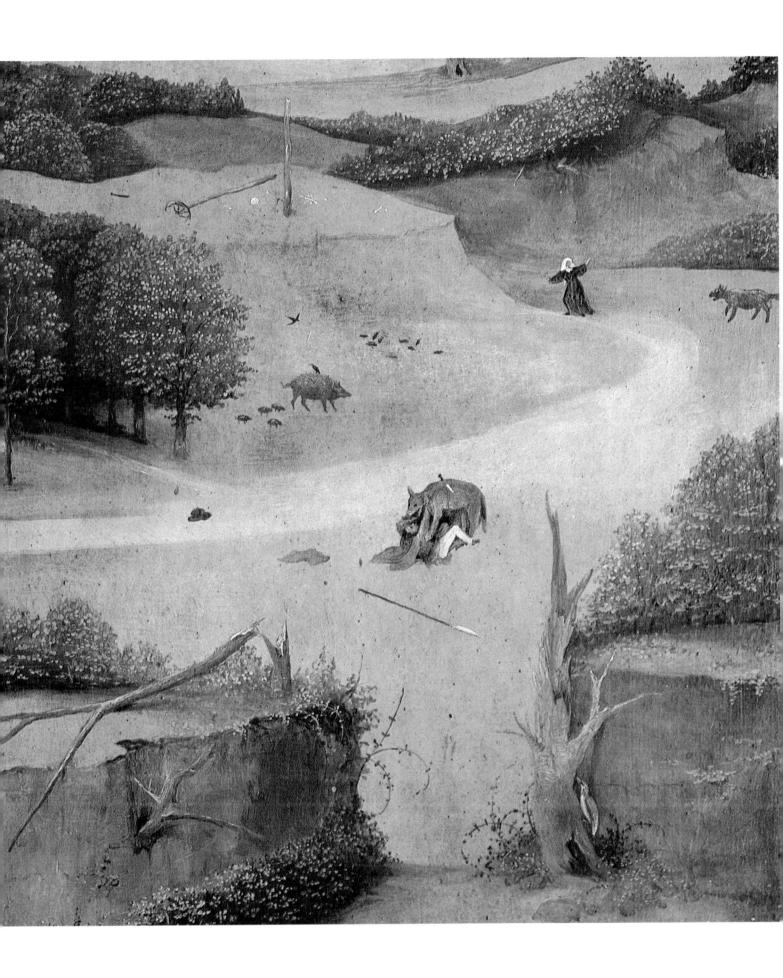

The Temptation of Saint Anthony

One might think this a purely idyllic picture: an aged hermit one could scarcely call restless or even discontented sits, presumably lost in thought, waiting certainly, but not for anything agitated and only for the uninterrupted continuance of the peace that so visibly radiates from the entire picture. But since he is the desert father Anthony, and since his name is synonymous with temptation, then tempted he must be. Even such placid waiting is, after all, no assurance of safety. A man who has withdrawn from life and only thereby won the peace that permits him to sit and stare out at nothing has perforce only too recently gained the upper hand over his own unrest. With such self-command it is difficult to say

what might still be able to tempt him. It could be that temptation here means nothing other than serene acceptance coupled with disdain for all agitation from whatever source it might come. Such a renunciation of all reality would be what the mystics call the contemplative state, and thus the tempted Anthony would be an Anthony in meditation.

But is that really what the picture shows us? In a moderate bird's-eye view the eye looks down on a valley basin lightly planted with shrubs and slender trees and made up of generally sloping flat areas broken up at intervals by hillocks lying athwart them. Sunk into it like so many spheres are a church, a hollowed-out tree trunk, and the saint himself. No movement disrupts the calm. The landscape laid out in strips is typical of the scenery in Bosch's late works, where he aimed at spatial depth by extension both forward and backward. Not lacking, however, is the by then old-fashioned way of separating off the remoter landscape (and thereby making it seem even more distant) by tall trees, a procedure that puts one in mind of some sort of latticework or grating stretched across the picture. It is reminiscent also of the alcovelike construction of space used by the miniaturists of the latter half of the fifteenth century, not chiefly the Dutch (though Geertgen tot Sint Jans has rightly been adduced here) but certainly such Flemings as the Master of Mary of Burgundy. Within this sort of spatial organization Bosch's figures exhibit the same carefully set-down style found notably in an Oxford book of hours from around 1490, though Otto Pächt, in his monograph on that anonymous miniaturist, alludes to Patinir rather than to Bosch. Certainly, however, we must go beyond this recourse to the past and recognize what is new plastic, and tightly drawn "skins" or "integuments" we have so often mentioned. Nor must we allow the all-too-obvious serenity of the picture to blind us to the fact that, though the saint may not be outright tempted, he is nonetheless threatened. This picture too is haunted by the terrifying little monsters that Bosch invented and unleashed on so many poor tortured souls. But now they have been transformed into armored vehicles from which emerge arms brandishing hammers and knives, or the stings of insects, offensive mechanisms to be launched in rage against a peaceful adversary. Except that the creatures have become so lost, so dispersed, so deprived of that baleful atmosphere of menace that attends them elsewhere, that here they would scarcely scare a fly.

And that is the key to it all: the absence of that particular atmosphere. Not that there is any lack of signs to suggest it. The saint pursues his meditations unperturbed, but his calm is not as matter-of-course as it looks to be. He stares fixedly at nothing only as a way of eluding a terror that still

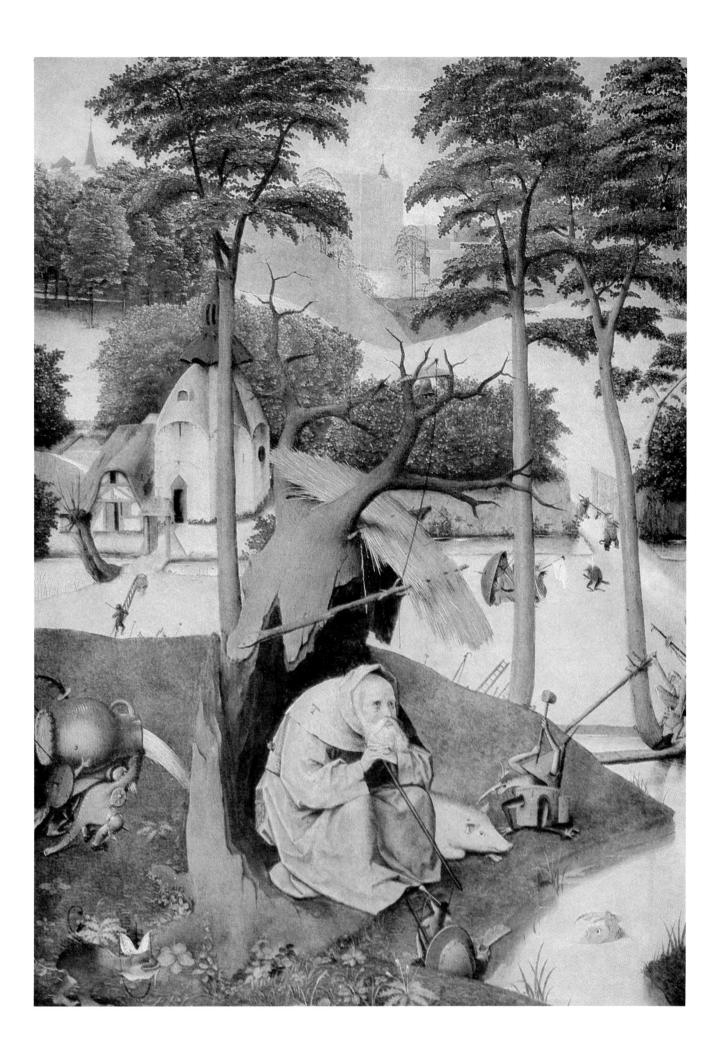

The Temptation of Saint Anthony (detail)

has him in its grip: the screaming head that rises from the opaque and unmirroring water in front of him, the only source of aggression in the entire picture that is not crudely mechanical but rages and blusters on its own. One would expect at least a show of revulsion or disgust from the hermit, but he sits placidly on. No one has remarked on the significance of this head except Fraenger who, however, does not see here a confrontation between meditation and temptation but, rather, anticipations of Jungian psychoanalysis. Others, notably Tolnay and Combe, have even more casually taken for granted that, in this and in others of Bosch's paintings, there can be detected the influence of the medieval religious mystic Ruysbroeck. After all, they argue, in the sequence of stages of contemplation is not one of the chief features just such motionless staring at absolutely nothing?

But to cite Ruysbroeck himself: "The advocates of outward quietude sit themselves down and remain quiet, but without any sort of even inner discipline, as the way to attain the peace desired. This cannot be tolerated, because it brings out in men blindness, ignorance, and indolence, they forget God, themselves, and all things. This repose is the very opposite of the supernatural repose which is possessed in God, for only the latter is a true fusion of the spirit through love and is linked with a fixed gaze into the Brightness that passes understanding." For myself, I doubt that it is really necessary to drag in the mystic Ruysbroeck to explain the depiction of a hermit sunk in thought. Ruysbroeck was a fellow Dutchman, but he was active more than a century before Bosch, even if we concede that it was one of his pupils in the late work of Bosch: the interplay of deeply folded, who founded the Brotherhood of the Common Life with which it is conjectured our painter was associated. Instead, two points seem to me more important: that, as Combe grants, there are pictorial prototypes for the depiction of a man meditating, and that in Bosch's picture no less important than the meditating hermit would seem to be the half-remote, half-desert world.

The atmosphere, we have said, changed, but its new source was not mysticism whose only aim is to bring man and God closer, or even into union. In this reassuring and imperturbable picture as elsewhere, Bosch holds it impossible to transcend the real world or even to put it out of mind. The world, for him, is not amenable to transformation

into a utopia without adversaries or disorders. So a saint like Anthony can only hold himself immobile, his gaze fixed on, and yet aloof from, the troubled breakers that, though so far off, yet come to him from the world of men. And this, for every eye willing to explore deeper into this picture, is how Bosch paints him. Here too, in harmony with the receptacle-like form of the hollow tree, the entire terrain must be viewed as a thin shell or bowl: the desert-yellow, wavelike mounds to the rear as well as the marshy soft turf in the foreground. The eye is permitted to move only from one small patch of land to the next in this entirely unnaturalistic construction of the landscape. The green bushes, simultaneously barriers and portals to the next step the eye is to take, seem stamped out of metal, though not so tightly compressed as not to be moved by the wind, which is how the Flemish rendered them. Alongside a house, like nothing so much as a hump of the ground itself, rises an octagonal chapel, which wears some sort of blue umbrella over its steeple and is clad in its own thin-walled dress which stands out around it, just as the blue in the far distance also proves to be an enigmatic edifice in some sort of heavy, close sheathing. As far as one can see in this landscape, all the cloaked or masked forms are peaceful in feeling. So much the more upsetting then, in the lower left corner, the most horrible apparition in any painting by Bosch (page 125). Silent, not howling, yet the essence of aggression: a twolegged porcupine with big, gray, human feet, a terrapin head made of blue-green mud, with huge toothed mouth and bulging yellow dewlap. Unlike the screaming head in the water it is more likely to provoke disgust and revulsion than fear. The old world of Bosch is not extinct, then, but has only retreated into a hiding place all too easy for it to emerge from again.

Light and darkness flow tough and gentle in the greenish yellow waves of a picture like none ever painted before, one which, like Combe, I take to be the last work by Bosch to come down to us. Neither mysticism nor pastoral calm really prevails in its undulating countryside. Yet there would seem to be no trace at all left of the stark world-drama that racks Bosch's other pictures. All his life Bosch had observed and painted that drama which almost always had passed him by, even when he stood in the thick of it. Now, in his last years, was it at last appeased? Was it giving way to something else, to a great peace on earth? Scarcely. Soon after Bosch's death began an era in which the turmoil he had so often glimpsed became more real and terrible from year to year, with no more than brief pauses for a world in travail to catch its breath, moments of peace as evanescent as in this picture of a saint: the picture of an ideal world of the artist's dreams.

Project Manager: Kate Norment Designer: Martin Perrin Production Manager: Justine Keefe

Library of Congress Cataloging-in-Publication Data

Linfert, Carl, 1900–
Hieronymus Bosch / by Carl Linfert.
p. cm.
"Masters of art."
ISBN 0-8109-9132-2
1. Bosch, Hieronymus, d. 1516—Criticism and interpretation. I.
Bosch, Hieronymus, d. 1516. II. Title.

N6953.B66L56 2003 759.9492—dc21

2003013679

This is a concise, paperback edition of Carl Linfert, *Hieronymus Bosch*, originally published in 1972.

Copyright © 2003 Harry N. Abrams, Inc.

Published in 2003 by Harry N. Abrams, Incorporated, New York. All rights reserved. No part of the contents of this book may be reproduced without written permission of the publisher.

Printed and bound in Japan 10 9 8 7 6 5 4 3 2 1

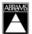

Harry N. Abrams, Inc. 100 Fifth Avenue New York, N.Y. 10011 www.abramsbooks.com

Abrams is a subsidiary of LA MARTINIÈRE